First published in 2013 by
Liberties Press
140 Terenure Road North | Terenure | Dublin 6W
Tel: +353 (1) 405 5701
www.libertiespress.com | info@libertiespress.com
Trade enquiries to Gill & Macmillan Distribution
Hume Avenue | Park West | Dublin 12
T: +353 (1) 500 9534 | F: +353 (1) 500 9595 | E: sales@gillmacmillan.ie
Distributed in the UK by
Turnaround Publisher Services
Unit 3 | Olympia Trading Estate | Coburg Road | London N22 6TZ
T: +44 (0) 20 8829 3000 | E: orders@turnaround-uk.com
Distributed in the United States by
International Publishers Marketing
22841 Quicksilver Drive | Dulles, VA 20166 | Tel: +001 703 661 1586

ISBN: 978-1-907593-57-4
2 4 6 8 10 9 7 5 3 1

A CIP record for this title is available from the British Library.

Cover and internal design by Ros Murphy

WHERE THE STREETS HAVE 2 NAMES

U2 AND THE DUBLIN MUSIC SCENE 1978 - 1981

Patrick Brocklebank
with Sinéad Molony

Dedications

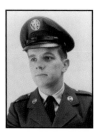

Damian Leo Brocklebank was a sergeant in the US Air Force. It was he who purchased the camera used to take the photos for the first-ever interview of U2 and the Virgin Prunes for *Hot Press* magazine. He served his adopted country with distinction, with two tours of duty in Vietnam and Korea in the sixties and early seventies.

Gero Reimann was a school teacher, academic, and science fiction writer. He was a native of the old West Germany although he was born in Poland during the Second World War, after his family fled from the advancing Red Army. He published a book of short stories in 1982 and his first novel in 1984. He was later shortlisted posthumously for the Deutscher Science Fiction Preis, this is for science fiction writers in the German language. Gero was a great fan of U2 and spoke about them on his many visits to Ireland.

In the summer of 2009, an old acquaintance, **Fintan Kerrigan**, contacted Patrick about a photo of the first-ever U2 gig at the Dandelion Market, which he had seen online. He had recognised himself in the foreground and wanted to know if he could get a copy. There was no word from him again. He died in Vietnam in 2009.

Maggie Gleeson was the founder of the Dalkey Writers' Workshop. Her comedy was broadcast by RTÉ and she wrote the scripts for a number of award-winning documentaries. The very popular long-running Irish soap drama *Fair City* was Maggie's creation.

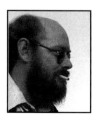

Paul Funge was a very successful painter and close friend of Paul McGuinness and U2. He was founder/organiser of the Gorey Arts Festival, Wexford and hosted shows by such luminaries as Horslips, U2 and Makem & Clancy in the 1980s. In the last year of his life he was more than helpful in providing information for this book.

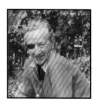

School teacher **Moire Noone** was the model for the bust of Countess Markievicz in Dublin's Stephen's Green. Moire sported a monocle at all times and was a noticeable figure in Tobin's Pub off Grafton Street, where she socialised during the seventies and eighties.

Acknowledgements

Special thanks are due to the following people for their help in the production of this book: Patrick's late mother Louise Brocklebank, Miriam Molony, Tom and Aidan Brocklebank, Kevin Killoran, Kerin Orlowski-Killoran, Paul McGuinness, The Edge, Adam Clayton, Larry Mullen, Bono, Rachel O'Sullivan, Strongman, Guggi, Guc, Dik Evans, Gavin Friday, Brummie, George and Richard Purdy, Capt. Dave Greenlee, Don O'Connor, Smiley Bolger, Johnny Bonny, Frank Kearns, Philip Byrne, Dave Donnelly, Errol Walsh, Turlough Kelleher, Ferdia MacAnna, Pete Holidai, Antonia Leslie, Terry O'Neill, Tom Mathews, Ita Carr, Kav Kay, Cathy Owens, Cathy O'Donoghue, John Fisher (johnfisher.ie/Dandelion_Market.html), Cllr. Mannix Flynn, Rusty Egan, Pat Pidgeon, George Murray, Carolyn Fisher, Dr Mark Holmes, the Dalkey Writers' Group, the Irish Architectural Archive, the Dublin Digital Library, the National Library of Ireland, Trevor White and all the staff at the Little Museum of Dublin, Mike Maguire (Limerick City Library), Mairin Sheehy and all at *Hot Press*, Geoff Muir (www.U2theearlydayz.com), Garry O'Neill (*Where Were You? Dublin Youth Culture and Street Style 1950-2000*), Sam McGrath (www.comeheretome.com), Kieran Owens, www.irishrock.org, Dermott Hayes, Barbara Fitzgerald (RTÉ), www.ucdhiddenhistory.wordpress.com, Bill Hughes, Johnny McCoy B.L., Eoin O'Shea Solr., Marie and Pat Murphy, Angel Loughrey, Tony Strickland, Carmen Rodriguez Piquer, David Hayes (Hayes & Associates), Eugene and Oksana Podzerov, Padhraig Nolan (Artisan Design), Liam Kerrigan, Joy McCormack, Joe Donnelly, Stuart Marchall, Comghall Casey, Brendan Nelson, Karl Tsigdinos, Sé Merry Doyle, Diarmuid Teevan Solr., and Gerry Noonan.

Contents

1978	7
1979	143
1980	215
1981	237

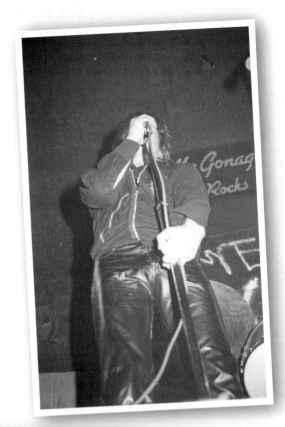

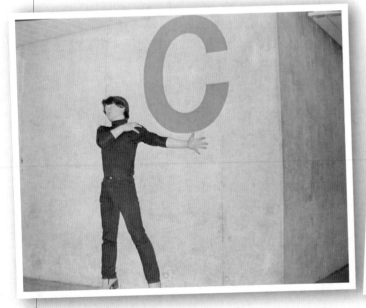

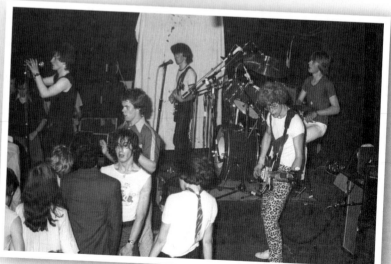

1978

WHERE THE STREETS HAVE **2** NAMES

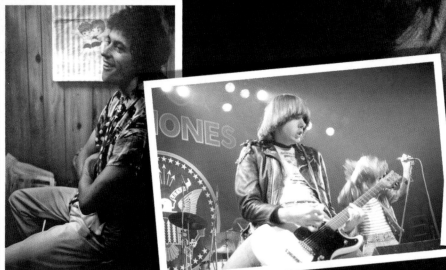

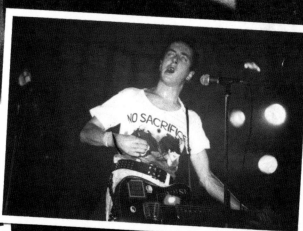

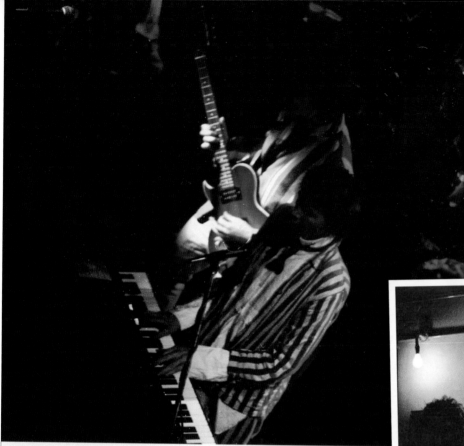

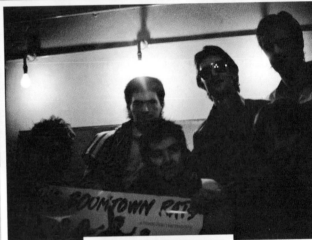

The Boomtown Rats play the
Olympia Theatre, 11 June, 1978.

In 1978, the Boomtown Rats' 'Rat Trap' was the
first Irish and the first new wave single to reach
number one in the UK charts. At a gig in
Dalymount Park in August 1977, Bono
approached Bob Geldof to ask him if he had
any advice for young bands. Well known for a
colourful turn of phrase, the Rats vocalist
replied, 'Yes, I do – fuck off!'

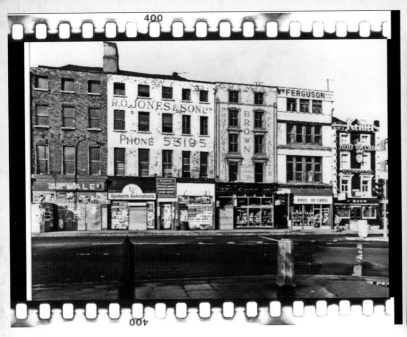

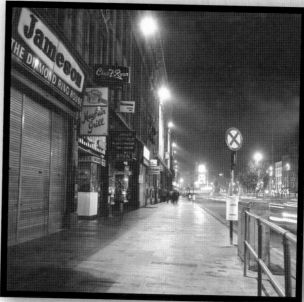

Stephen's Green West prior to its redevelopment, circa 1981. Just out of shot to the left of the picture was the entrance to the Dandelion Market. Photo courtesy of the Irish Architectural Archive.

O'Connell Street, 1973. Image produced courtesy of Dublin City Public Libraries.

Introduction

Where the Streets Have 2 Names is a photographic history of the Dublin music scene from 1978–81, charting the rise of the city's most legendary band, U2, alongside lesser-known greats such as the Atrix, the Blades, the Radiators from Space, and the Virgin Prunes to name but a few. The photos in this book depict the cultural milieu of Dublin and Ireland in the days leading up to the release of U2's first album *Boy* in 1980, and culminate in the band's performance at Slane Castle in 1981. This book in no way attempts to answer the question as to why U2 hit the international big-time when so many other innovative Irish bands disappeared from mainstream consciousness, but rather to give a glimpse of what was an incredibly rich period in Irish music history.

The title of this book is derived from the U2 song 'Where the Streets Have No Name', the third single released off the 1987 album *The Joshua Tree*. While the U2 song references the violent class and sectarian divisions of Belfast City, the title of this book plays on the fact that in Dublin, as in the rest of Ireland,

the streets really do have two names, one in the Irish language and one in the English language. In this sense, the city's street signs reflect the historical tensions that have shaped Irish public life and culture, but also intimate the cultural wealth of this urban centre which for decades has been marked by extremes of poverty and privilege, opportunity and loss, freedom and constriction.

Where the Streets Have 2 Names is not a comprehensive history, but the documentation of one individual's journey through the Dublin music scene – the snapshot of a brief but formative moment in Irish culture. Most of the material in this book comes from the personal archive of Patrick Brocklebank, who began taking photographs with a Konica SLR camera brought to Ireland by his older brother Tom on

The Atrix, the Blades, the Radiators from Space, and the Virgin Prunes

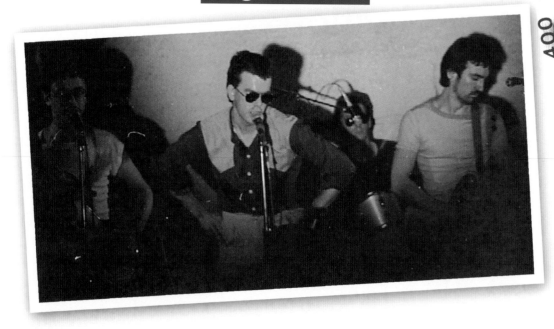

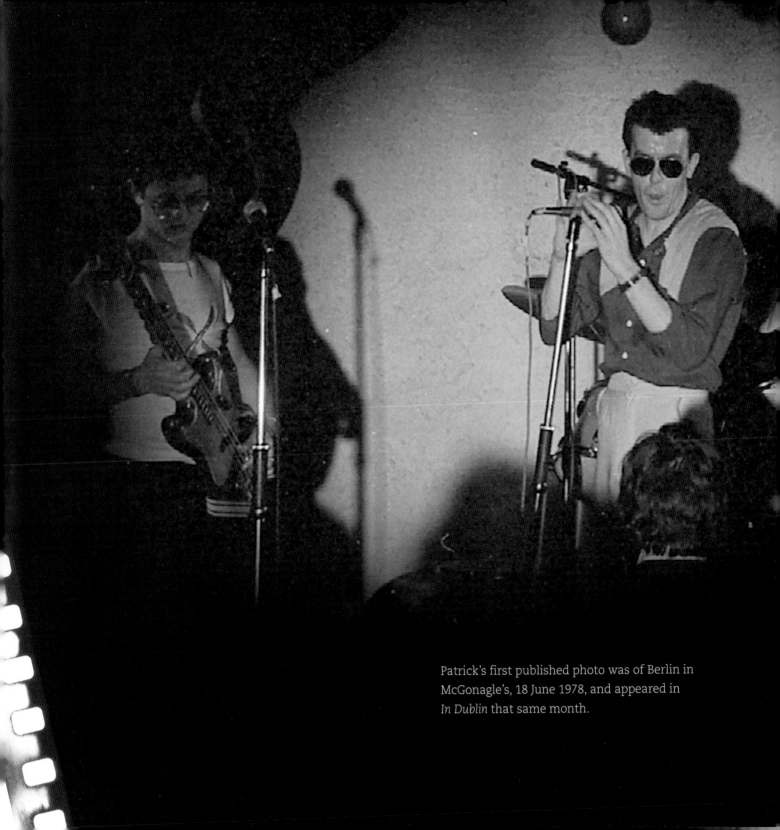

Patrick's first published photo was of Berlin in McGonagle's, 18 June 1978, and appeared in *In Dublin* that same month.

a trip home from the States in June 1978. It was this camera that Patrick brought to a Boomtown Rats gig in the Olympia Theatre on 11 June 1978. At the gig, Pat Moylett, brother of the Rats' Johnny Fingers, approached Patrick and asked him to photograph Berlin (whom he was managing at the time) in McGonagle's Nightclub a week later on 18 June. *In Dublin* paid Patrick about a fiver for one of the Berlin photos – his first published picture. In the same year, having gained a bit more practice, Patrick began working as a freelance photographer for *Hot Press* and as a graphic designer for the fortnightly magazine *In Dublin*. This work shaped Patrick's journey around the Irish music scene, providing him with the opportunity to snap stars like Phil Lynott, Bob Geldof, Pete Shelley and of course U2, who were themselves at almost every one of the gigs pictured here.

Music has always provided an outlet for countercultural expression, whether that be in the traditional folk music of a colonised people, or in the sexual provocations of 1950s' rock 'n' roll. In the 1960s, bands like the Dubliners and the Chieftains spearheaded the Irish folk revival, introducing traditional Irish music to an international audience. At the same time, showbands played cover versions of American and British popular music in Irish dancehalls packed to the rafters with jiving young audiences always hungry for more. Despite their acoustic differences, both of these traditions were of fundamental importance to the development of the Irish rock, punk, new

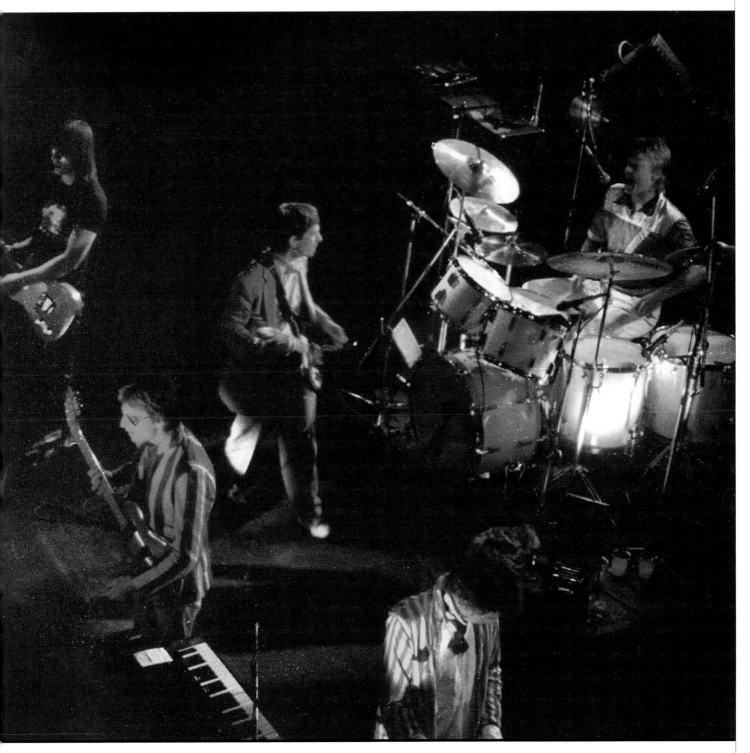

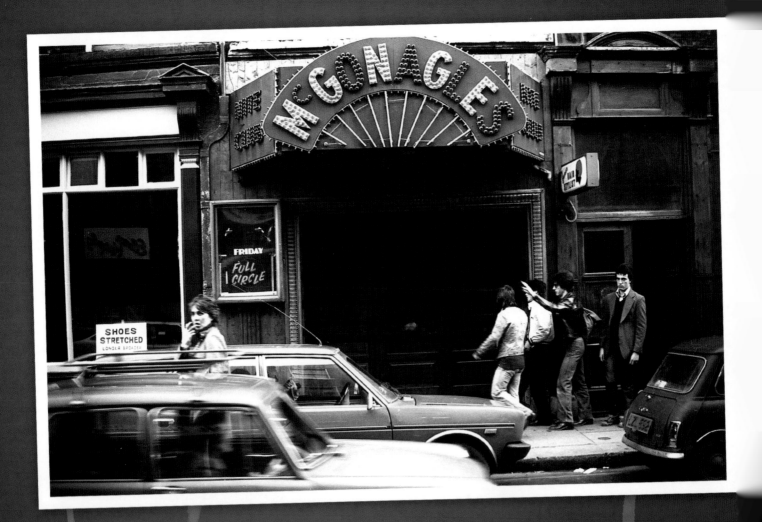

wave, and powerpop of the seventies and eighties. Limerick ensemble Reform (whose success it was predicted that U2 might one day emulate), were formed by members of the Berwyn Showband and the Colours Showband. The legendary Rory Gallagher himself began his musical apprenticeship as a teenager with showbands the Fontana and the Impact. Formed in 1971, Horslips' fusion of Irish folk and rock music birthed the genre known today as 'Celtic Rock'.

Ireland's punk and new wave movement was incubated in venues like Moran's Hotel, McGonagle's, the Dandelion Market

Meanwhile, the 1972 cover of the traditional song 'Whiskey in the Jar' saw Irish band Thin Lizzy finally break into the UK top ten in 1973. These acts were the forerunners of U2. In a bleak economic landscape, they realised the rock 'n' roll dream that has haunted many a young hopeful since Elvis first sang of his blue suede shoes.

Ireland's punk and new wave movement was incubated in venues like Moran's Hotel, McGonagle's, the Dandelion Market, Zero's Rock Palace and the Project Arts Centre. In these oftentimes makeshift sweatboxes, bands and their fans sang, danced, fought, loved, drank, doped, raged and pogoed themselves into fantastic frenzies. For the city's disenfranchised youth, music provided one of the few antidotes to social and political impoverishment.

An example of Patrick's original artwork as a graphic designer for *In Dublin*. Strips of typesetting (known as galleys) were cut up and laid out on sheets, then glued in place with Cow Gum. Once the copy was finalised, it was sent to the *Nationalist* and *Leinster Times* in Carlow to be printed for publication. The U2 gig listed under 'New Wave Festival Concerts' took place in the Project Arts Centre with support from the Virgin Prunes (see photos later in this book). The pen and ink drawing of Ian Dury is also by Patrick.

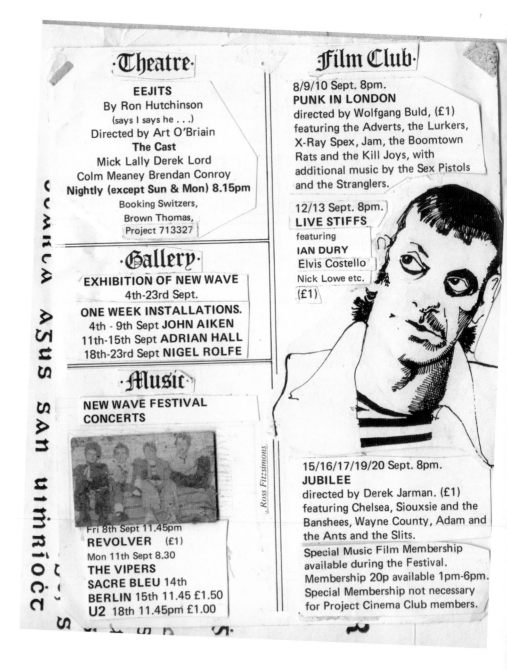

Theatre

EEJITS
By Ron Hutchinson
(says I says he . . .)
Directed by Art O'Briain
The Cast
Mick Lally Derek Lord
Colm Meaney Brendan Conroy
Nightly (except Sun & Mon) 8.15pm
Booking Switzers,
Brown Thomas,
Project 713327

Gallery

EXHIBITION OF NEW WAVE
4th-23rd Sept.
ONE WEEK INSTALLATIONS.
4th - 9th Sept JOHN AIKEN
11th-15th Sept ADRIAN HALL
18th-23rd Sept NIGEL ROLFE

Music

NEW WAVE FESTIVAL CONCERTS

Fri 8th Sept 11.45pm
REVOLVER (£1)
Mon 11th Sept 8.30
THE VIPERS
SACRE BLEU 14th
BERLIN 15th 11.45 £1.50
U2 18th 11.45pm £1.00

Ross Fitzsimons

Film Club

8/9/10 Sept. 8pm.
PUNK IN LONDON
directed by Wolfgang Buld, (£1)
featuring the Adverts, the Lurkers,
X-Ray Spex, Jam, the Boomtown
Rats and the Kill Joys, with
additional music by the Sex Pistols
and the Stranglers.

12/13 Sept. 8pm.
LIVE STIFFS
featuring
IAN DURY
Elvis Costello
Nick Lowe etc.
(£1)

15/16/17/19/20 Sept. 8pm.
JUBILEE
directed by Derek Jarman. (£1)
featuring Chelsea, Siouxsie and the
Banshees, Wayne County, Adam and
the Ants and the Slits.
Special Music Film Membership
available during the Festival.
Membership 20p available 1pm-6pm.
Special Membership not necessary
for Project Cinema Club members.

Reform

7 July 1978. After driving through the night from Tullamore for a gig the next day in Newcastle West, Reform pose beside a Morris Minor in the Faranshone district of their native Limerick. From left to right: Don O'Connor (vocals, drums), Joe Mulcahy (vocals, bass, harmonica) and Willie Browne (vocals, guitar, mandolin). Noel Casey (bass) was also an original member of the band, which formed in 1968, but had left the band by 1973. Reform's

'I'm Gonna Get You' was voted the number one original song on the RTÉ television programme *Spin Off* and was released as a single by CBS records in September 1973. In December 1974, Don O'Connor complained to James Morrissey in *Spotlight* magazine about the Irish media's privileging of Dublin groups who 'have little to offer' and flop when they play in country venues. 'It's unfair to lead people up the garden path by saying there's such a thing as a Dublin rock scene . . . Where? . . . I'd like to know the rock venues . . . Yes there's Zero's and maybe one or two pub venues. Does that mean there's a healthy rock scene in Dublin? No sir.'

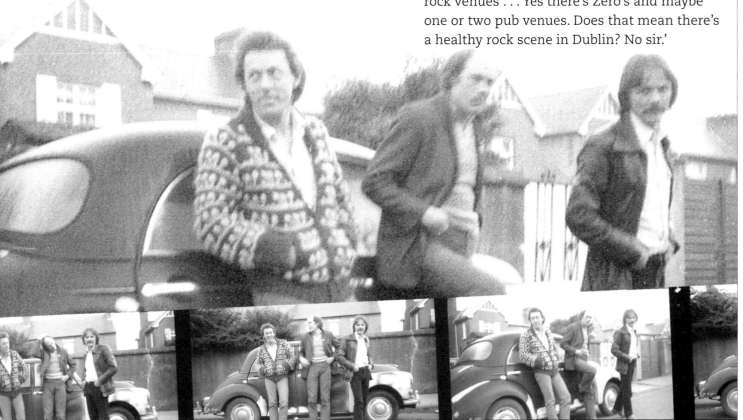

U2's Big Break

In 1976, fourteen-year-old Dublin drummer Larry Mullen stuck an advertisement up on the Mount Temple school notice board seeking members for a band. Amongst the six people who responded were Paul Hewson, brothers Dave and Dik Evans, and Adam Clayton. Their first rehearsal took place in Larry's parents' kitchen in Artane, and for about half an hour this group of technically limited but highly ambitious teenage musicians called themselves the Larry Mullen Band. However, it quickly became apparent that although Larry was the founding member, the band's dominant personality was undoubtedly the lead singer Paul Hewson. The name 'Feedback' was decided upon as a democratic compromise, then changed to 'the Hype', but this new title still didn't quite fit.

the band's dominant personality was undoubtedly the lead singer Paul Hewson

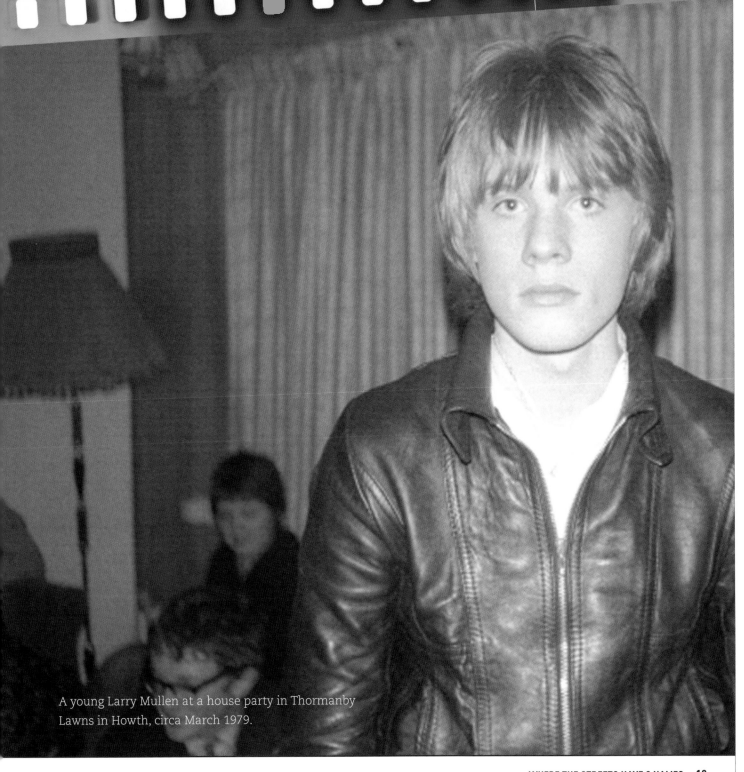

A young Larry Mullen at a house party in Thormanby Lawns in Howth, circa March 1979.

In March 1978, U2 received their first mention in the *Hot Press* listing pages which announced their participation in the Limerick Civic Week band competition in the Stella Ballroom on Shannon Street in Limerick City. Sponsored by Harp Lager and the *Evening Press*, the prize was £500 and a record deal with CBS – everything needed to set a band on the road to fame and fortune, and certainly enough to entice musicians from Dublin to make the 193km journey to Limerick.

On St Patrick's Day 1978, the Hype played a late night show at the Project Arts Centre on Dublin's Essex Street along with a few other local bands. They were anxious to decide on a new name for the Limerick competition, and on the westbound train the next day, they settled on 'U2' following a suggestion by Steve Averill, vocalist with the Radiators from Space.

The ever-faithful U2 entourage also journeyed to Limerick for the occasion. Amongst them were Bono's partner Alison Stewart, Guggi, Strongman, Pod and Maeve O'Regan. Adam Clayton's father was a pilot with Aer Lingus and he stopped over in nearby Shannon Airport to attend the gig. Going for broke, the band booked in to the Royal George, Limerick's poshest hotel. MC for the night was local DJ Michael McNamara and the judges were Jackie

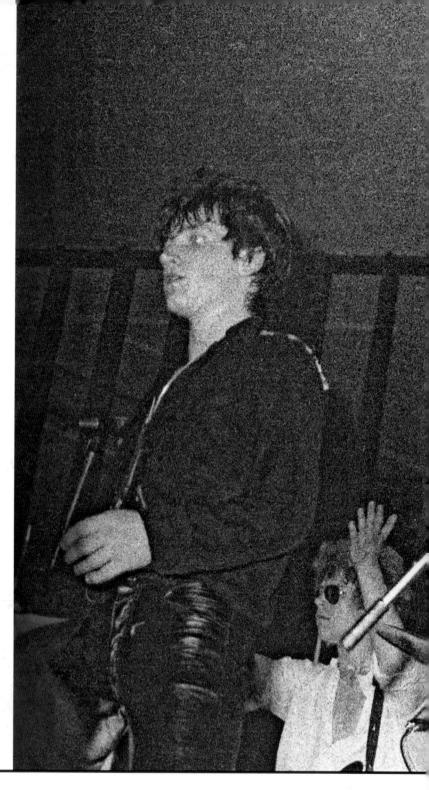

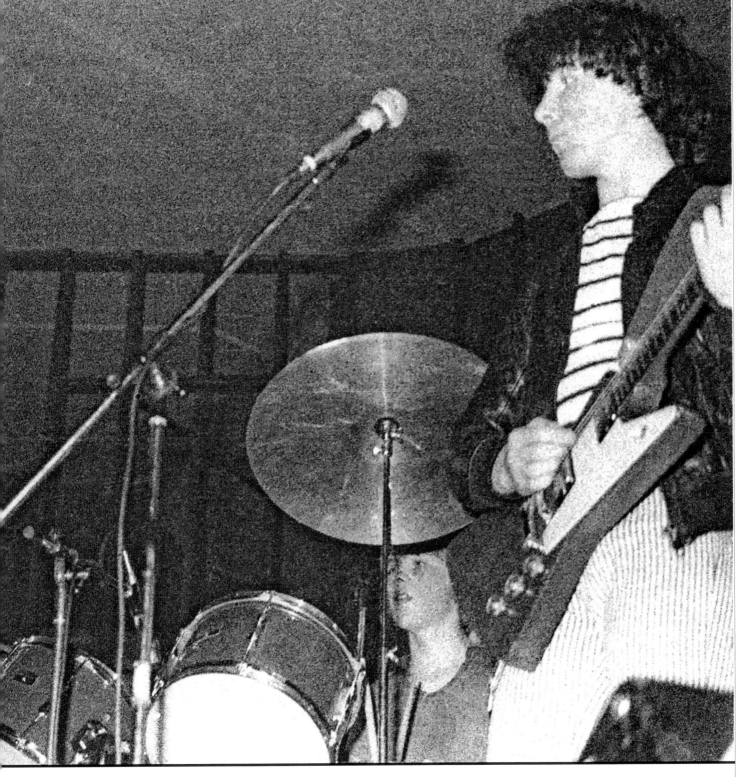

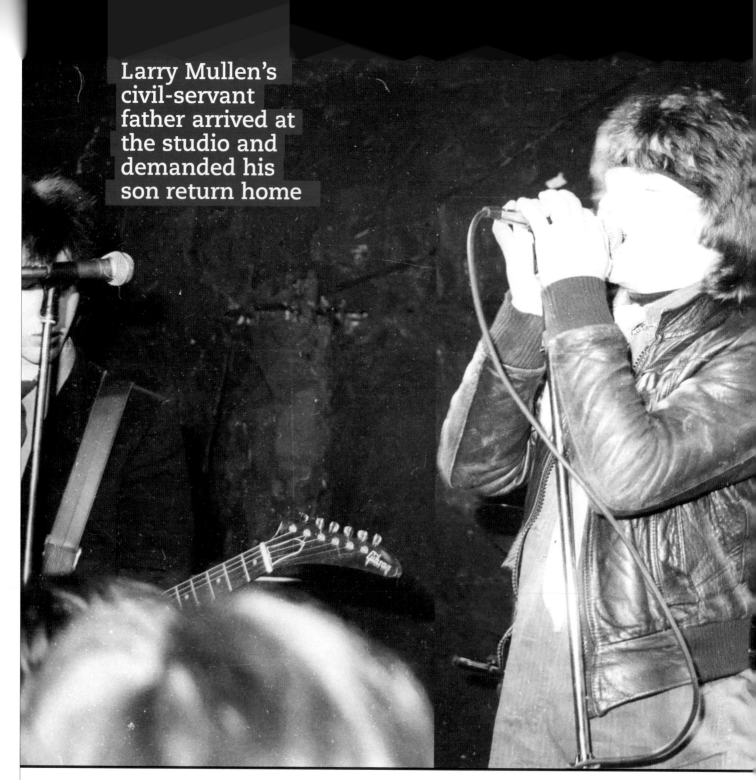

Larry Mullen's civil-servant father arrived at the studio and demanded his son return home

Hayden, then marketing manager with CBS Records Ireland, and Billy Wall, head of entertainment at RTÉ. There were some pretty decent professional bands in the competition, including an R&B outfit called the East Coast Angels from Dublin.

Newly named U2 played three songs that night: 'Street Mission', 'Life on a Distant Planet' and 'The TV Song'. When it was announced that they had won the competition, the mood in the venue turned sour with surprise and resentment. During the presentation of the prizes, competition judge Hayden surmised that, 'Perhaps U2 will have the same amount of success as local Limerick act Reform some day.' Some disgruntled party shouted from about three rows back, 'Fuck U2!'

Nevertheless, U2 got the £500 cash prize, a trophy, and the chance to record a demo with Jackie Hayden and to audition for CBS Records. The session at Keystone Studios on Harcourt Street went reasonably well, until Larry Mullen's civil-servant father arrived at the studio and demanded his son return home. Larry had to go to school the next morning – his academic education considered far more important than the pipe dream of rock 'n' roll superstardom.

Above: Guggi at the house party in Thormanby Lawns, Howth. There were six boys and three girls in the Rowen family including Derek (Guggi), Clive, Trevor (Strongman) and Andrew (Guc). The Rowens' father was a strict follower of the minority religious group, the Plymouth Brethren, and the family spent every Sunday at religious services. The young Derek Rowen rebelled, adopted the name Guggi and turned to art as an outlet for self-expression and release. Guggi's mother encouraged her son's creative streak, but he refused to attend Art College. Even as a young boy, he felt constrained by institutions and was the only one of his brothers not to attend the prestigious Mount Temple School. 'In regard to school,' he says, 'I didn't like it, so I left.' Guggi had a jocose air about him. He never looked

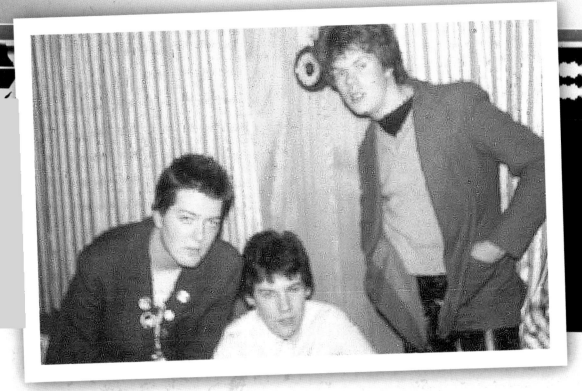

under the weather and was always in a good mood, even after being roughed up – a fairly regular occurrence in those days. Amongst his favourite apparel were his mother's fur coat, skin-tight jeans and laced-up ankle-length silver work boots. In the late seventies, he was a flamboyant presence.

Above: Tommy McCann, Trevor Skelton, and Dave-Id at Mark Holmes's Lypton Village Party in Howth.

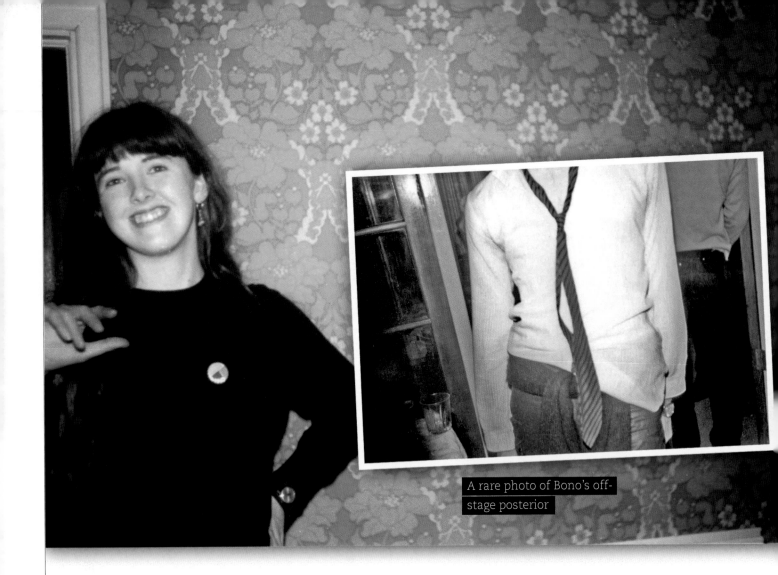

A rare photo of Bono's off-stage posterior

Above: Maeve O'Regan was present at the first dress rehearsal of the band, even before they were known as U2. She was amongst the Lypton Village entourage who travelled to Limerick when they won their milestone competition on St Patrick's Day, 1978.

The Lypton Village social circle was composed of mostly middle-class Northsiders from minority religious groupings, many of whom met at Mount Temple School in Clontarf – one of the few schools in the greater Dublin region not under Catholic control. Larry Mullen,

U2 and the Virgin Prunes attracted a lot of hostility and aggression

Bono and the Edge all married the childhood sweethearts they met in Mount Temple. The Village was an underground movement, a powerhouse of ideas, out of which emerged U2, the Virgin Prunes, Gavin Friday and the artist Guggi. Despite its anarchistic attitude, some observers saw the movement as an exclusive clique and the Lypton Villagers – in particular U2 and the Virgin Prunes – attracted a lot of hostility and aggression. Around Dublin's all too common derelict sites, derisive graffiti proclaimed, 'U2 can be a Virgin Prune'.

Right: Strongman (Trevor Rowen) was a stalwart of the Lypton Village entourage and founding member and bassist with the Virgin Prunes. In September 1978 he met Rachel O'Sullivan at a Virgin Prunes/U2 gig in the Project Arts Centre and the couple married a few years later. Rachel is the sister of Aislinn O'Sullivan, first wife of U2's the Edge.

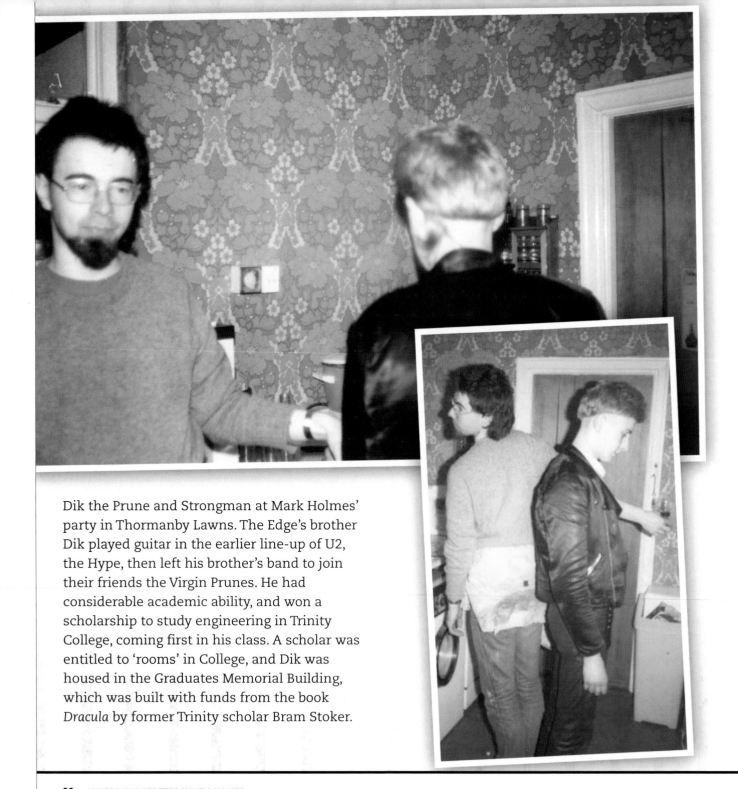

Dik the Prune and Strongman at Mark Holmes' party in Thormanby Lawns. The Edge's brother Dik played guitar in the earlier line-up of U2, the Hype, then left his brother's band to join their friends the Virgin Prunes. He had considerable academic ability, and won a scholarship to study engineering in Trinity College, coming first in his class. A scholar was entitled to 'rooms' in College, and Dik was housed in the Graduates Memorial Building, which was built with funds from the book *Dracula* by former Trinity scholar Bram Stoker.

The Edge's brother Dik played guitar in the earlier line-up of U2, the Hype

Dik's city-centre flat served as a social centre for Lypton Village and as a rehearsal and storage space for both U2 and the Prunes. On Thursday evenings friends would congregate in Dik's city-centre flat to watch the BBC's *Top of the Pops*. On one of these occasions, the Edge was observed practising guitar by playing along to the Police hit 'Message in a Bottle'.

Right: Dave-Id practises his stage routine at the Lypton Village Party in Thormanby Lawns. Although Dave-Id (or as he sometimes called himself, 'Busárus Scott Watson Bang') was an original member of the Virgin Prunes and appeared in most of their publicity shots, many would be forgiven for thinking he was just a support act. He usually took to the stage before Guggi and Gavin Friday to perform his own bizarre repertoire with backing from Prunes' musicians: Pod (drums), Dik (guitar) and Strongman (bass). As with much of the Prunes' work, Dave-Id's idiosyncratic, Dadaist stage-act was an acquired taste.

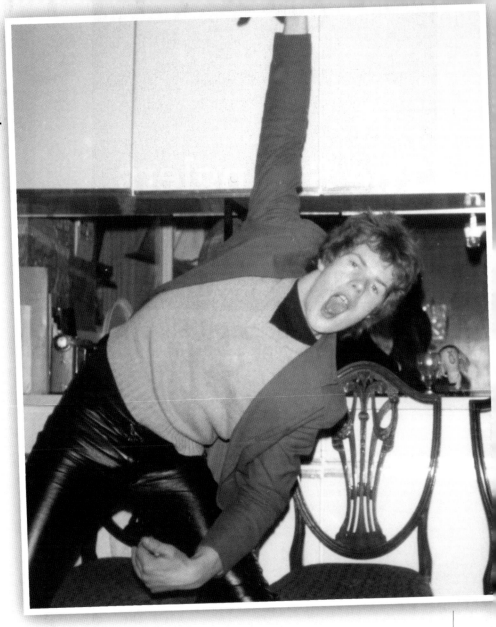

The Stranglers with support from U2

Top Hat Ballroom, Dún Laoghaire
9 September 1978

U2 used their Keystone Studios demo as their calling card, but the following December, with much more experience behind them, they recorded a second demo at the long-gone Eamonn Andrew's Studios, also on Harcourt Street. The album was produced by Barry Devlin, bass guitarist with the Celtic rock-band Horslips. This session was considered much better and the result became their official demo tape. Following their Limerick success, U2 were asked to support the Stranglers at short notice. The promoter, Pat Egan, paid them £50 for this gig in the Top Hat Ballroom, Dún Laoghaire.

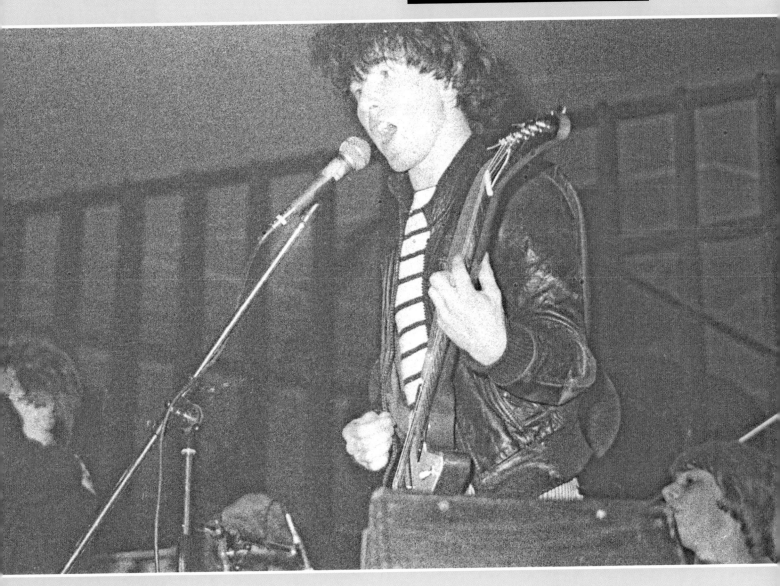

Pat Egan paid them £50 for this gig

BONO

Christened Paul Hewson, Bono grew up on Cedarwood Road, Glasnevin, where he met fellow residents – Gavin Friday and Guggi. Whether fate or coincidence brought the Hewson, Rowen and Hanvey families to this small stretch of Dublin 11 is up for debate, but there is no doubt that the friendship between Bono, Gavin Friday and Guggi amplified each of their unique talents. U2's lead singer was given a number of nicknames before adopting Bono as his moniker of choice. Unsurprisingly, the lengthy 'Steinhegvanhuysenolegbangbangbang' evolved to become 'Huyseman' and then 'Houseman', before being abandoned altogether. A hearing aid shop on Dublin's O'Connell Street inspired the nickname 'Bono Vox' which was eventually shortened to just 'Bono'. It certainly seems fitting that the name of U2's lead singer is derived from 'Bonavox', which translates from Latin as 'good voice'. In the early eighties a friend telephoned the Hewson household and asked to speak to Paul. In response he was told that 'Paul is dead. This is Bono.'

> **'Paul is dead. This is Bono.'**

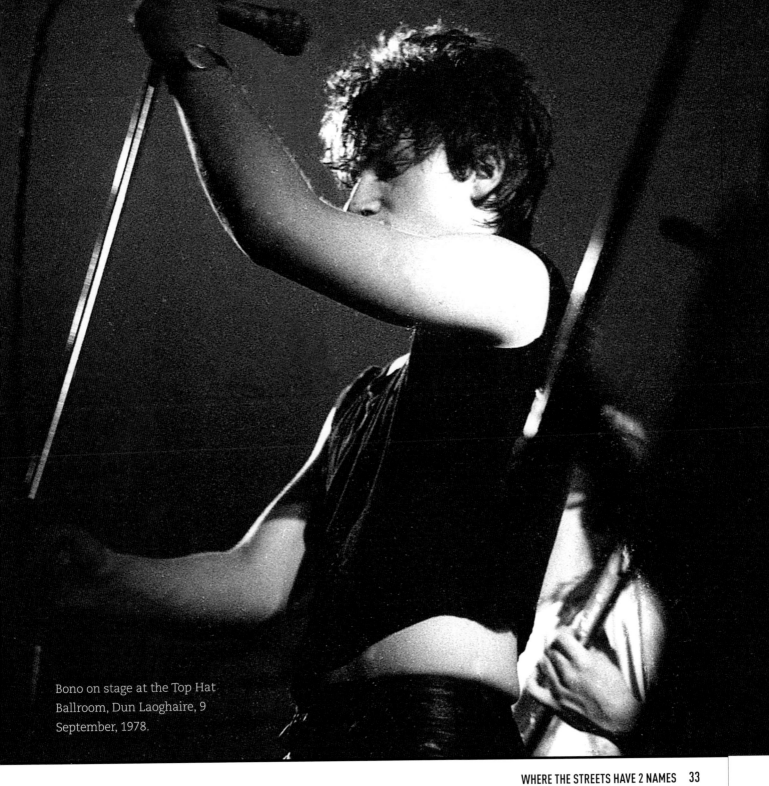

Bono on stage at the Top Hat Ballroom, Dun Laoghaire, 9 September, 1978.

THE EDGE

The Edge on stage at the Top Hat Ballroom, 9 September 1978. Apparently Dave Evans received his nickname 'the Edge' because of the sharp angles of his face, but his quietly questioning personality meant the nickname was a perfect fit. Like his brother Dik (who left U2 in 1978 to join the Virgin Prunes) the Edge never wasted words. He was academically inclined and impressed people from early on with his musical prowess. Dave and Dik both shared an interest in engineering and one of their earliest collaborations was to build a guitar:, not an easy thing to do. Innately intelligent and capable at anything he turned his hand to, the Edge was not one to express emotion; he laughed only reluctantly and seldom showed any anger. When trouble broke out during a support gig for Patrik Fitzgerald on 8 September 1979, the Edge continued to play his Gibson Explorer as if nothing unusual was going on.

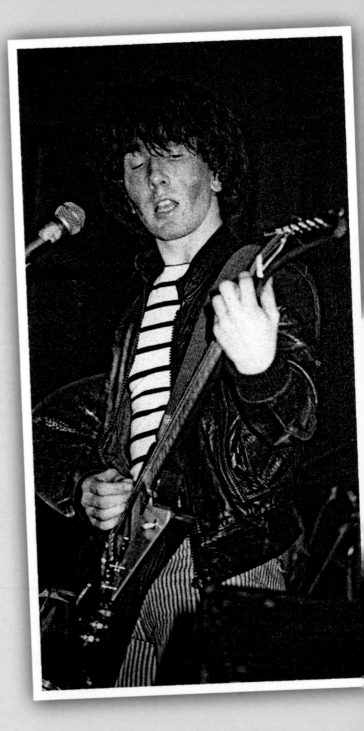

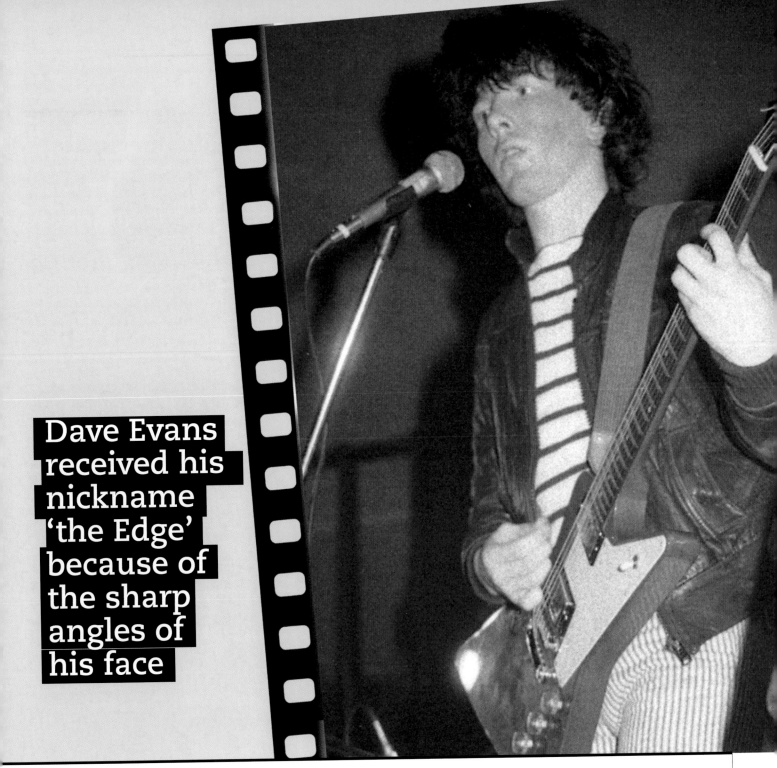

Dave Evans received his nickname 'the Edge' because of the sharp angles of his face

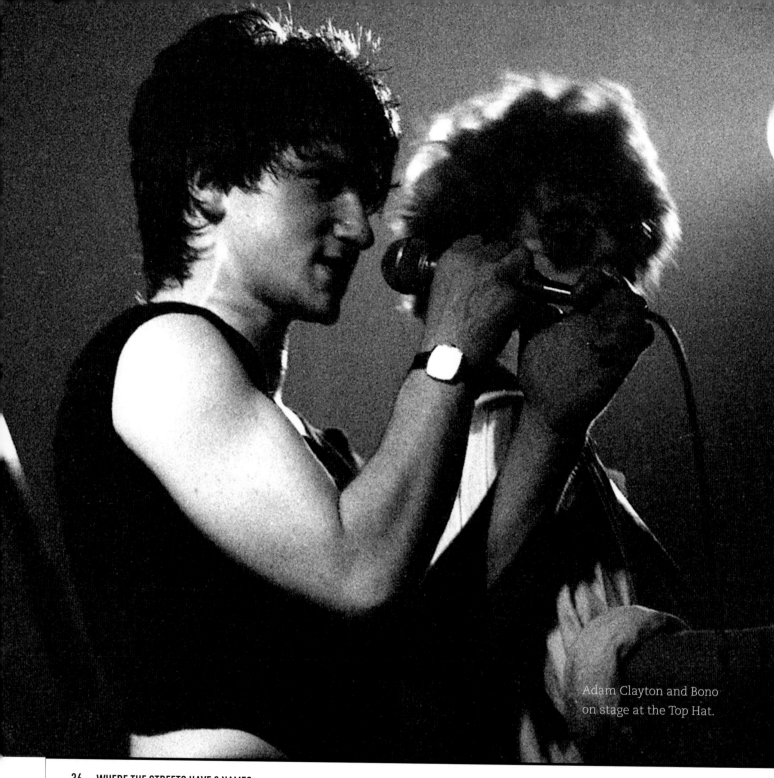

Adam Clayton and Bono
on stage at the Top Hat.

ADAM CLAYTON

Bassist Adam Clayton was the most garrulous of the U2 four. He smoked and drank more than his bandmates, but was also an interesting and intelligent conversationalist. There was never a dull moment when Adam was around. His upper middle-class background was not well received in some quarters and although this resulted in numerous physical attacks on his person, he never tried to hide it. He was not afraid to experiment with fashion and in his leopard skin jeans, Afghan coat, and soft sports shoes, Clayton looked more like a member of the avant-garde Virgin Prunes than U2. Even though in the early days he had a part-time job as a van driver, he never seemed to have much spare cash; all his money was invested in the band.

There was never a dull moment when Adam was around

Hugh Cornwell, guitarist and vocalist with the Stranglers, joined on stage by some enthusiastic fans in the Top Hat, Dún Laoghaire.

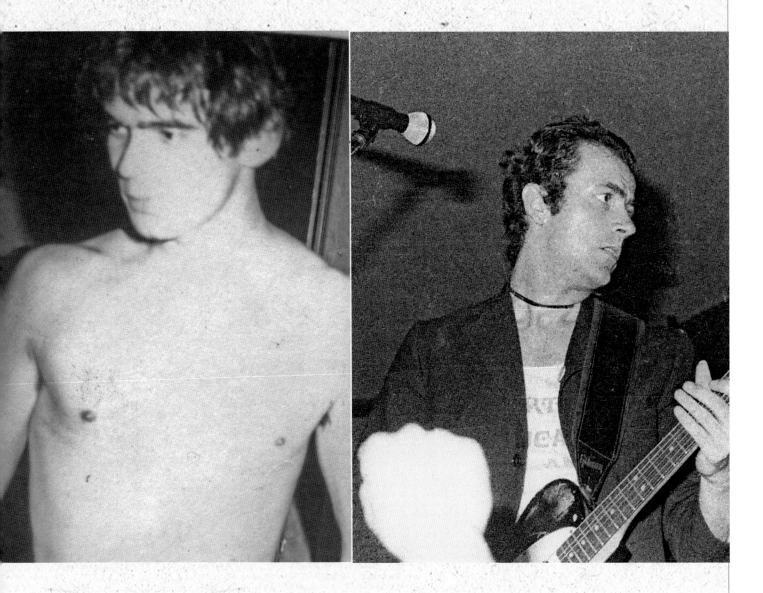

Jean Jacques Brunel on his way from
the dressing room at the Top Hat
Ballroom, 9 September 1978.

Hugh Cornwell of the Stranglers.

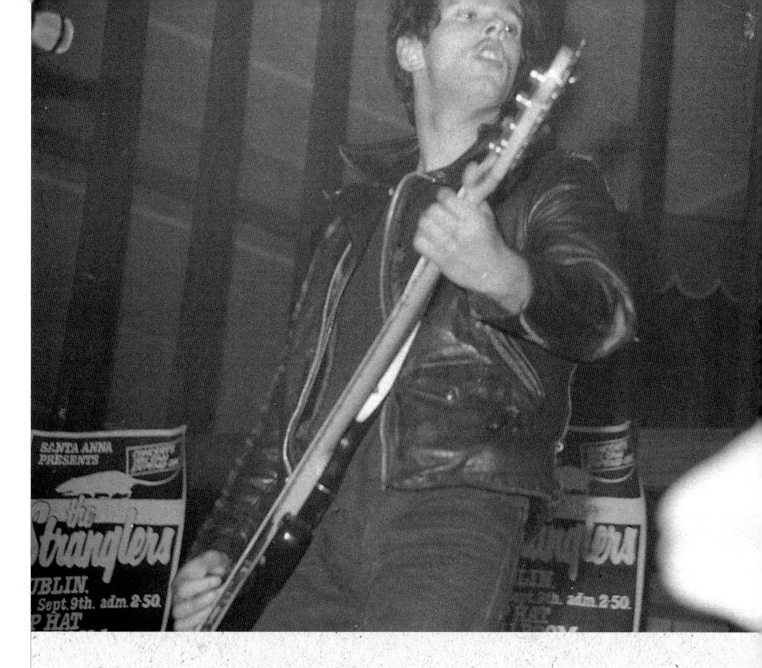

Jean Jacques Brunel, bass player of the Stranglers,
Top Hat Ballroom, Dún Laoghaire.

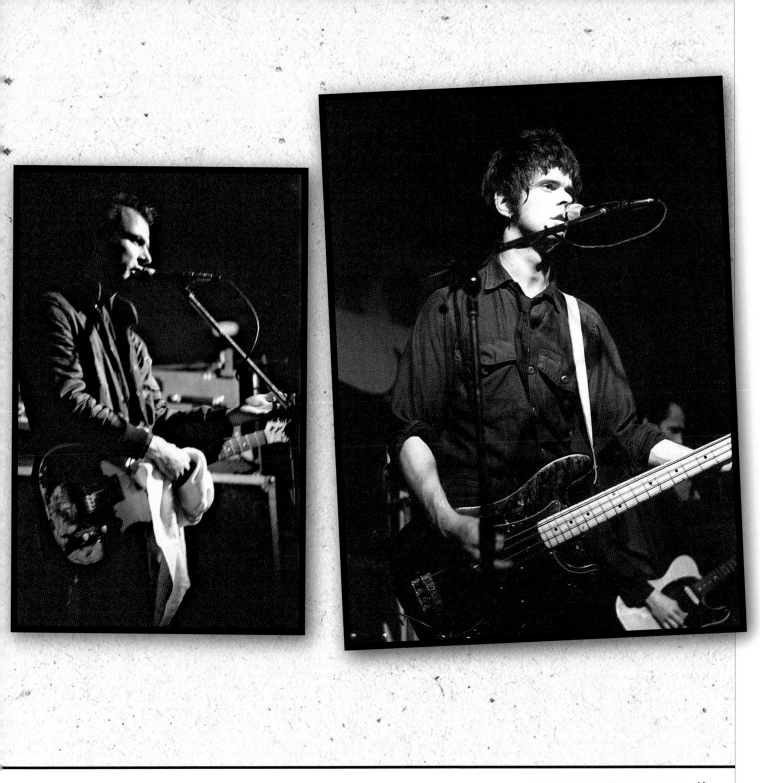

U2 and the Virgin Prunes

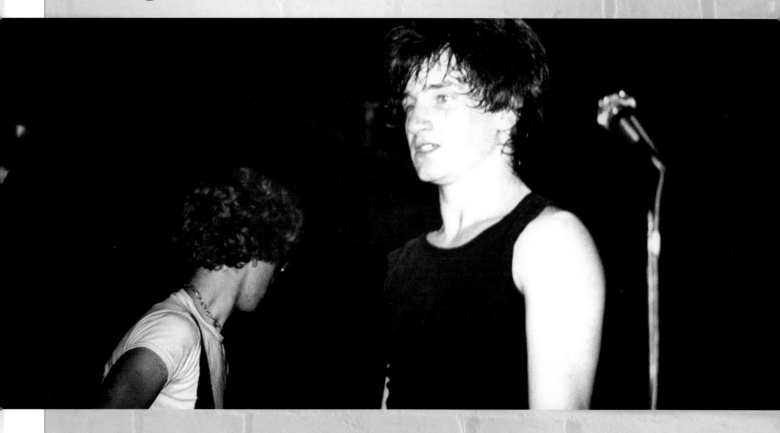

The Project Arts Centre was born in 1966 out of a three-week arts festival in the Gate Theatre on Parnell Street. The success of this innovative and experimental programme was such that by 1967 a permanent centre for the alternative arts was established on Lower Abbey Street. In 1972, the Project moved to a disused factory on South King Street, before finding its current home on South Essex Street in Temple Bar in 1974 – opposite the back door of the Clarence Hotel, which was bought by the Edge and Bono in 1992.

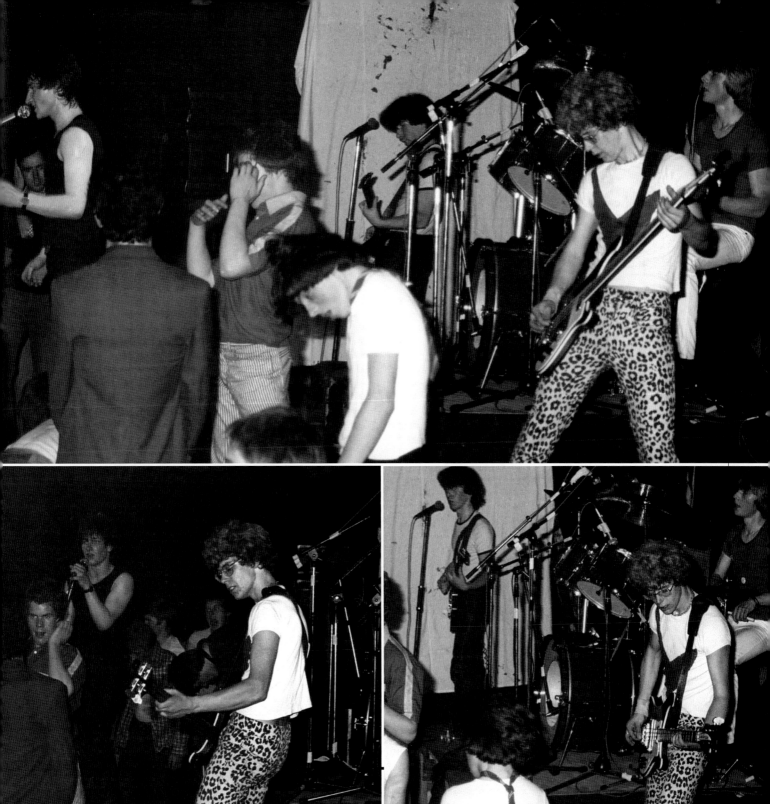

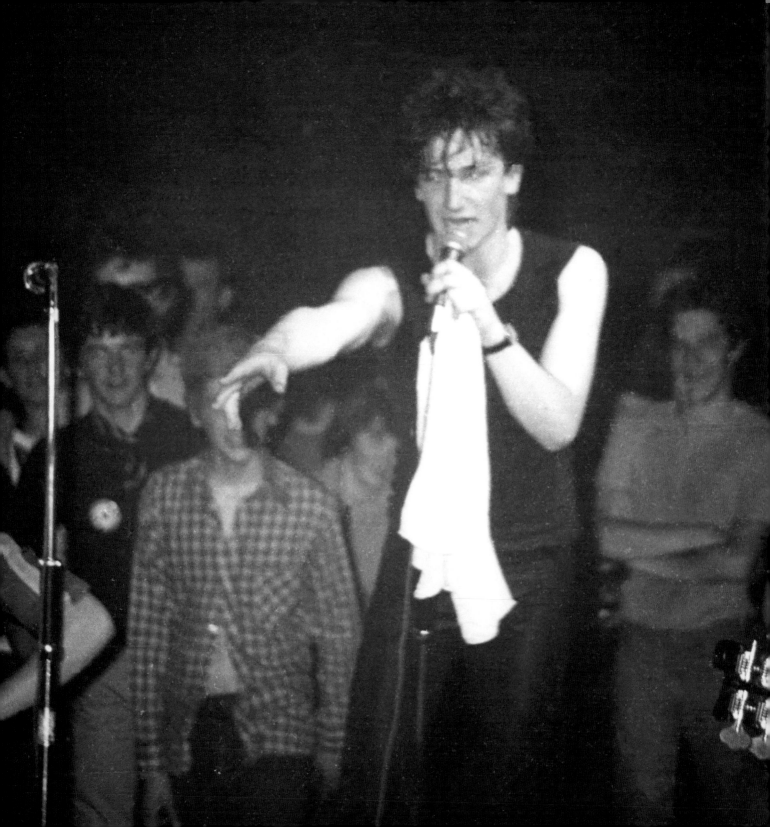

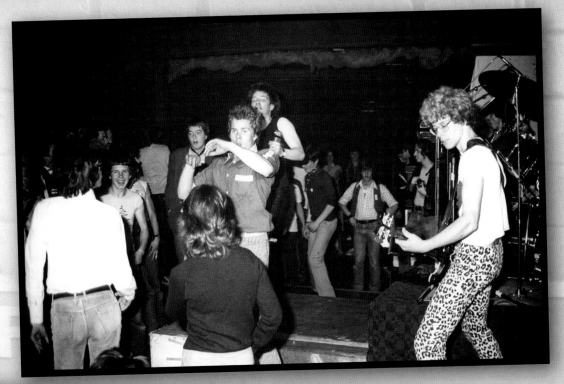

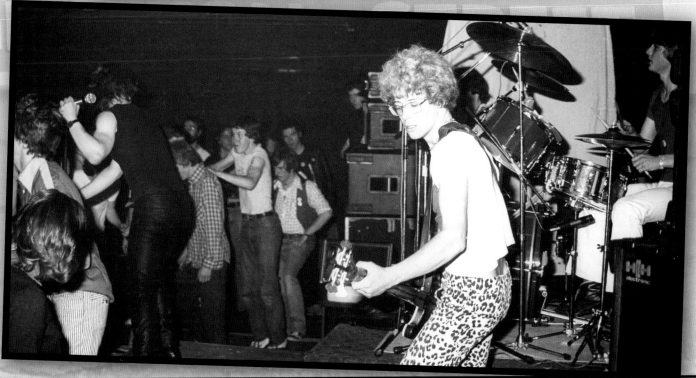

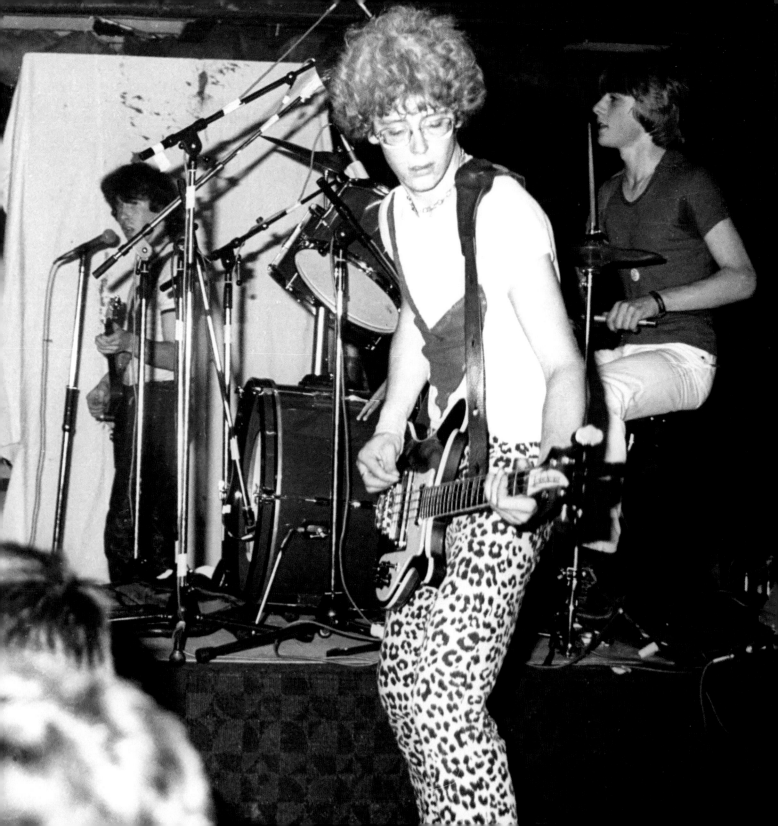

Right: Guggi, Bono and Gavin Friday sharing the stage during the evening show at the Project Arts Centre, 18 September 1978.

The Virgin Prunes first started off as a fan club for U2, and in the early days Gavin Friday used to jump on stage to help the young Bono with his encores. Such was the power and enjoyment of his performance that he soon decided to start his own band.

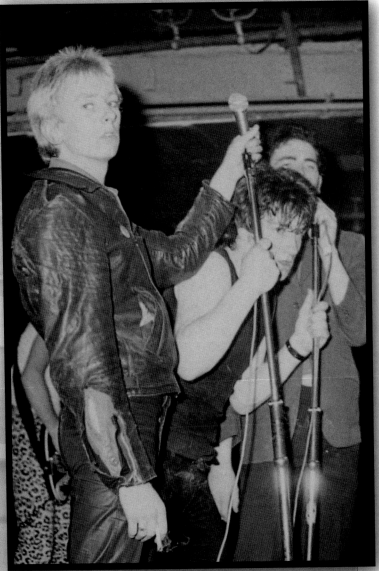

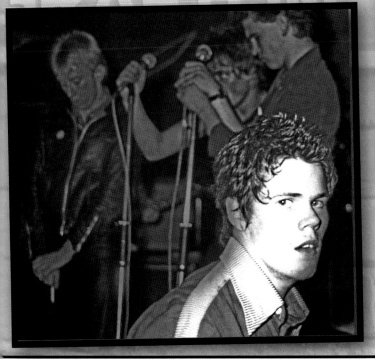

Left: Guggi, Bono and Gavin Friday on stage at the Project with Dave-Id in the foreground.

Gavin Friday, christened Fionan Hanvey, was from the 'Catholic-end' of Cedarwood Road and in some people's opinion, he was the only musical member of the Virgin Prunes. He had great stage presence, commanding gigs with his diabolical makeup, dresses and haunting vocals. One of Gavin's mottos was, 'If you have hassle in your head, get rid of the hassle, not the head.' He and Guggi would take trips round the country 'collecting heads' – befriending idiosyncratic characters from whom they could draw inspiration. They did not always need to travel far; the name 'Virgin Prunes' is derived from the moniker Gavin and Guggi gave the patients of a psychiatric institution in nearby Glasnevin.

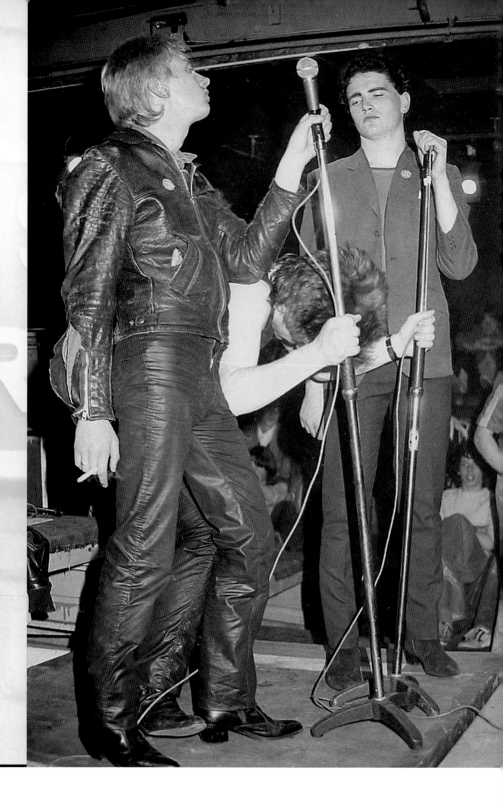

3	7 he II, thomas F	£21
5	Rowen, Robert S	£21
7	Avery, Tomas	£21
8	Irby, Denis J	
10	Hewson, Brendan R	
12	O'Sell, Archie J	
138	Hanvey, Robert	£19
140	Hanvey, Robert	£18
142	Corless, Christopher	£19

Thom's Dublin Street Directory entries for Cedarwood Road, 1978.

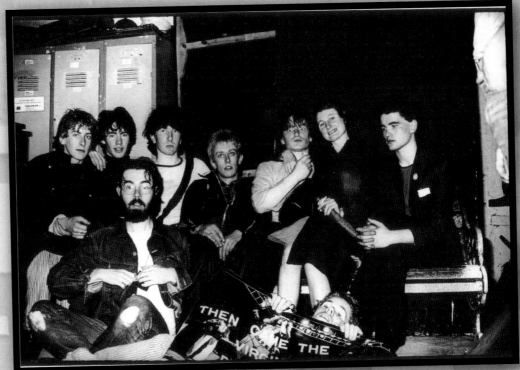

Following the Limerick win, U2 set about capitalising on their victory. Adam Clayton got the home telephone number of Bill Graham, a music journalist with *Hot Press* magazine, and badgered him for publicity. Adam left many a message with Bill's late mother Eileen Graham at their then home on Earlsford Terrace, Dublin. After a couple of weeks, Bill agreed to meet the young band at the Blue Dolphin pub near Mount Temple School. Schoolbooks and bags were tucked out of sight as the band laid out their plans to conquer the world in a lounge that smelled like stale tobacco smoke and spilt beer.

Graham was impressed with U2's enthusiasm and exuberance, but at that moment he couldn't do much for them. The Limerick competition win was old news, and *Hot Press* hadn't been involved in it, so all he could do was to wait for the demo and make a mental note that they were a group to watch. But he did agree to attend one of their rehearsals, during which they played a number of Ramones numbers, having little original material of their own.

The meeting with Graham was a turning point for U2, because the journalist eventually introduced the band to his old college friend Paul McGuinness, who was to become their legendary manager. McGuinness worked in a Dublin advertising agency called Young's with his girlfriend Kathy Gilfillan, who he later married.

Having read a piece Bill wrote for *Hot Press* in April 1978 entitled 'Yep it's U2', Paul went to see the group play at this gig in the Project Arts Centre on 25 May 1978, and after the show agreed to manage them.

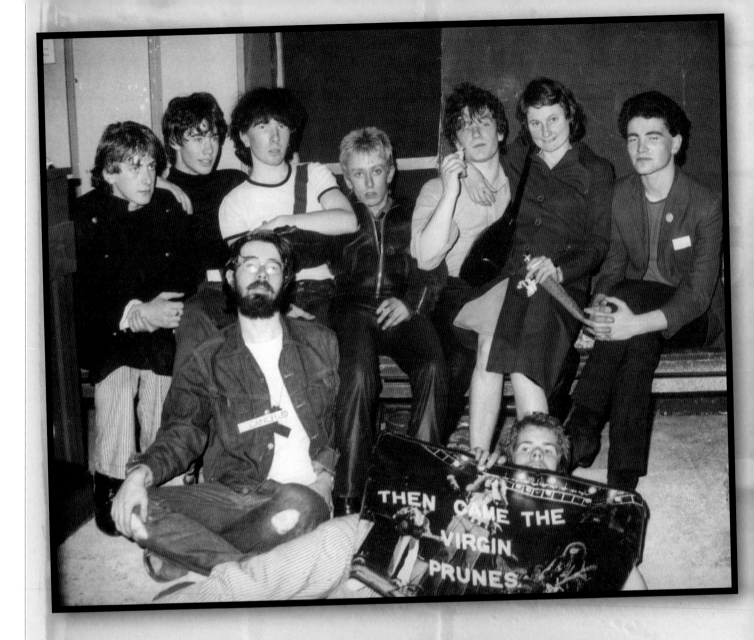

Post-gig photo session with U2, the Prunes and fans backstage in the Project, 18 September 1978. Back row: Strongman, Pod, the Edge, Guggi, Bono, the Enigmatic Elsie, Gavin Friday. Front row: Dik, Dave-Id, on the floor holding a modified Led Zepplin poster, and Adam Clayton. Larry Mullen was absent as he was busy packing away his drum kit.

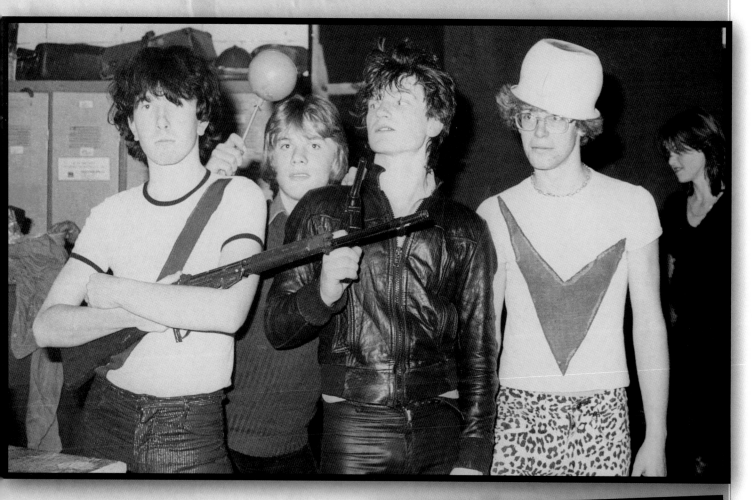

In March 1978, Dik bowed out of the original line-up of U2. He just happened to be caught in shot in the background of this early publicity photo in the Project Arts Centre, 18 September 1978.

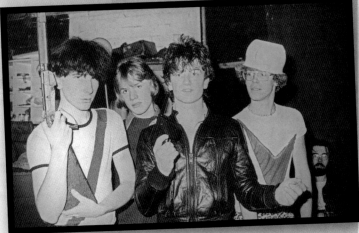

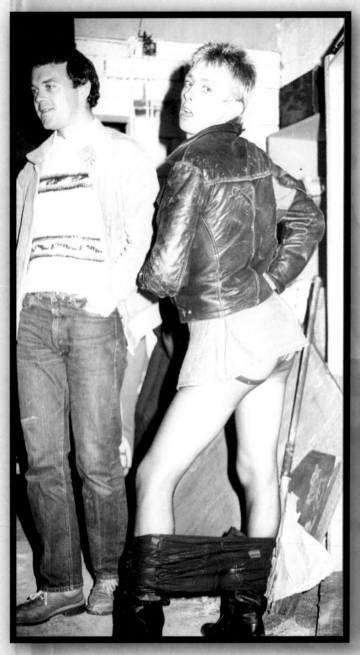

Guggi asked for these particular photos to be taken, and during the impromptu photo shoot an unsuspecting Paul McGuinness walked into shot, causing much amusement in the *Hot Press* offices. The photo on the left was one of the first photos published of Guggi and appeared in the November 1978 issue of *Hot Press*.

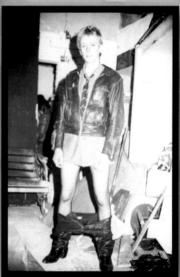

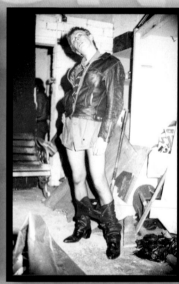

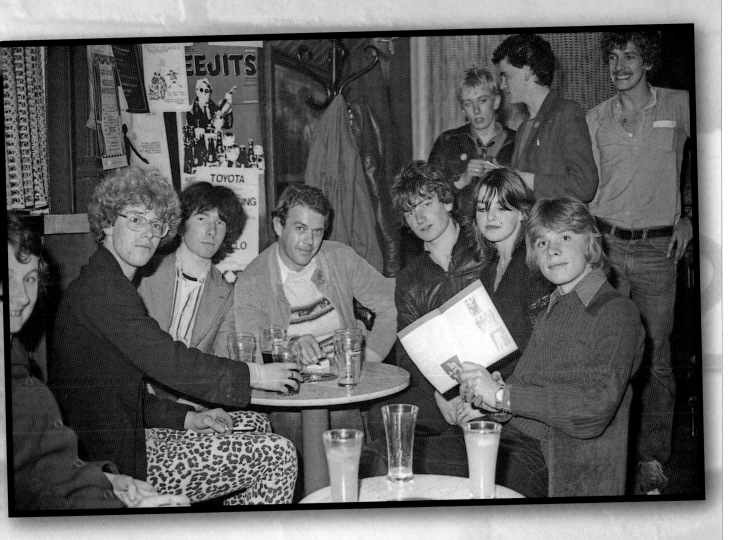

Drinks in the Granary Bar after the Project Arts Centre gig on 18 September 1978. Elsie, Adam, the Edge, Paul McGuinness, Bono, Rachel O'Sullivan and Larry Mullen holding up a booklet about the Limerick Civic Week competition. In the background are Guggi, Gavin Friday and Clive Rowen.

Blackrock Park
Open Air Festival
2 July 1978

Ireland's punk subculture was singled out by the tabloid press as social evil number one when an eighteen-year-old Dubliner died following a stabbing at the Belfield Punk Festival in 1977. Amongst the bands playing that night were the Threat, the Vipers, the Undertones, Revolver, the Gamblers, and headliners the Radiators from Space whose debut single 'Television Screen' had been released in April of that year. In the aftermath of the event, the Threat released a statement saying that, 'We realise that there has been trouble at a few different gigs around Dublin, an example of which was after our own gig last Friday in Belfield. We want to make it quite clear that we don't want any trouble at our gigs. We want everyone, that includes us, to enjoy themselves.' Following the tragedy, the Radiators from Space found it hard to get gigs in Ireland and left for London shortly after.

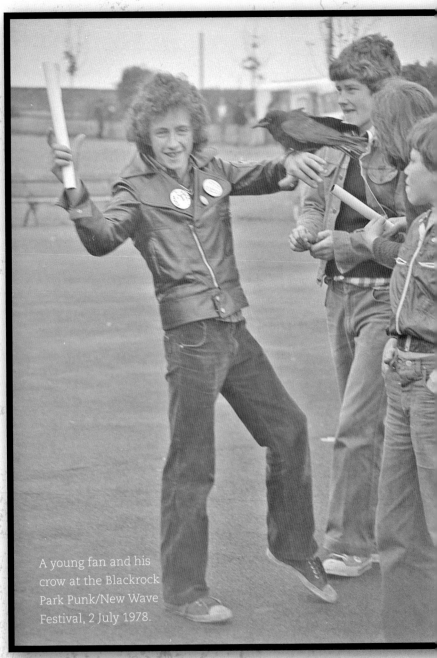

A young fan and his crow at the Blackrock Park Punk/New Wave Festival, 2 July 1978.

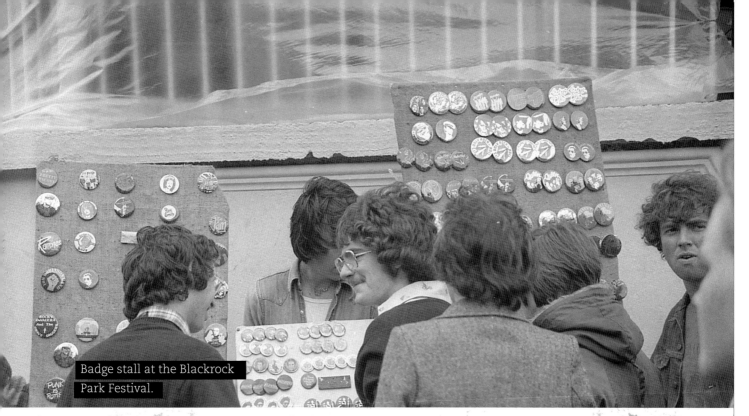

Badge stall at the Blackrock Park Festival.

The Irish music scene recovered somewhat from the Belfield tragedy and the subsequent loss of the Radiators from Space, and in 1978 a number of free concerts were held in Blackrock Park on the south side of the city. On 5 June 1978 at a peace concert in Blackrock Park, the Strange Movements were chased off stage after burning the papal flag, throwing holy water into the nearby lake and threatening to burn down Leinster House. Lead singer Turlough Kelleher claimed that the crowd had confused 'Leinster House' with 'Loughan House' – a detention centre in County Cavan and subject of one of his band's songs. In response to the controversy, guest speaker Betty Williams from the Peace Movement is reported in the *Irish Press* as saying, 'God love them, they'll never be rock stars.' Despite this bad press, another festival, organised by Patrick Croke, was held in the Park on 2 July 1978. The line-up included Velvet Valves, Boy Scoutz, Rocky De Valera and the Gravediggers, the Sinners, and Sasperilla. The Vipers and U2 were supposed to play but didn't because the outdoor sound equipment that had been hired for the festival never turned up and the rest of the bands had to use the Schoolkids' indoor amps. The whole affair was a bit of a shambles, the sound quality was awful and a number of fights broke out, with one member of the audience being taken to hospital. It did make for some great photos though . . .

Left: Tony Pugh centre-stage on vocals and guitar, playing with what could be an early line-up of the Sinners.

Right: Ireland's first all-female punk band the Boy Scoutz on stage at the Blackrock Park Festival, minus their drummer, Ita Carr. The original Boy Scoutz line-up was Adrian Darragh (keyboards and vocals), Carol Walters (guitar), Cathy Owens (bass and vocals) and Ita Carr (drums). By the time they played here in Blackrock, Cathy Owens had left the band and Kathy O'Donoghue joined as main vocalist, while Adrian Darragh took over duties on bass.

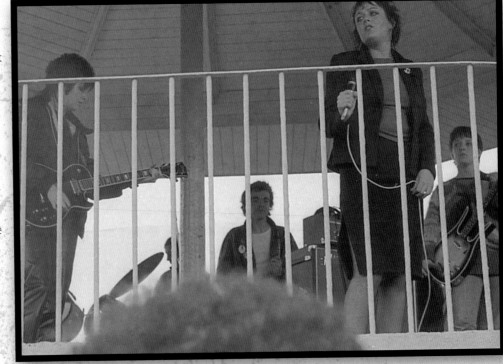

GIRLS
WANTED

HEAT EQUAL
OPPORTUNITY ADVERT.

YEAH, COME ON GIRLS...
ANY GIRLS INTRESTED IN
FORMING AN ALL-GIRL
PUNK BAND OR WRITING
FOR THIS RAG. CONTACT
US. O.K.

APPLY WITHIN.

The *Heat* magazine ad which led to the formation of Ireland's first all-female punk group, the Boy Scoutz. Heat's creators were the graphically talented Pete Nasty (Pete Price) and Ray Gunne (Jude Carr). Content was all hand-written, and featured reviews, interviews and comics. The zine was first released in July 1977 and although sources say its circulation was increasing by two hundred copies per issue, the publication folded in 1979.

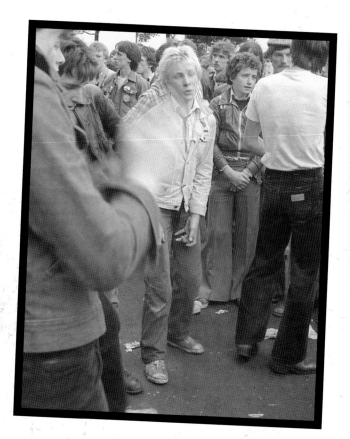

Above: Phillipa and Aislinn O'Sullivan, who later married U2's the Edge.

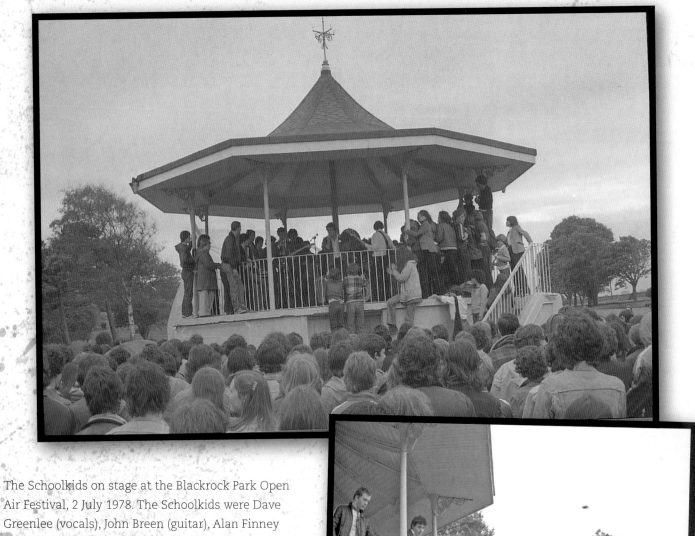

The Schoolkids on stage at the Blackrock Park Open Air Festival, 2 July 1978. The Schoolkids were Dave Greenlee (vocals), John Breen (guitar), Alan Finney (bass) and Charlie Hallinan (drums). Hallinan joined Berlin when the Schoolkids broke up shortly after this gig.

The Schoolkids throw badges to the crowd.

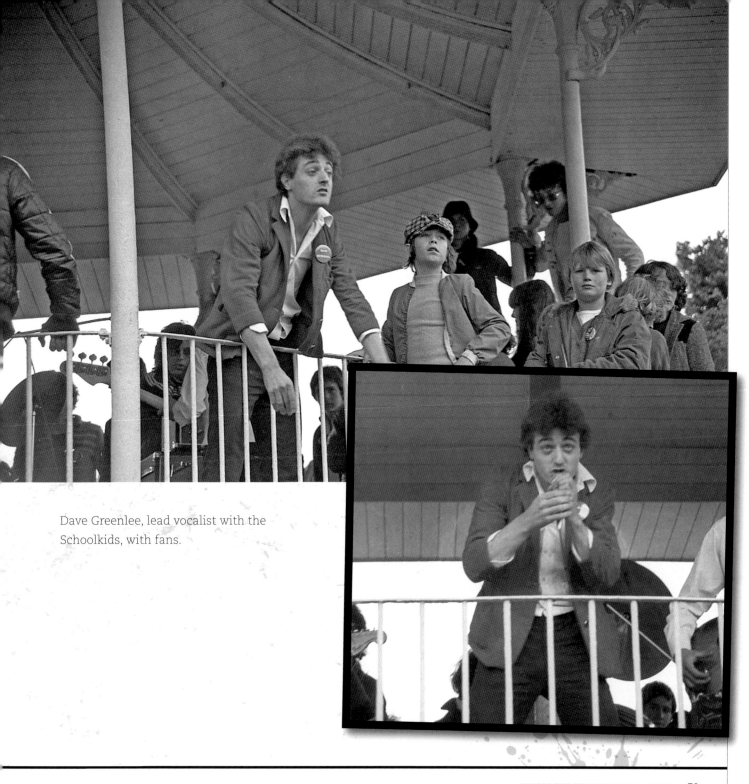

Dave Greenlee, lead vocalist with the
Schoolkids, with fans.

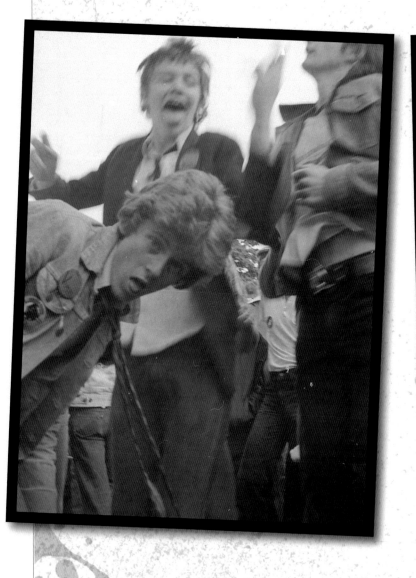
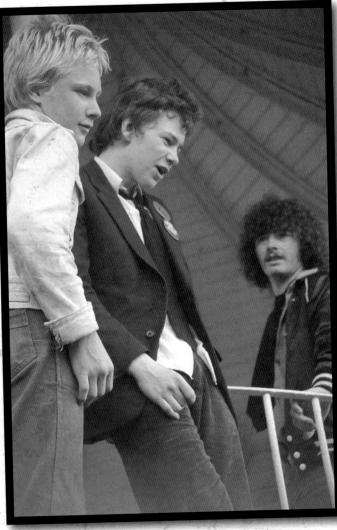

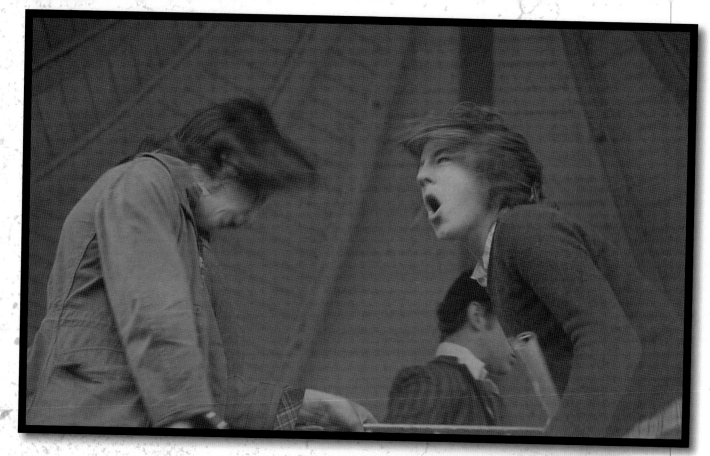

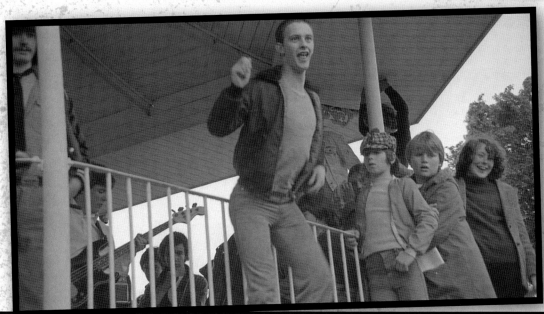

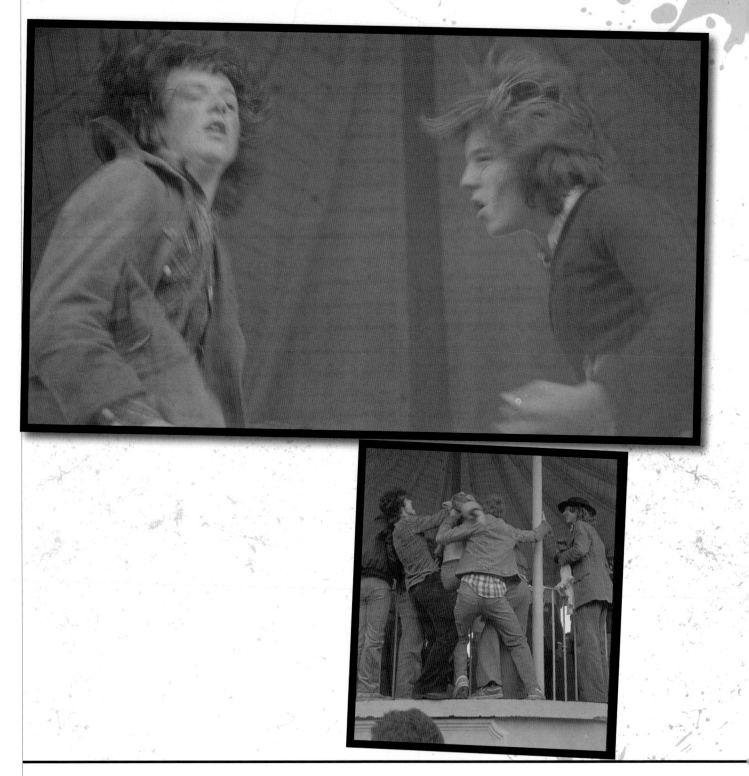

Dave Greenlee surrounded by admirers following the Schoolkids' final performance.

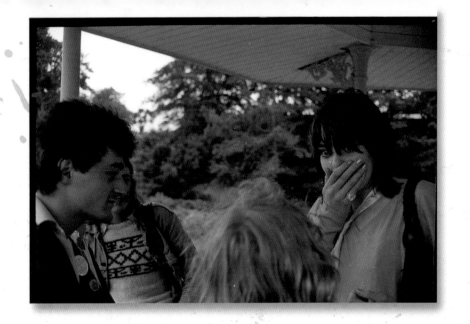

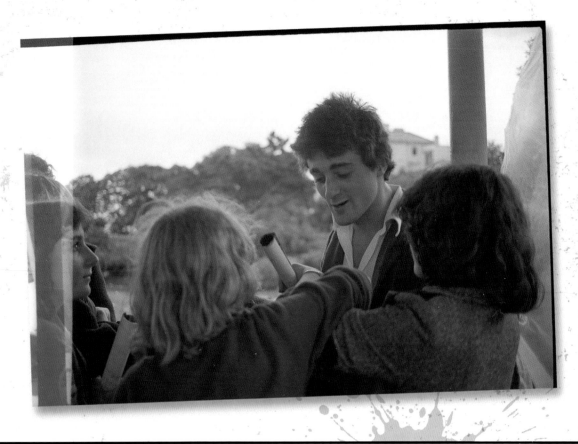

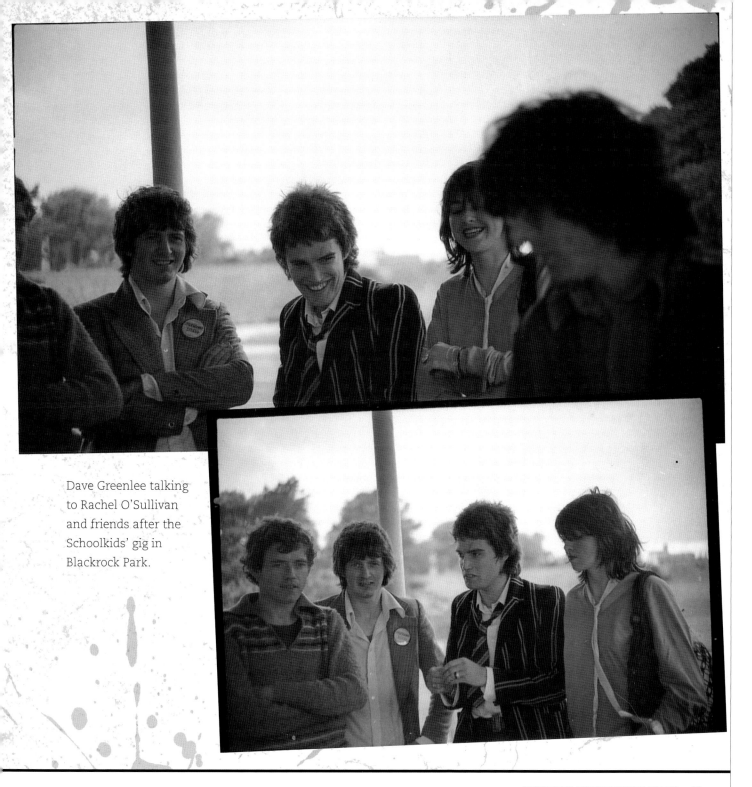

Dave Greenlee talking to Rachel O'Sullivan and friends after the Schoolkids' gig in Blackrock Park.

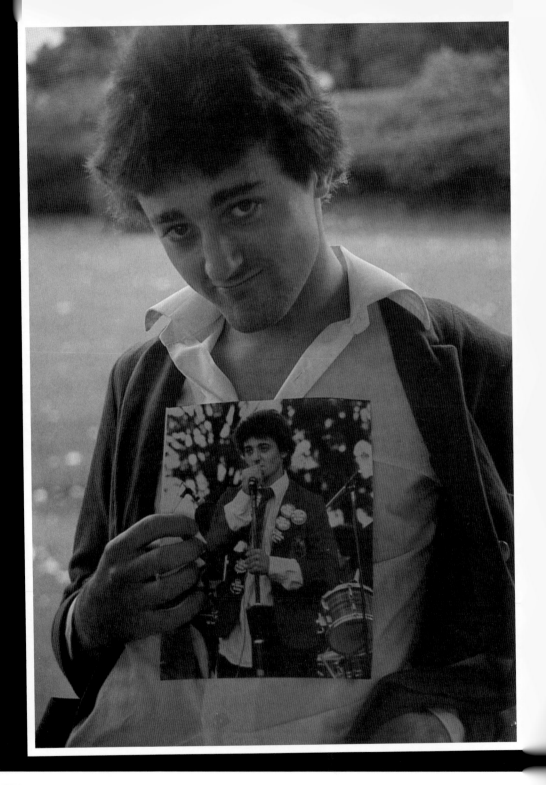

Dave Greenlee of the Schoolkids posing with a publicity photo.

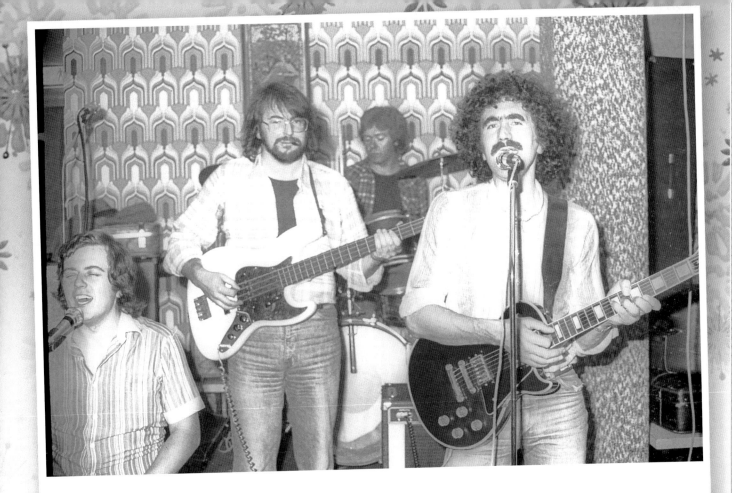

Stacc

The band Stacc had a residency at the Coliemore Hotel, Dalkey. From left to right: Bill Whelan (keyboards), John Drummond (bass), Des Reynolds (drums) and Des Moore (guitar). In July 1978, Patrick had been sent to photograph a wedding at the Coliemore Hotel and at some point during the night, snuck out to see Bill Whelan's old band. In the late eighties, Bill joined Christy Moore and Dónal Lunny's legendary folk band Planxty and produced U2's third album *War*, which was released in 1983. He composed Riverdance for an interval in the 1994 Eurovision Song Contest and such was the response to this piece that it was later developed into the internationally renowned full-length performance.

Bob Geldof Interview

with Big D Radio Station, 19 August 1978

Below: Bob Geldof, Paula Yates, Ian Wilson and Dave Fanning in Big D radio studios, Chapel Lane, Dublin 1, 19 August 1978. Big D was the most popular pirate radio station in the late seventies and early eighties. The music station was known for playing bootlegs and demo tapes of up and coming local bands.

The Ramones

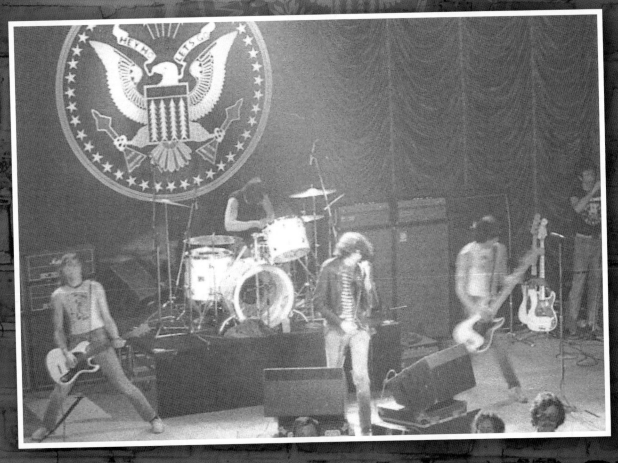

Two different stories account for U2's attendance at this gig. One version is that promoter Pat Murphy (front of stage in glasses) had an arrangement of sorts with Paul McGuinness and admitted the entire band for free. Others say that a friend of U2 snuck them in through the fire exit halfway through the show. The Edge met his future wife Aislinn O'Sullivan (Rachel's sister) at this gig. When it all ended, the whole crew bundled into Guggi's tiny chocolate-coloured NSU Prinz to be ferried home.

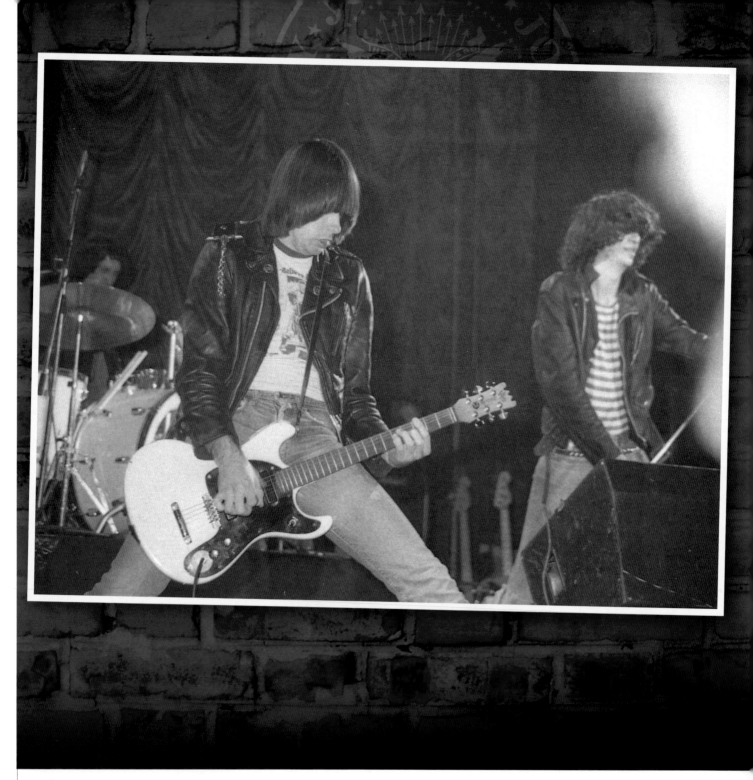

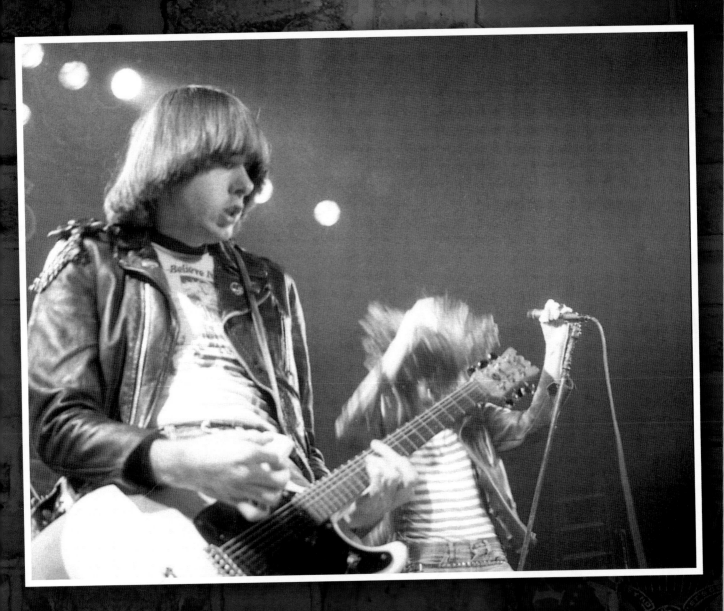

Johnny with his iconic Mosrite guitar and Joey
Ramone at the State Cinema.

The Buzzcocks

**Dingo's Rock Palace, Wolfe Tone Street,
Dublin and Ulster Hall, Belfast
27 September 1978**

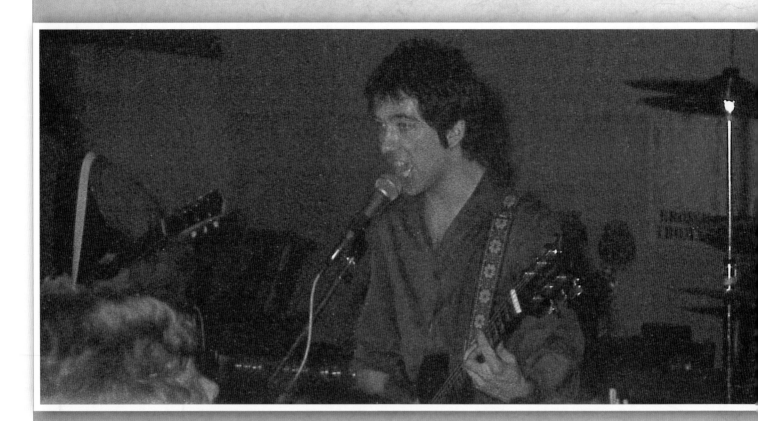

Pete Shelley of the Buzzcocks in Dingo's
Rock Club.

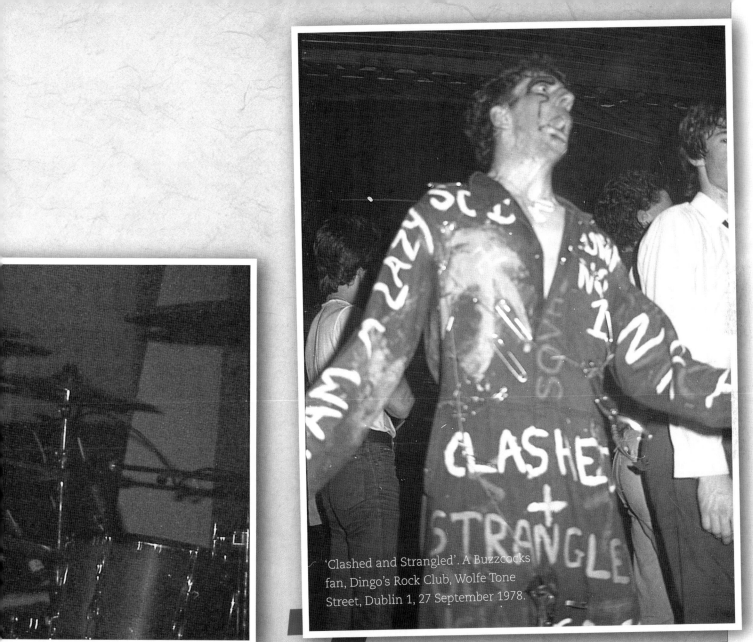

'Clashed and Strangled'. A Buzzcocks fan, Dingo's Rock Club, Wolfe Tone Street, Dublin 1, 27 September 1978.

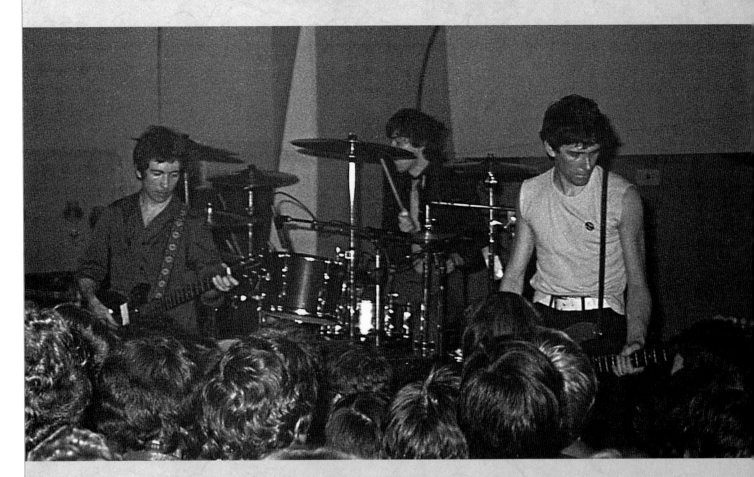

The Buzzcocks on stage at Dingo's Rock Palace,
Wolfe Tone Street. Steve Diggle (guitar), Pete Shelley
(guitar, vocals), John Maher (drums) and Steve
Garvey (bass).

BUZZCOC

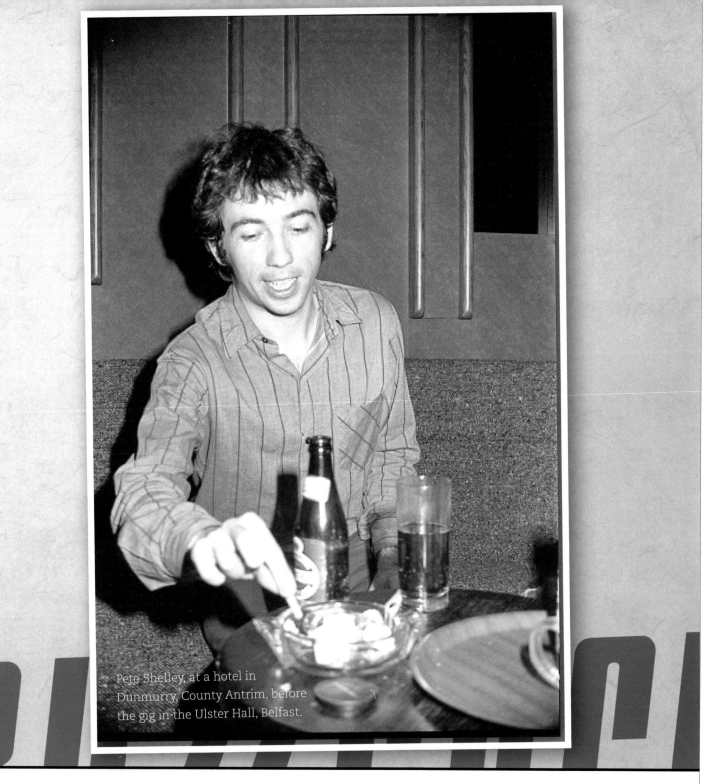

Pete Shelley, at a hotel in Dunmurry, County Antrim, before the gig in the Ulster Hall, Belfast.

The Virgin Prunes and Berlin Support
The Clash

**Top Hat Ballroom, Dún Laoghaire
12 October 1978**

The Top Hat was one of Dublin's legendary music venues, and the Clash, Nirvana, Sonic Youth, Berlin, Metallica, the Waterboys, Anthrax, Suicidal Tendencies, Ozzy Osbourne, Faith No More and Slayer were just some of the more famous bands to perform there. The large top hat on the rooftop made the building itself particularly iconic, however photos of the exterior are very hard to find.

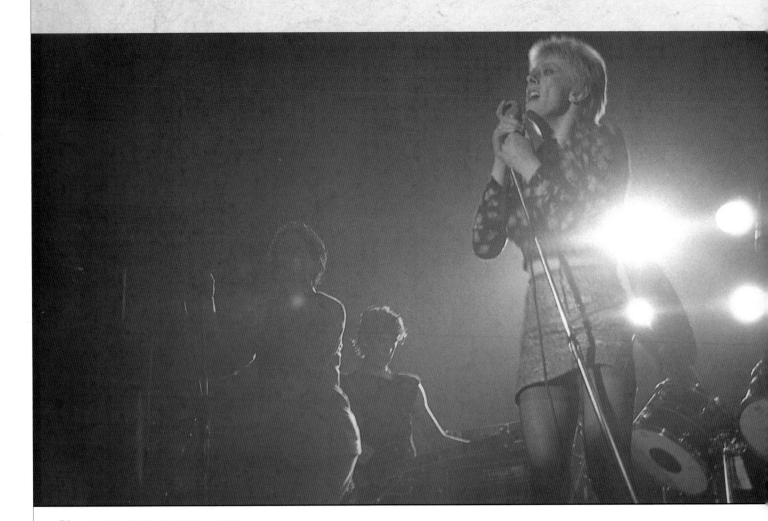

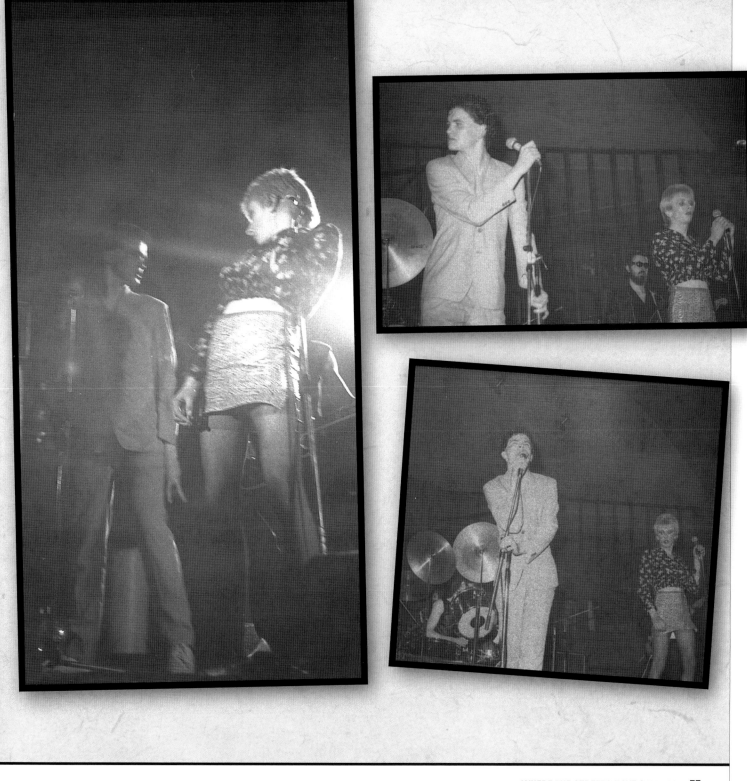

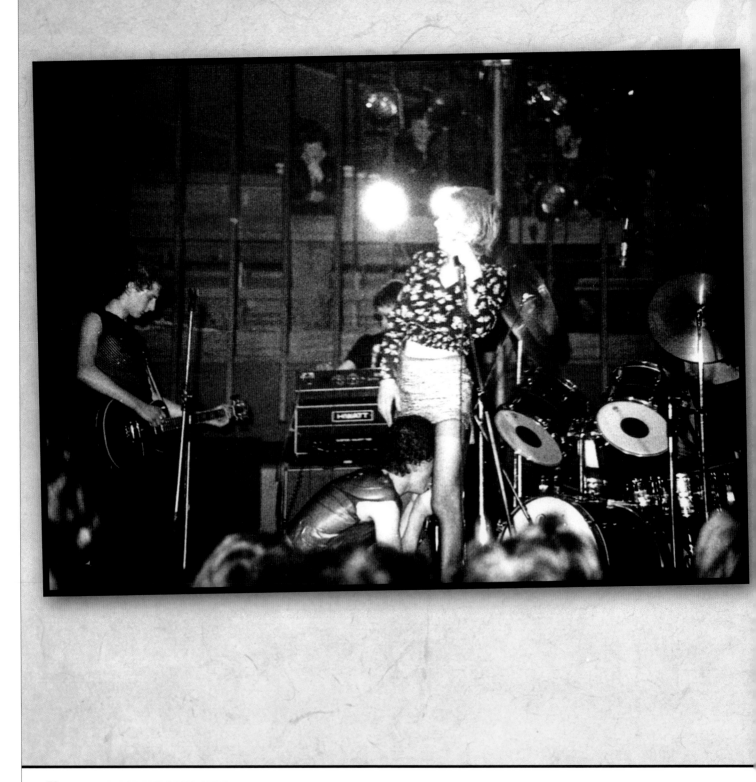

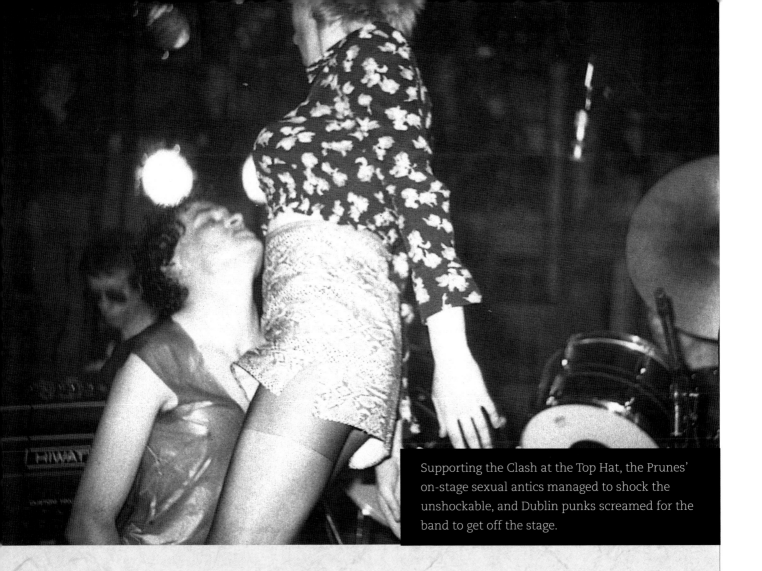

Supporting the Clash at the Top Hat, the Prunes' on-stage sexual antics managed to shock the unshockable, and Dublin punks screamed for the band to get off the stage.

The Virgin Prunes' gender-bending style and anarchic sounds pushed punk-era, avant-garde experimentalism to a different level. Many commentators said that the band relied more on shock-effect theatricality than any actual musical talent, and they had an extremely divided reception in Dublin; some saw them as breaking all kinds of boundaries, others saw them as talentless poseurs. The Prunes supported UK punk rockers the Clash at the Top Hat Ballroom, Dún Laoghaire, on 12 October 1978. The Irish band's usual line-up was complimented by Steve Averill on keyboards. In the

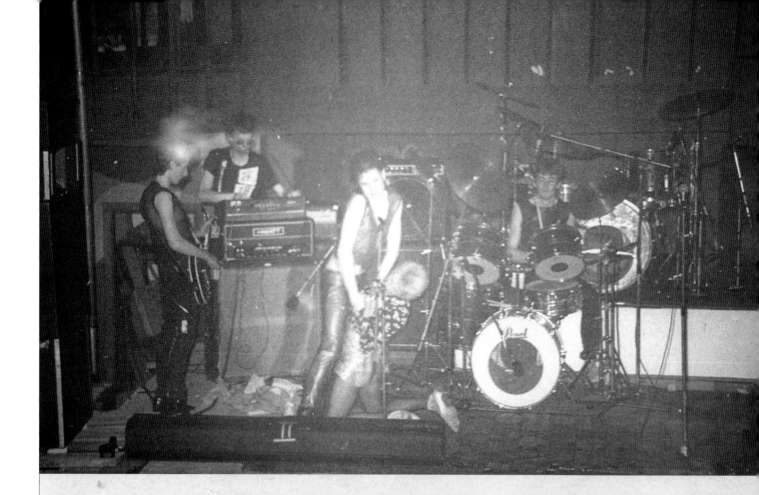

middle of a song about sexual frustration, Gavin
Friday's see-through pants split. Guggi was in drag
and sported a mini-skirt and nylon stockings. This
proved too much for the hardcore punk audience,
who screamed at the Prunes, 'Off! Off! Off!' The
promoter stopped their gig and the story gained the

Prunes a lot of media attention and notoriety.
Guggi later remembered Steve Averill playing
keyboards: 'As the mood of the crowd grew
more and more hostile, one could see less and
less of Steve. At one point all you could see of
him was his hands on the keyboards!'

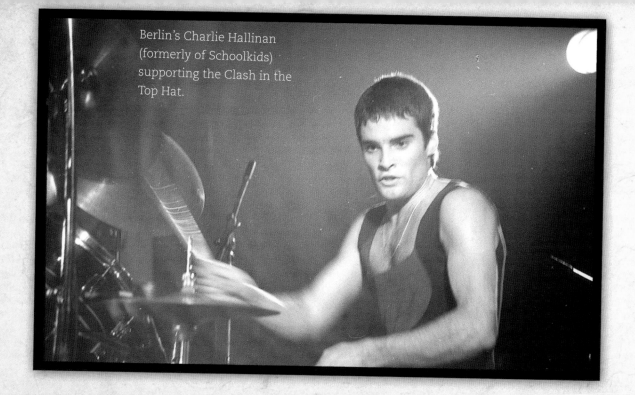

Berlin's Charlie Hallinan (formerly of Schoolkids) supporting the Clash in the Top Hat.

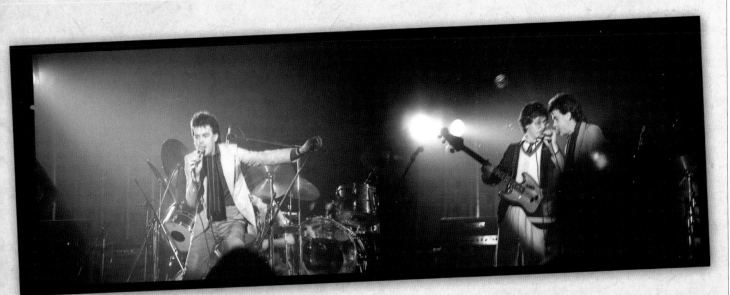

Berlin's Brian Freeze and Maurice Czerniak (bass) support the Clash at the Top Hat in Dún Laoghaire.

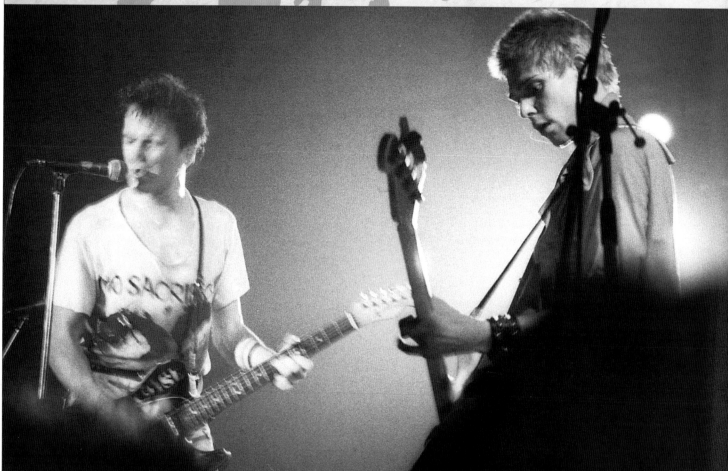

Joe Strummer and Paul Simonon
(bass) at the Top Hat.

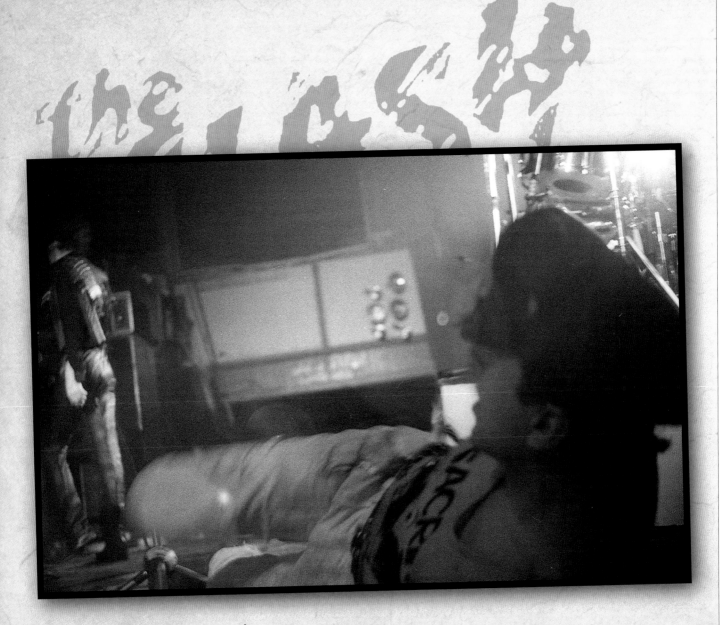

Joe Strummer on stage at the
Top Hat Ballroom following the
Prunes' infamous performance
on 12 October 1978.

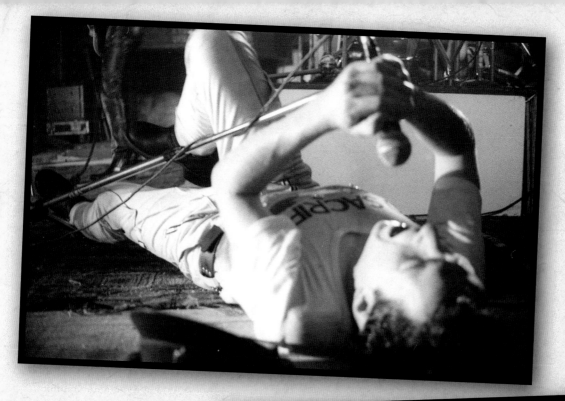

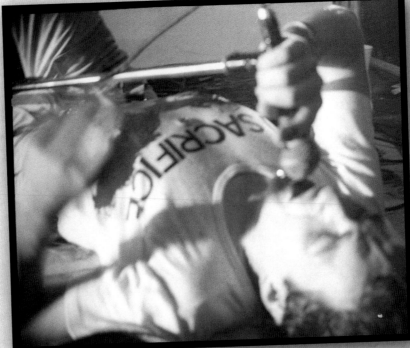

Joe Strummer on stage at
the Top Hat.

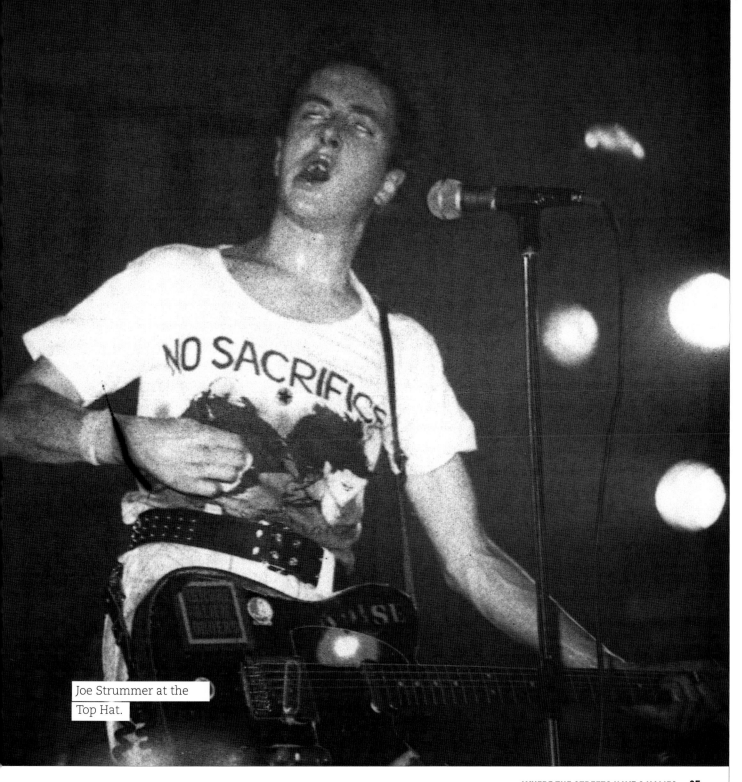

Joe Strummer at the Top Hat.

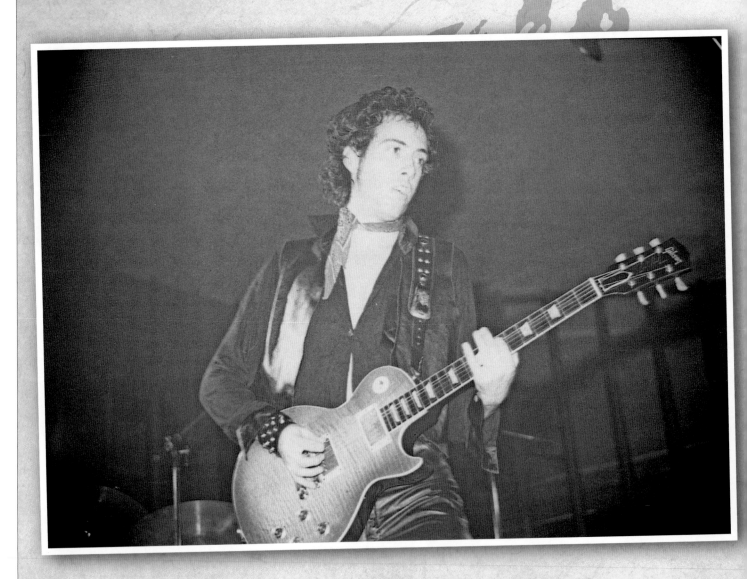

The Clash's Mick Jones on guitar
at the Top Hat.

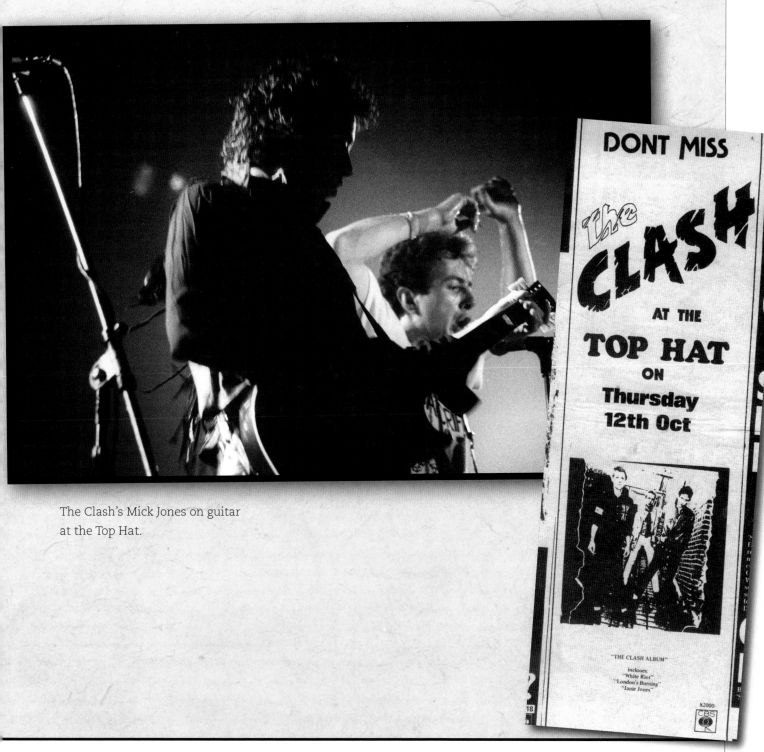

The Clash's Mick Jones on guitar
at the Top Hat.

DONT MISS

the CLASH

AT THE
TOP HAT
ON
Thursday
12th Oct

"THE CLASH ALBUM"
includes:
"White Riot"
"London's Burning"
"Janie Jones"

82000
CBS

New Versions
Outside Doheny & Nesbitt's
Circa October 1978

New Versions' Johnny Byrne, Paul Bibby, and Ingmar Kiang (running across a Ford Escort) after a gig in the Baggot Inn, circa October 1978.

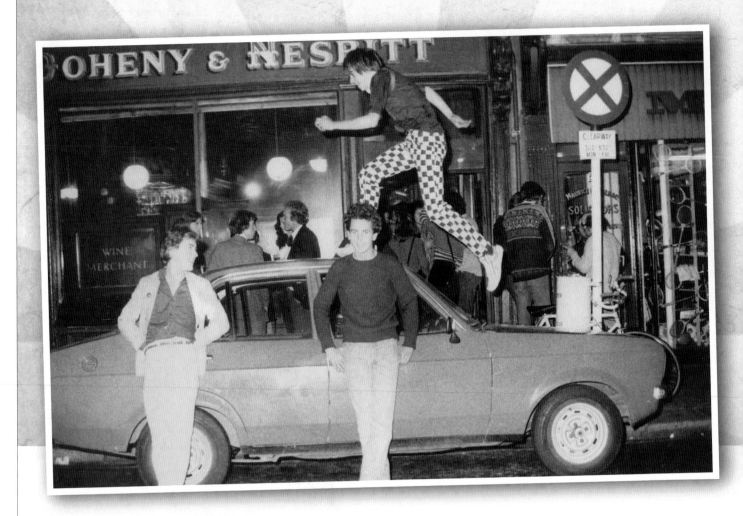

Tom Robinson Band

with support from the Stiff Little Fingers
Belfield Fringe Festival
Saturday, 14 October 1978

Tom Robinson making a political statement in Belfield. At their gigs, TRB gave out fliers espousing their political views and were regulars at Rock Against Racism concerts. Their most famous songs were 'Up Against the Wall' from their first album *Power in the Darkness* (1978), and '2-4-6-8 Motorway'.

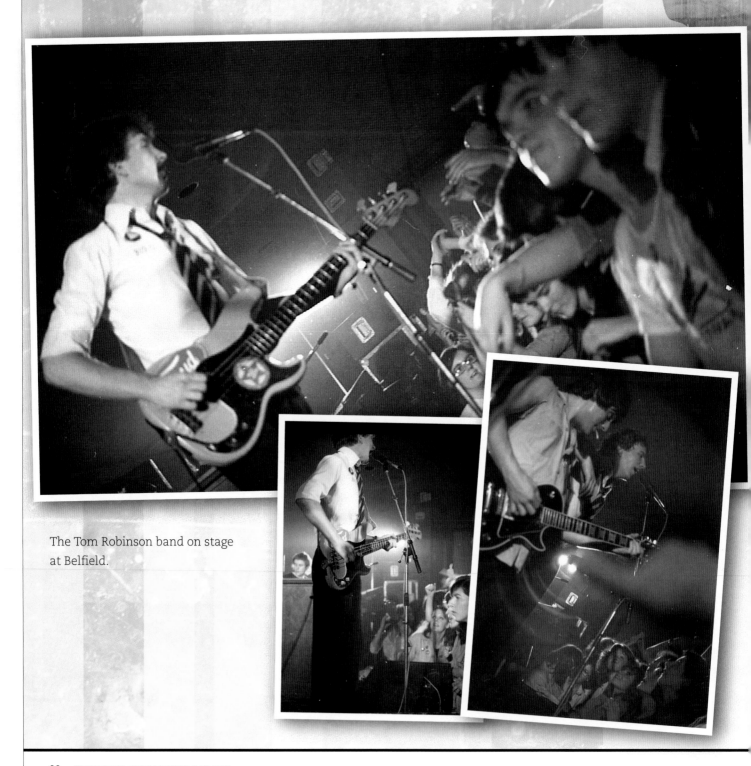

The Tom Robinson band on stage at Belfield.

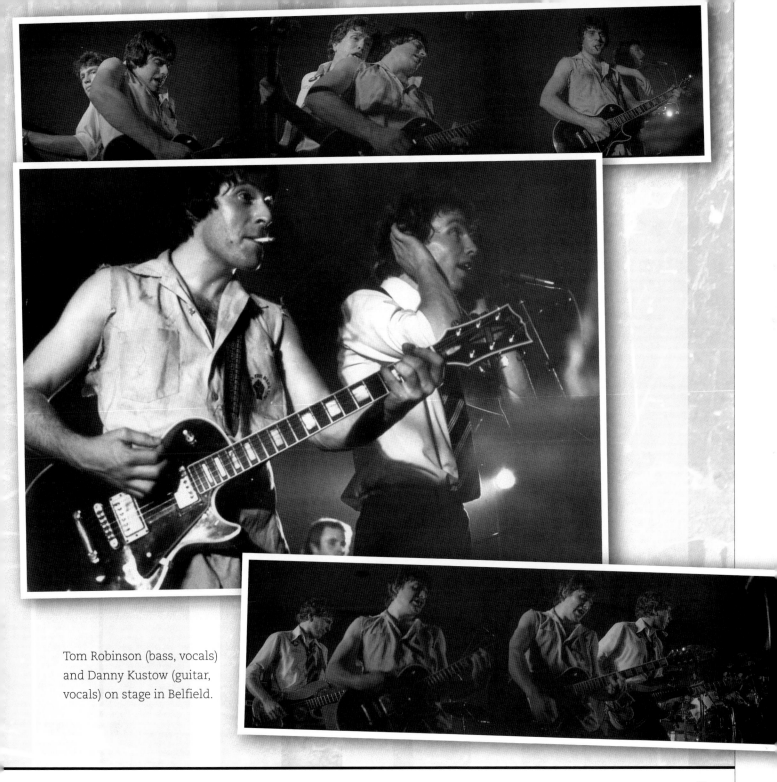

Tom Robinson (bass, vocals) and Danny Kustow (guitar, vocals) on stage in Belfield.

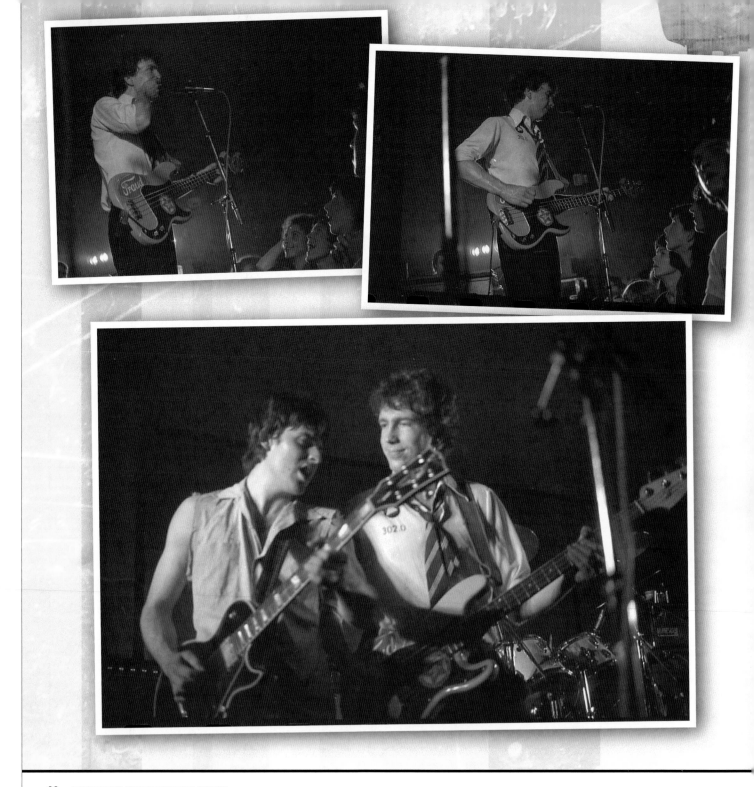

Rachel O'Sullivan (of whom it is said that the Boomtown Rats song 'Mary of the Fourth Form' is written) poses next to posters for *In Dublin*. This photo was one of a series taken by Patrick for an *In Dublin* advertising campaign with the theme 'In Dublin leaves me breathless'. A photo by Tony Murray was used for the actual advertisement but the Asthma Society of Ireland complained about the theme and the campaign was subsequently dropped.

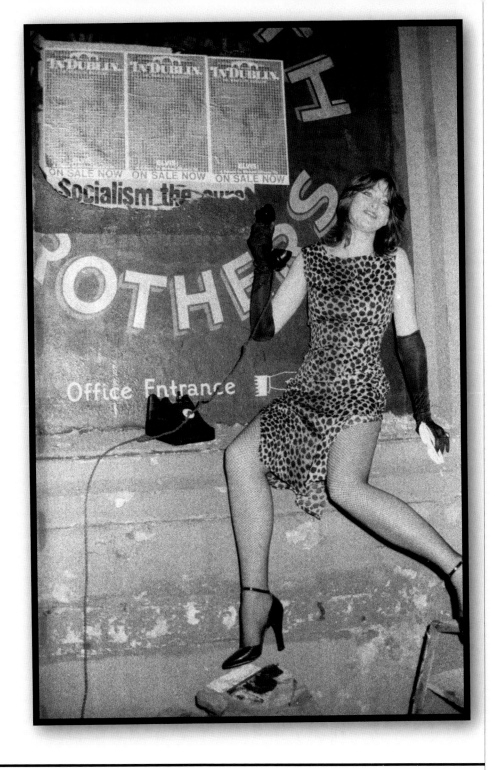

Stiff Records Be Stiff Tour

Stardust, Artane
30 October 1978

Established in 1976, Stiff Records was one of the best known punk/new wave independent record labels. In 1977 the label organised its own Stiff Tour, which subsequently became the subject of the documentary *If it Ain't Stiff . . .* directed by Nick Abson and featuring Elvis Costello, Ian Dury and the Blockheads, Wreckless Eric and the New Rockets, Nick Lowe, and Larry Wallis.

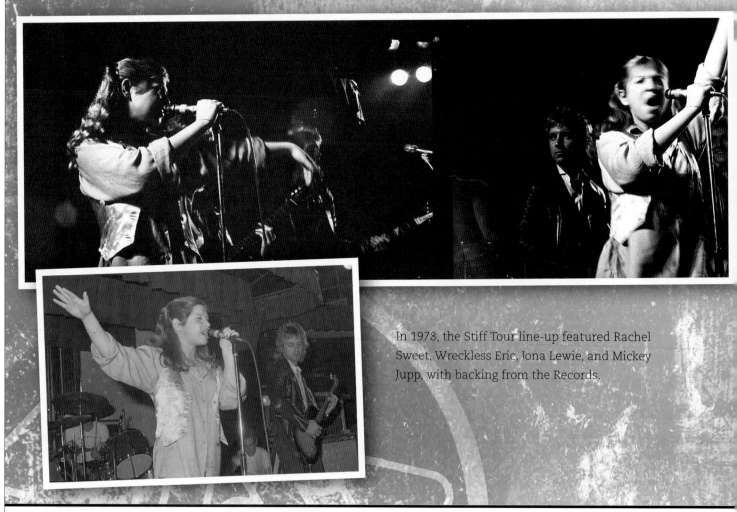

In 1978, the Stiff Tour line-up featured Rachel Sweet, Wreckless Eric, Jona Lewie, and Mickey Jupp, with backing from the Records.

Rachel Sweet at the Stiff Records Tour in Dublin. Sweet's career in the entertainment industry began at a young age, recording radio commercials when she was six years old and supporting Bill Cosby in Las Vegas at the age of twelve. She began recording country music in

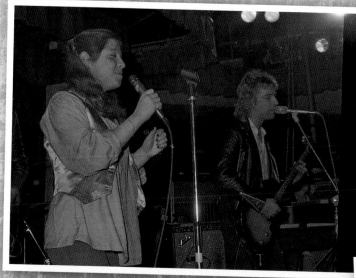

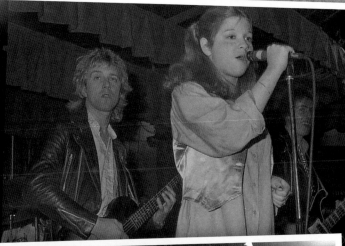

1974, but turned to rock and released her first album with Stiff Records in 1978, from which her cover of Carla Thomas's 1966 'B-A-B-Y' made it into the UK Top 40.

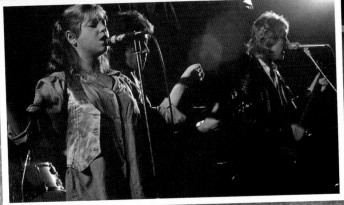

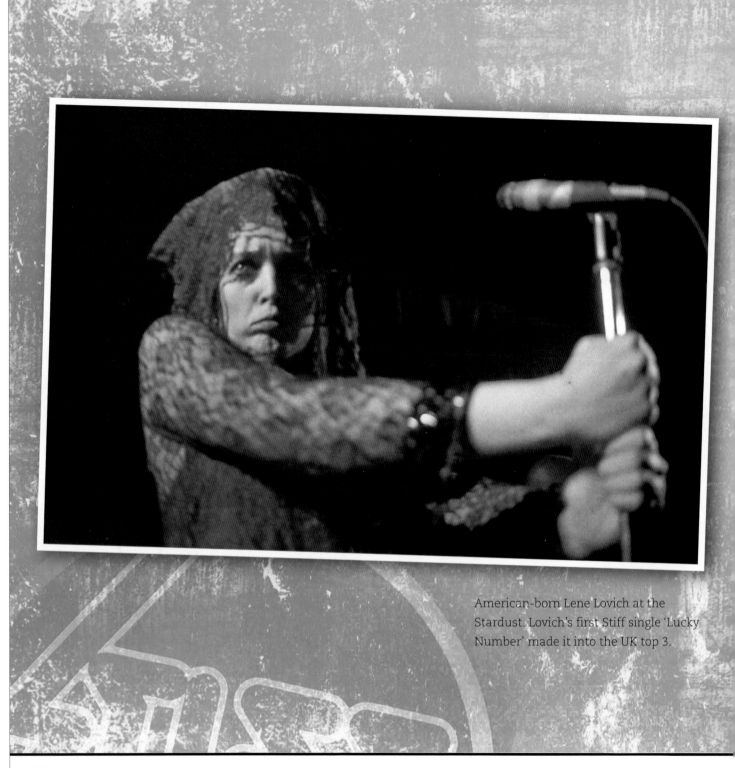

American-born Lene Lovich at the Stardust. Lovich's first Stiff single 'Lucky Number' made it into the UK top 3.

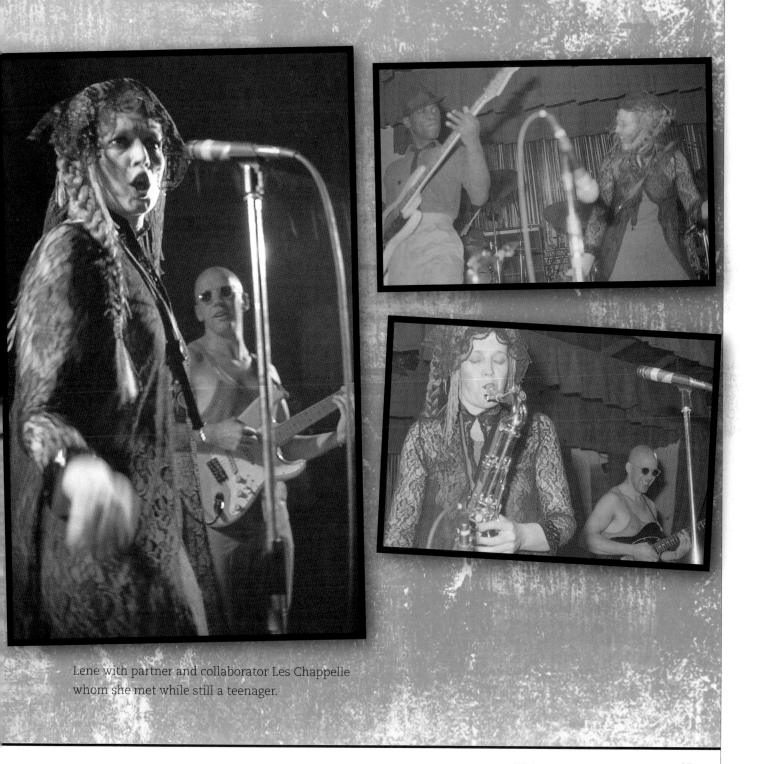

Lene with partner and collaborator Les Chappelle whom she met while still a teenager.

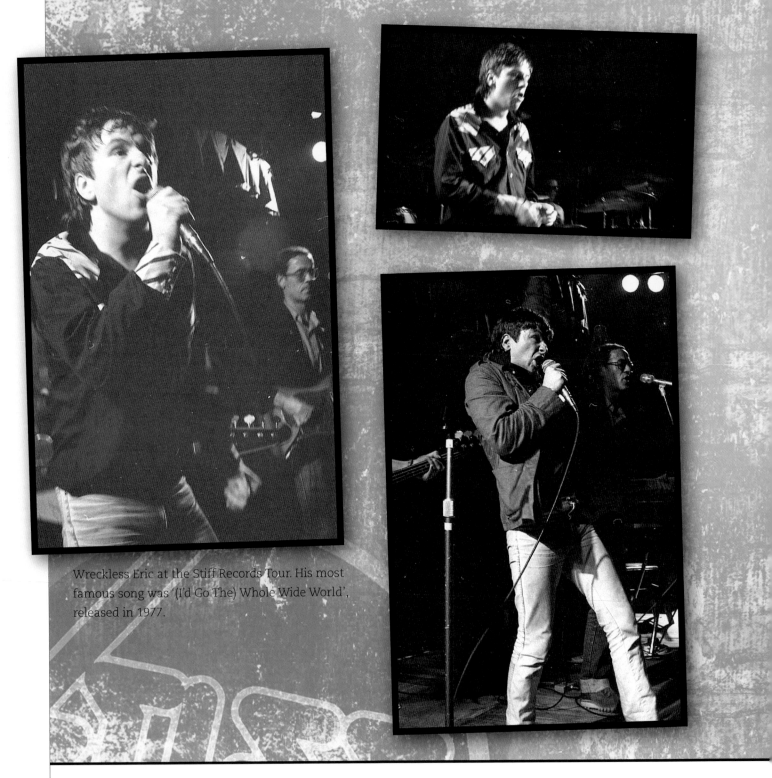

Wreckless Eric at the Stiff Records Tour. His most famous song was '(I'd Go The) Whole Wide World', released in 1977.

'I'm no good at chatting up and always get rebuffed.' Jona Lewie, whose best known songs are 'You'll Always Find Me in the Kitchen at Parties' and the Christmas favourite 'Stop the Cavalry'. Mickey Jupp was due to close the gig but there was a power cut shortly after he came on stage and the night ended abruptly. Bono and Gavin Friday were in the audience and headed back to Glasnevin shortly after.

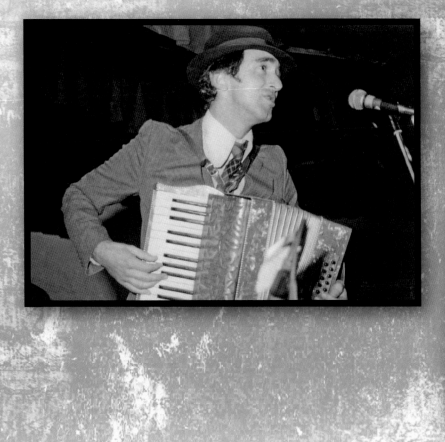

Rocky De Valera and the Gravediggers

Toners Pub, Baggot Street
Circa October/November 1978

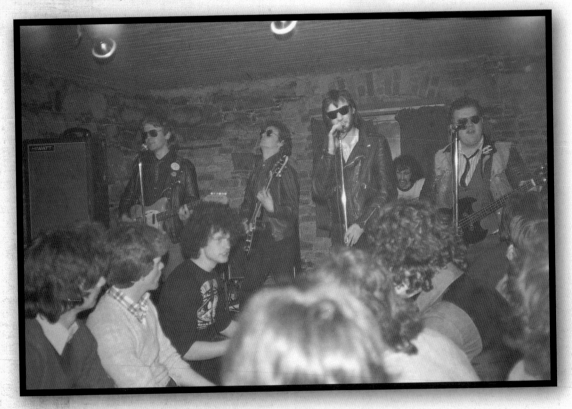

From left to right: Richie "Milkboy" Taylor (rhythm), Martin "the Lizard" Meagher (lead guitar), Rocky de Valera (vocals), Dave "Bucko" Buckley (drums) and Jack Dublin (bass). Rocky De Valera and the Gravediggers (possibly one of the best-named Irish bands in history) were formed when lead singer Ferdia MacAnna (Rocky De Valera) and Dave Sweeney (Lord Lucan/Dave Hero) got jobs working at Jon Fisher and Eoin O'Shea's stall selling badges at the Dandelion Market.

The Citizens
Grafton Street/St Stephen's Green, Late 1979/Early 1980

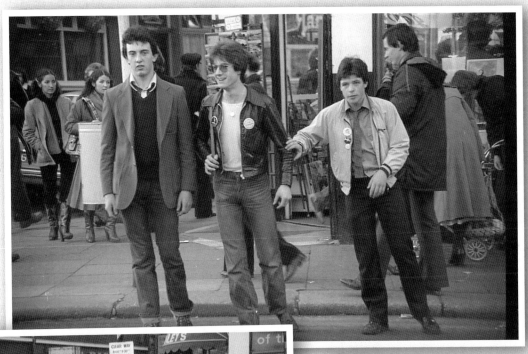

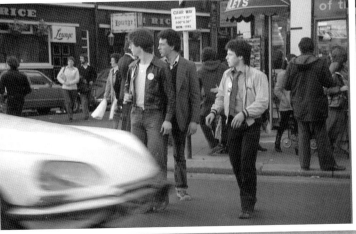

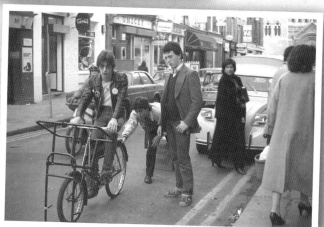

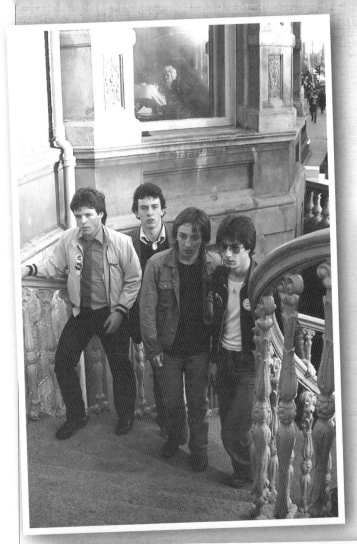

Left: The Citizens' Emmett O'Reilly (bass, vocals), Sean D'Angelo (guitar), George Purdy (manager) and Denis Rusk (guitar) on the steps of Dublin's exclusive Shelbourne Hotel, St Stephen's Green. David Herlihy, the Citizen's drummer, did not attend the photo shoot.

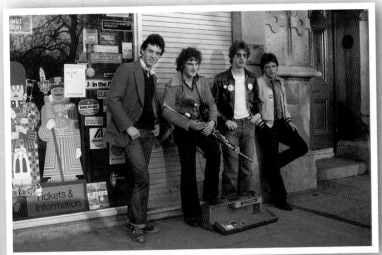

Davy Spillane, busking outside a travel agents on the top of Grafton Street/Stephen's Green is joined by the Citizens. At the St Anthony's Hall mini festival the Citizens did a version of the Sid Vicious hit 'My Way' with none other than Bono on vocals (some have disputed that this ever took place). Left to right: Sean De Angelo (guitar), Davy Spillane (later of Riverdance fame) Denis Rusk (guitar) and Emmet O'Reilly (bass, vocals).

Left: The Citizens and George Purdy in St Stephen's Green.

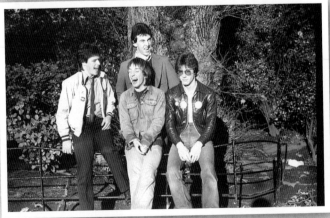

Punk/New Wave Festival
St Anthony's Hall
22 November 1978

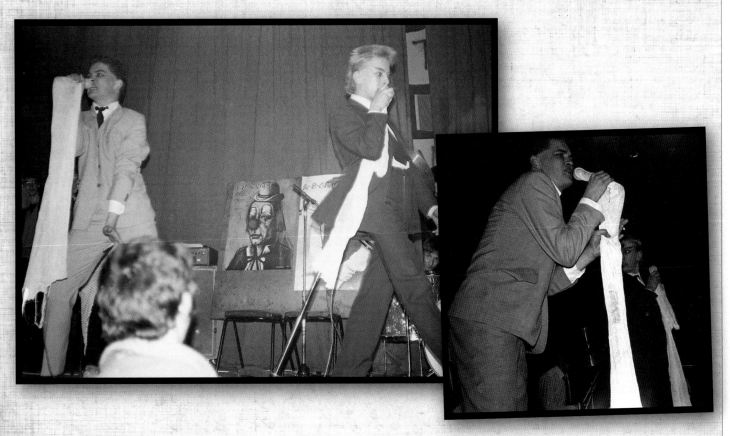

The Virgin Prunes at St Anthony's Hall on Merchant's Quay. The Punk/New Wave Festival was organised by George Purdy from Stoneybatter. U2 were supposed to play, but pulled out because Purdy wouldn't let them headline. The Strange Movements also pulled out of the festival because they didn't have sufficient sound equipment. Other acts on the night included the Citizens, the Skank Mooks (whose bassist Dick was George Purdy's brother), the Virgin Prunes, the New Versions and Berlin.

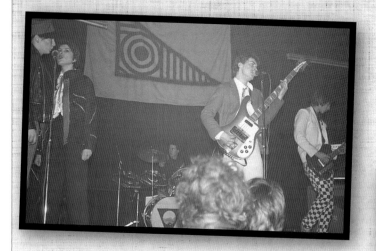

The New Versions at St Anthony's Hall. Regine Moylett (keyboards, backing vocals), Susan Moylett (backing vocals), Johnny Byrne (bass, vocals) and Ingmar Kiang (guitar).

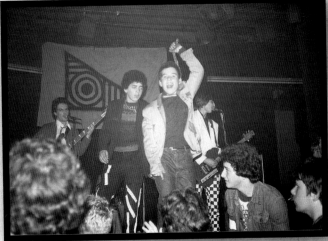

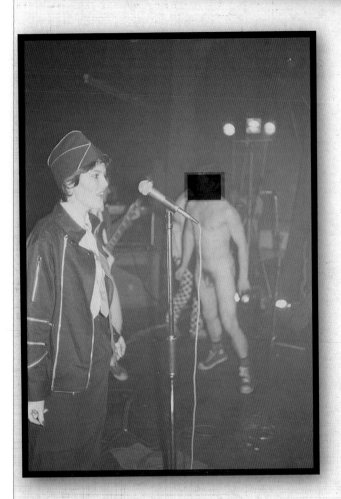

Above: Trouble broke out during the New Versions' St Anthony's Hall set, with fans clamouring on stage and setting fire to rags and pieces of paper that the Prunes had thrown into the crowd during their earlier set. There was no fire extinguisher in the Hall, so organisers had to run out to the nearest pub to get one.

Left: 'I've seen better.' The New Versions' Regine Moylett pays no heed to one fan's naked exuberance. Regine and her sister Susan ran the punk clothing shop No Romance in the Dandelion Market. Their brother was Johnny Fingers (John Moylett) of the Boomtown Rats. Regine eventually moved to London and began working as a publicist – her most famous clients being fellow Dubliners U2.

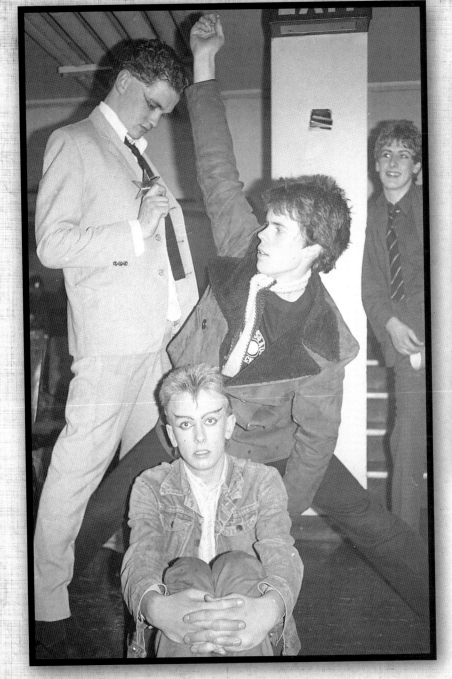

Gavin, Guggi, Dave-Id and Strongman backstage at St Anthony's Hall, 22 November 1978.

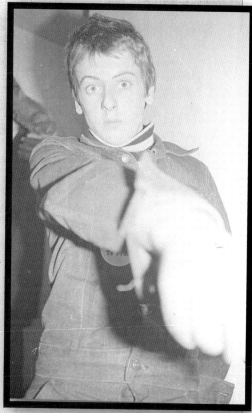

Guc, brother of Guggi, Strongman and Clive, at the St Anthony's Hall Punk/New Wave Festival, 22 November 1978. Guc was also a performer and his stage name was Pooh the Ventriloquist. In June 1979, Pooh the Ventriloquist was due to support U2 at one of their Christmas Balls shows in McGonagle's, but was pulled off stage by the venue's less than impressed bouncers.

Wilko Johnson

Edmund Burke Hall,
Trinity College Dublin
24 November 1978

This photo of Wilko Johnson was first published in the 1980 *Hot Press* Yearbook. Wilko was a founding member of Dr Feelgood before forming the Wilko Johnson band in 1977. He played with Ian Dury and the Blockheads for four years from 1981–'85.

Ian Dury and the Blockheads

Olympic Ballroom
12 December 1978

Ian Dury (guitar, vocals) and Norman Watt-Roy (bass). The original Ian Dury and the Blockheads line-up also included Chaz Jankel (keyboards, guitar), Charlie Charles (drums), Davey Payne (sax), Mick Gallagher (keyboards) and John Turnbull (guitar). Dury passed away 27 March, 2000.

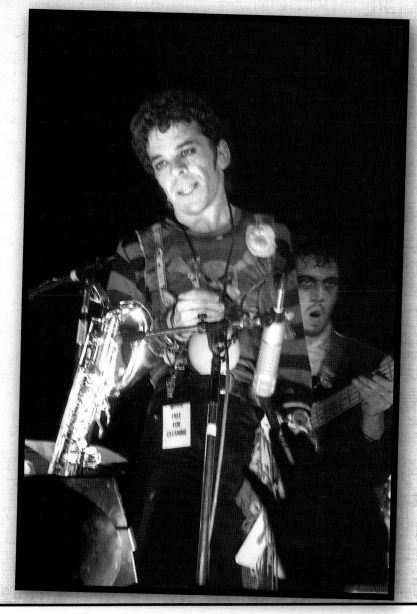

Ian Dury with Norman Watt-Roy (bass).

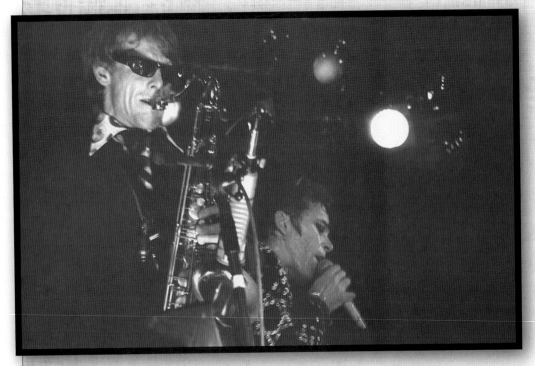

Left: Davey Payne (saxophone) and Ian Dury. Payne's twin saxophone playing achieved international fame in a solo for the 1978 single 'Hit Me with Your Rhythm Stick'.

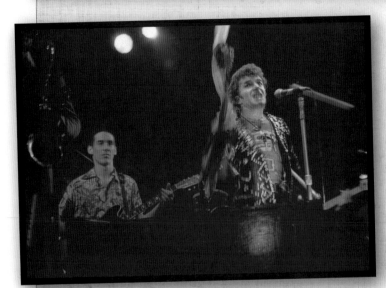

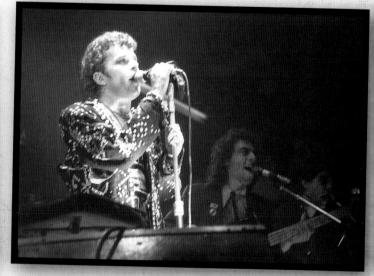

The great songwriting partnership of Chaz Jankel (keyboards, guitar) and Ian Dury (vocals, guitar) on stage at the Olympic Ballroom, Dublin.

Teenage Kicks –
The Undertones
McGonagle's
12 December 1978

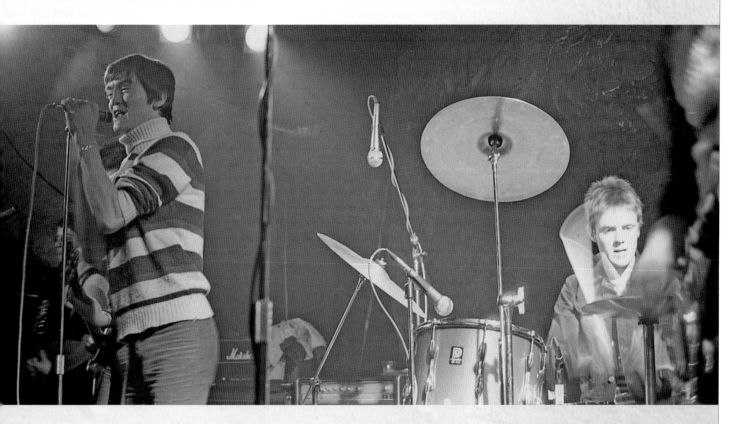

Above: The Undertones in McGonagle's: John O'Neill (guitar), Feargal Sharkey (vocals) and Billy Doherty (drums). It was so cold that night that Sharkey came on stage wearing a big parka jacket. Even though there were only about eighty people in the audience, it wasn't long before things heated up.

Above: Feargal Sharkey and Billy Doherty of the Undertones, McGonagle's, 12 December 1978.

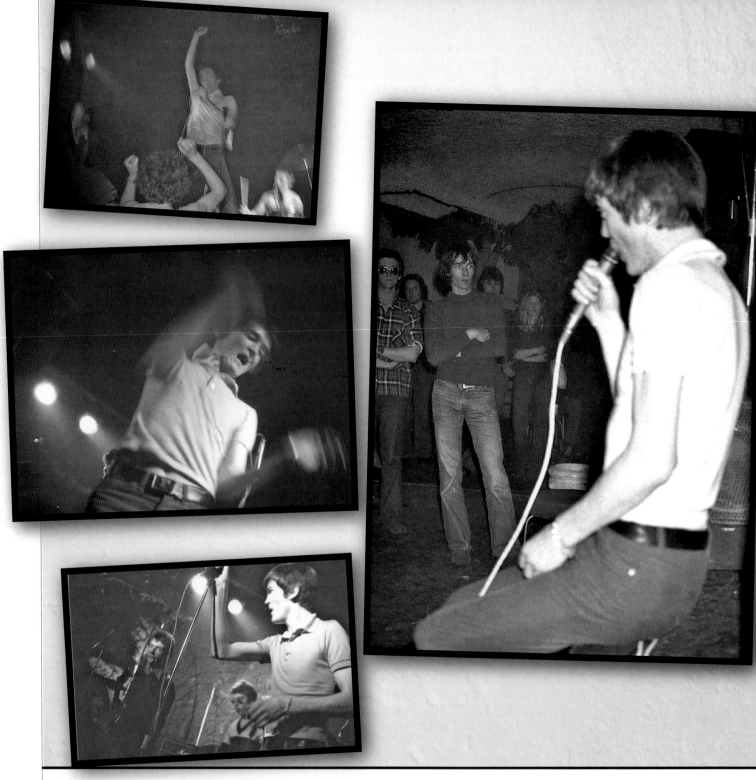

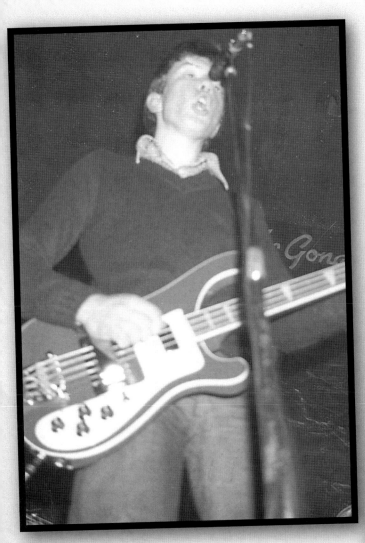

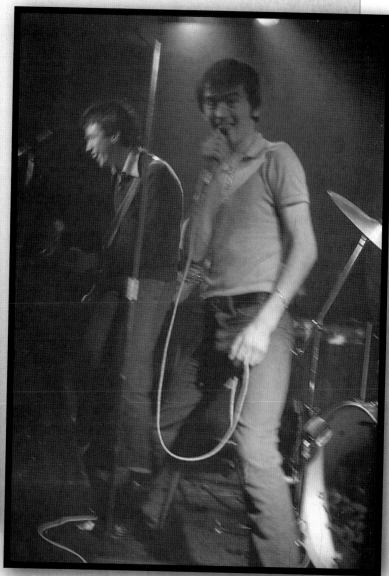

The Undertones' Mickey
Bradley on stage in
McGonagle's.

Stiff Little Fingers
McGonagle's
17 December 1978

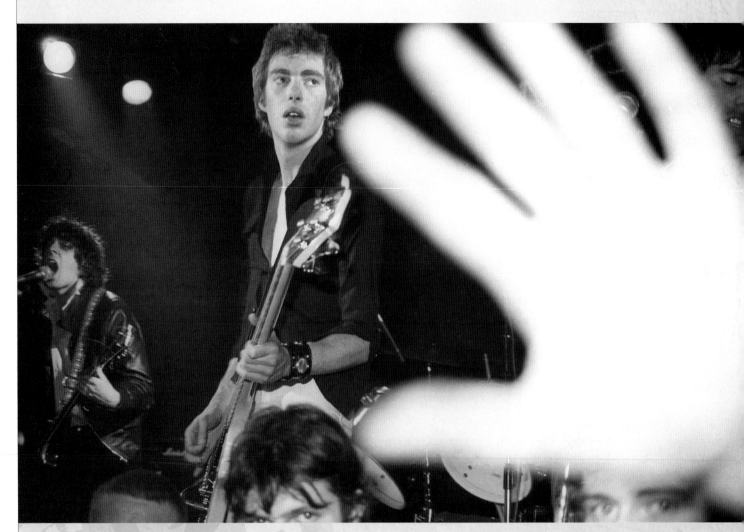

Jake Burns (vocals) and Ali McMordie (bass) of the Stiff Little Fingers.

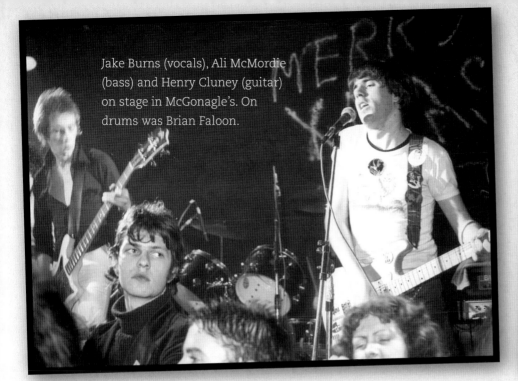

Jake Burns (vocals), Ali McMordie (bass) and Henry Cluney (guitar) on stage in McGonagle's. On drums was Brian Faloon.

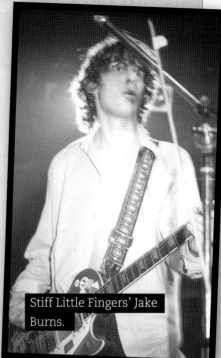

Stiff Little Fingers' Jake Burns.

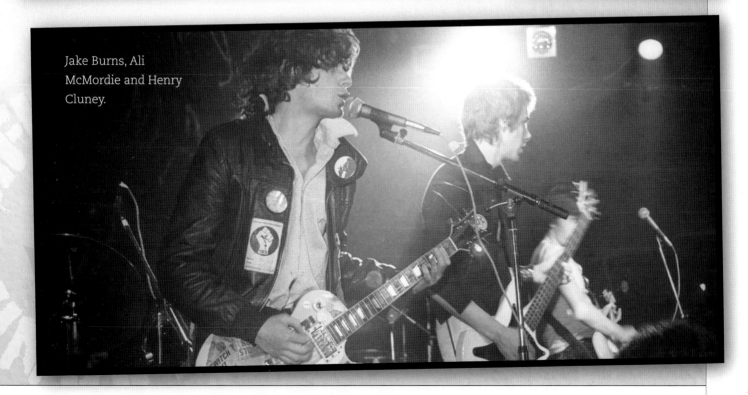

Jake Burns, Ali McMordie and Henry Cluney.

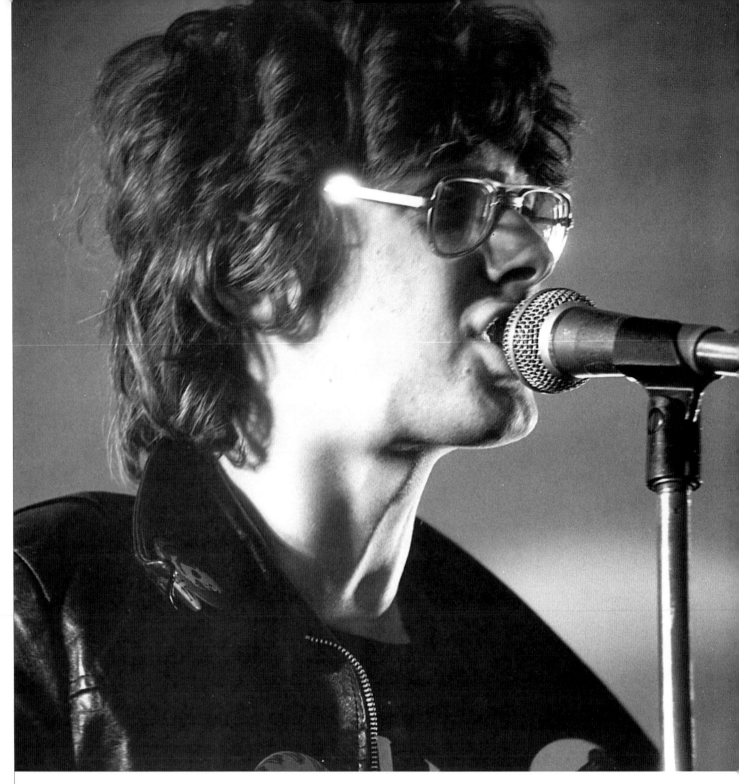

Hot Press Christmas Party

19 December 1978

The free food did not last long at the second annual *Hot Press* Christmas party when word got around Dublin that certain superstars might be in attendance. The Greedy Bastards, an amalgam of Thin Lizzy and the Sex Pistols, were playing in the Stardust Ballroom two nights later, and turned up at McGonagles' party to jam with virtually anyone who had an inkling to get on stage.

Horslips' Johnny Fean, Thin Lizzy's Phil Lynott, and the Sex Pistols' Steve Jones, with Deirdre McMahon.

Paul Cook, drummer with the Sex Pistols, tucks into food at party in McGonagle's. The Pistols had broken up in January 1978 when Johnny Rotten left the band after a gig in San Francisco. The Sex Pistols' bass player and vocalist Sid Vicious died from a heroin overdose in February 1979.

The Vipers' Paul Boyle and Dave Sweeney with Sex Pistol Steve Jones.

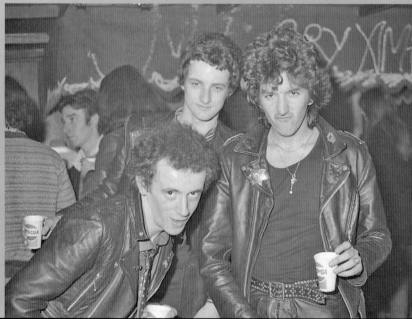

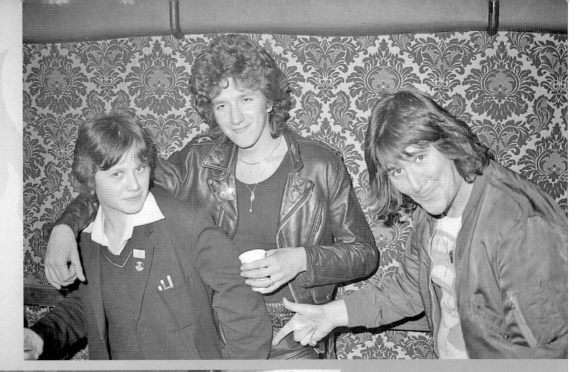

Annie Siggins with Steve Jones and an unidentified member of The Greedy Bastards' entourage.

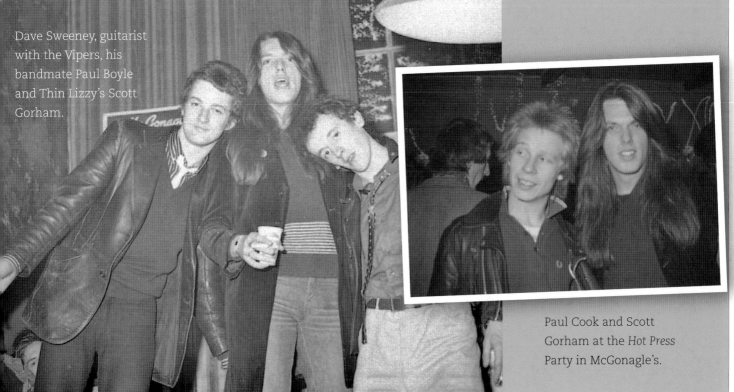

Dave Sweeney, guitarist with the Vipers, his bandmate Paul Boyle and Thin Lizzy's Scott Gorham.

Paul Cook and Scott Gorham at the *Hot Press* Party in McGonagle's.

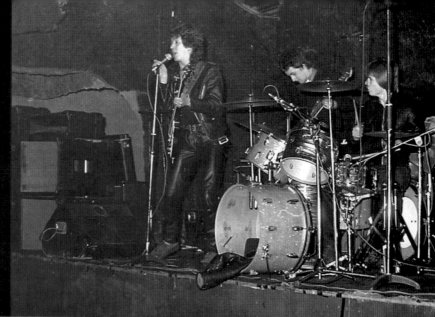

At the beginning of the night, Steve Jones from the Sex Pistols got up on stage and asked who would like to join him. Dave Sweeney, guitarist with the Vipers and Larry Mullen, drummer with U2, were quick to join the punk legend on the McGonagle's stage.

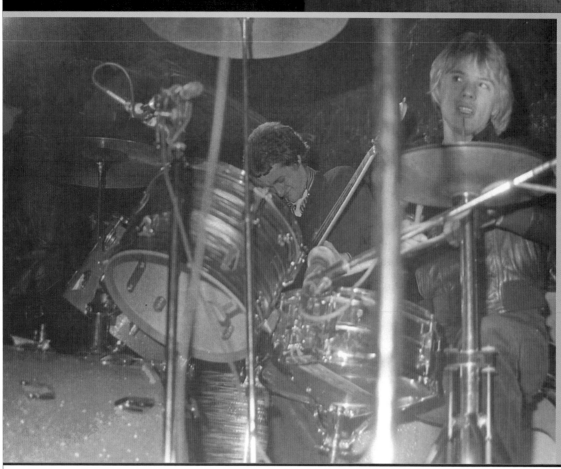

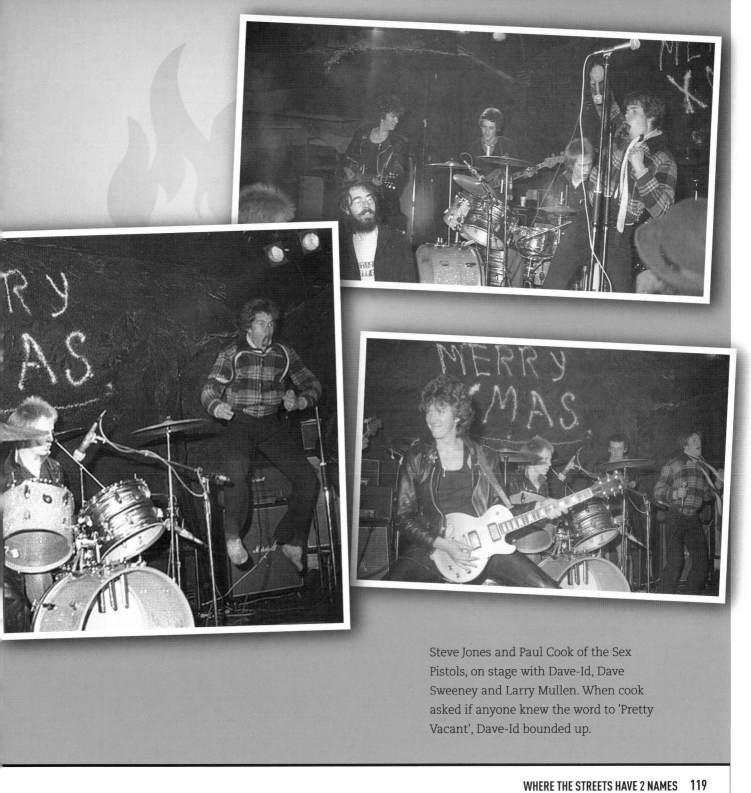

Steve Jones and Paul Cook of the Sex Pistols, on stage with Dave-Id, Dave Sweeney and Larry Mullen. When cook asked if anyone knew the word to 'Pretty Vacant', Dave-Id bounded up.

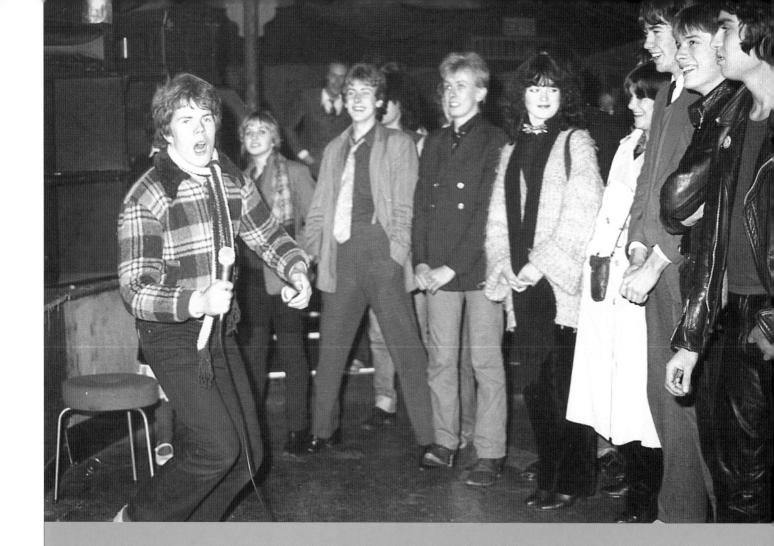

A group photograph of Lypton Village. From left: Dave-Id, Isobel Mahon, Trevor and Derek Rowen, Phillipa O'Sullivan, Donna Leonard, Pod (Anthony Murphy), Larry Mullen and Eric Briggs.

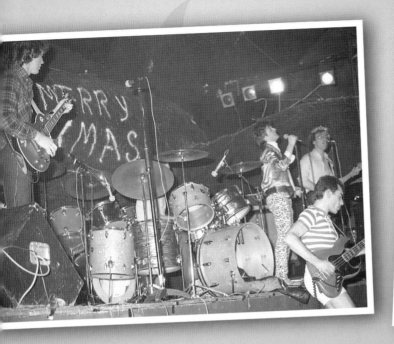

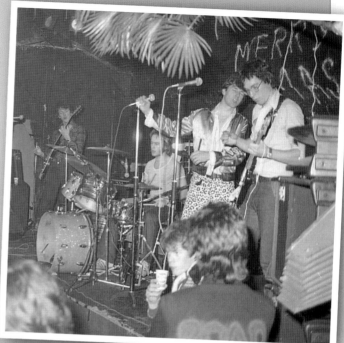

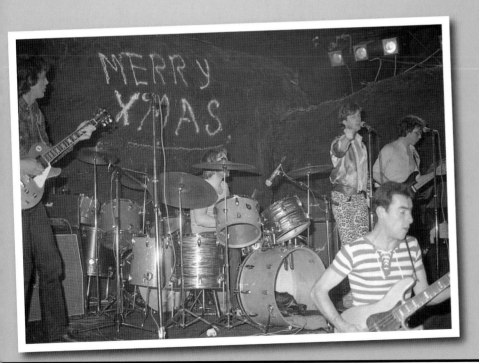

Fit Kilkenny and the Remoulds.
Roy Siggins (vocals), George
Sutton (guitar), Martin McEvoy
(guitar), Garrett Brown (bass) and
Bren Farren (drums).

Right: Dave Fanning and Smiley Bolger from pirate radio station Big D gave out lollipops as awards to luminaries of the Dublin music scene. Here they are with Berlin's Brian Freeze.

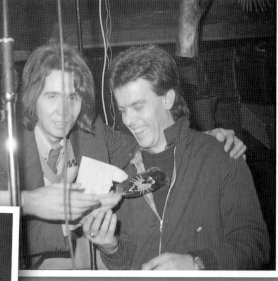

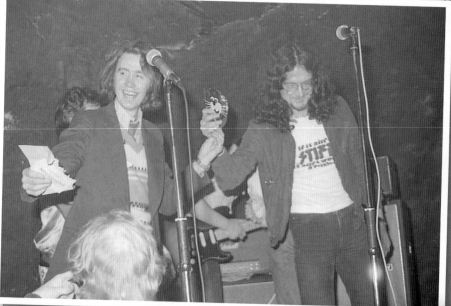

Left: Smiley Bolger with *Hot Press* editor Niall Stokes.

Right: Billy McGrath – whose band Stagalee had been voted best Irish rock group by *Hot Press* readers – with Smiley Bolger. McGrath also managed the Atrix.

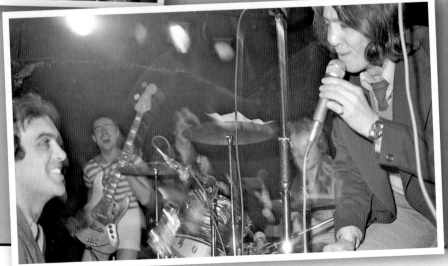

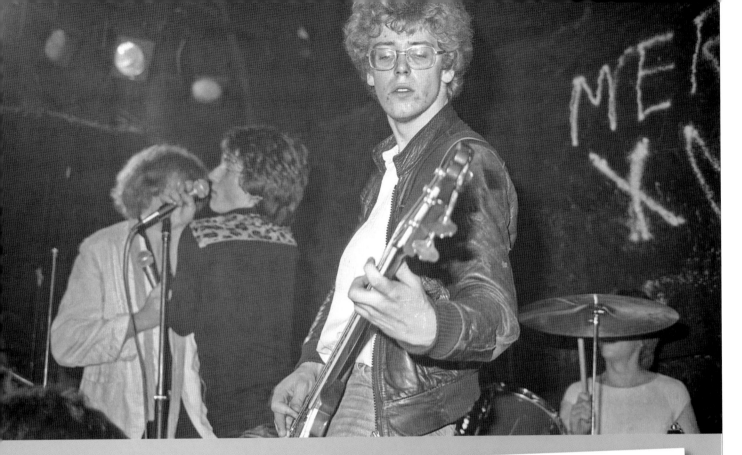

U2 and Bono singing a duet with Philip Byrne, lead singer of Revolver. When they were called the Hype, U2 regularly supported Revolver. At one such show in the Celebrity Club on Middle Abbey Street, Byrne had to reassure Larry Mullen's mother that her underage son would not miss the last bus home to Artane. During their career, Revolver used the Egyptian Ambassador's Residence in Terenure as a rehearsal space. Adam Clayton was Philip's best man at his wedding in 1979, but had to leave the nuptials early with the rest of U2 in order to put up posters for a show. Clayton was later made godfather to Philip's son Simon.

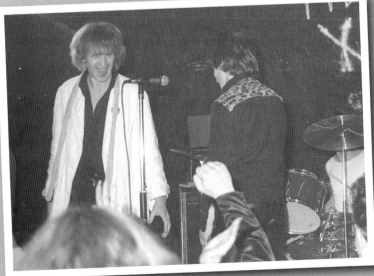

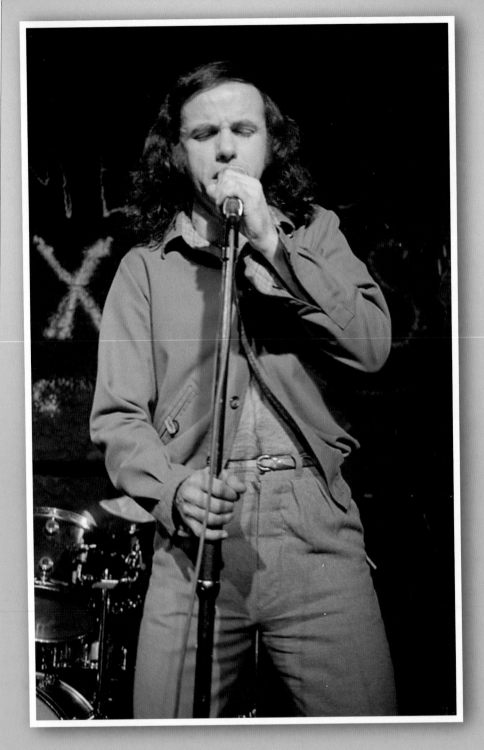

Brush Shiels on stage with Skid Row. In 1968, Brush formed Skid Row with Phil Lynott, drummer Noel Bridgeman, and guitarist Bernard Cheevers, who was replaced by sixteen-year-old Gary Moore a short time later. When Phil took a leave of absence, the band tightened up as a three-piece with Brush on vocals, which meant that there was no place for the former front man when he returned. Feeling bad for his friend, Shiels bought Lynott a bass guitar and taught him how to play.

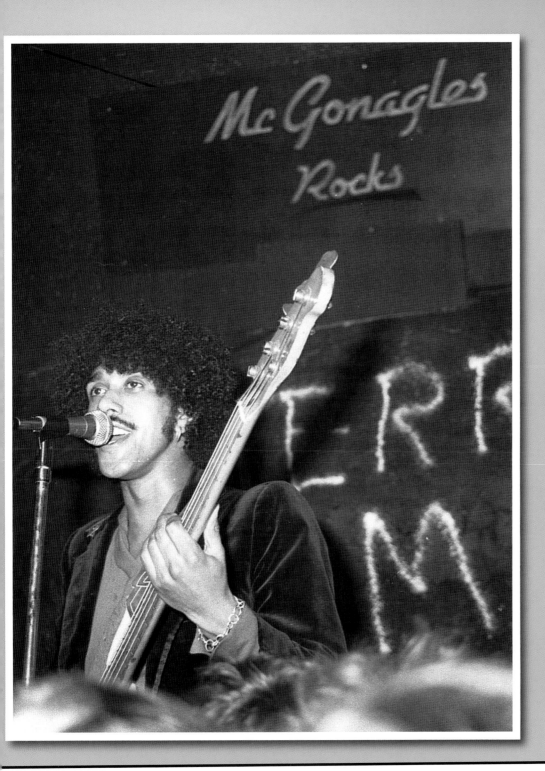

Local hero Phil Lynott on stage at the Christmas party. Thin Lizzy had just released their critically acclaimed *Live and Dangerous* album in June 1978 and despite ongoing line-up difficulties were at the height of their success.

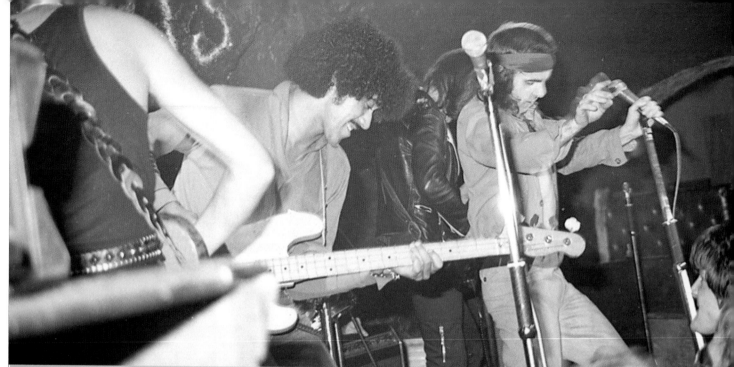

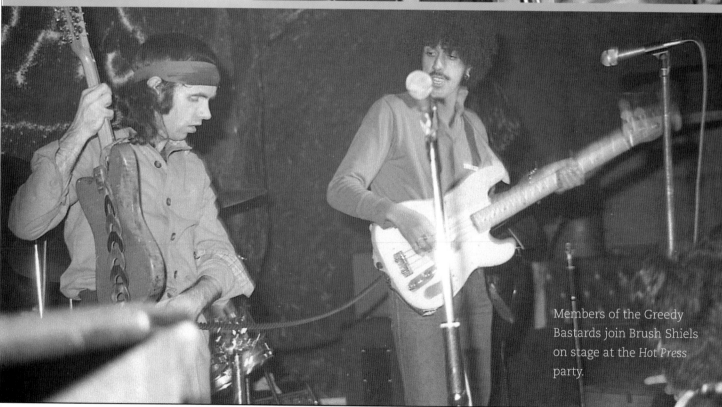

Members of the Greedy Bastards join Brush Shiels on stage at the *Hot Press* party.

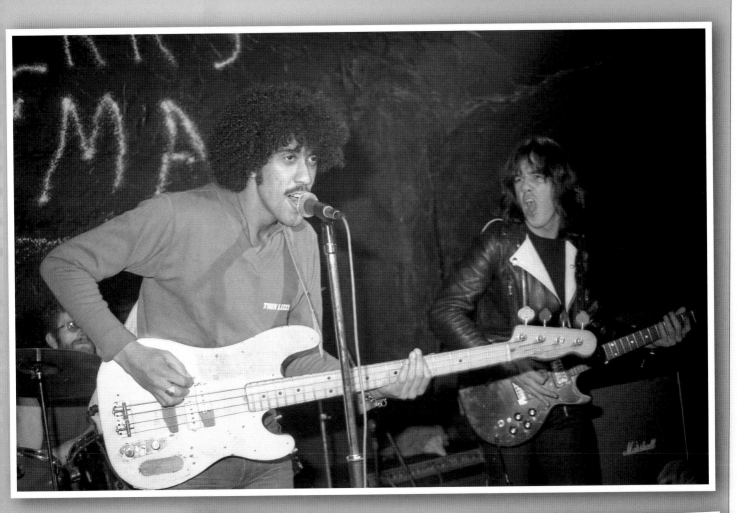

Phil Lynott, Steve Jones and guitar hero Gary Moore performed later in the night to a more than appreciative audience.

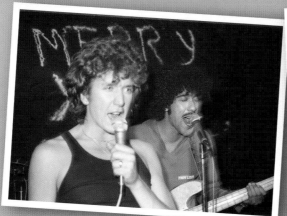

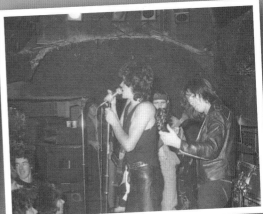

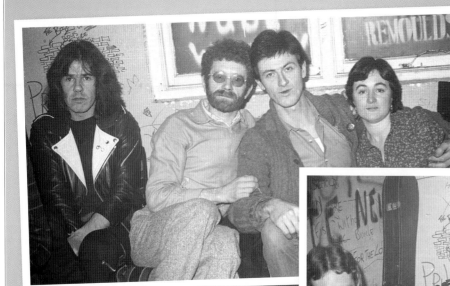

Below: Unidentified musician, Gary Moore (Thin Lizzy/Greedy Bastards), Noel Bridgeman (Skid Row) and Freddie White, upstairs in McGonagles' not-so-private dressing room.

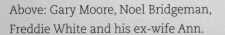

Above: Gary Moore, Noel Bridgeman, Freddie White and his ex-wife Ann.

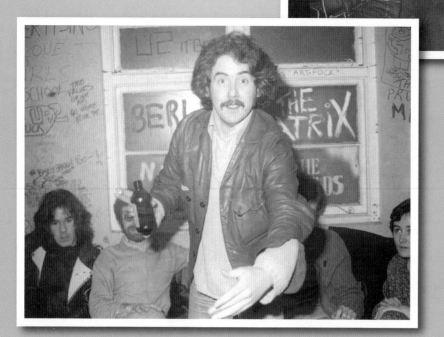

Left: Jimmy Faulkner – virtuoso guitarist who played with Paul Brady, Christy Moore, Rocky De Valera and the Rhythm Kings, and the Freddie White band, to name but a few. He passed away on 4 March 2008.

Phil Lynott and Paul Cook pose in
front of a windowed niche used by
Hot Press for advertising purposes.

The Edge leaving the
Hot Press party.

Larry Mullen leaving
McGonagle's, 19 December
1978.

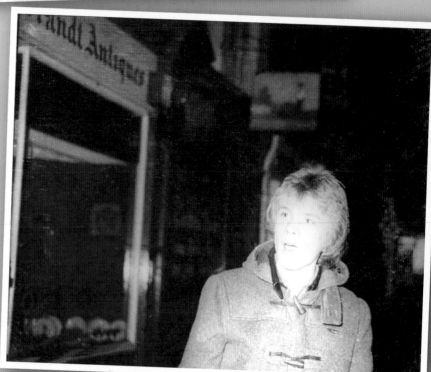

U2 Support the Greedy Bastards

Stardust, Artane
21 December 1978

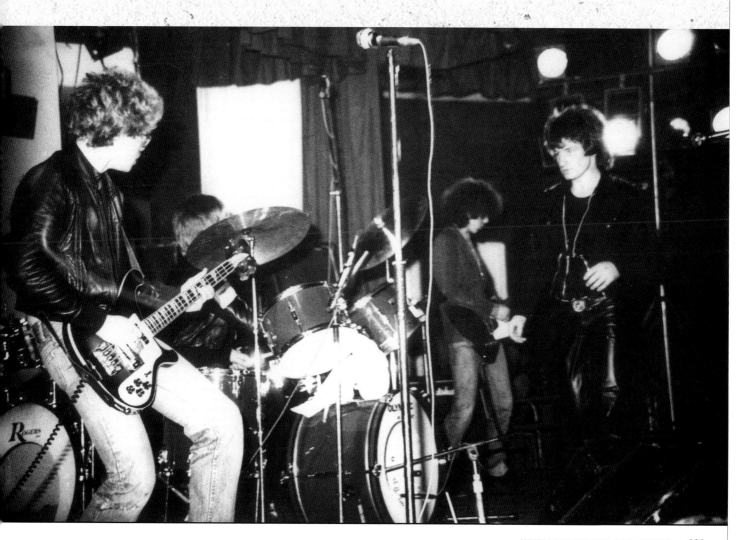

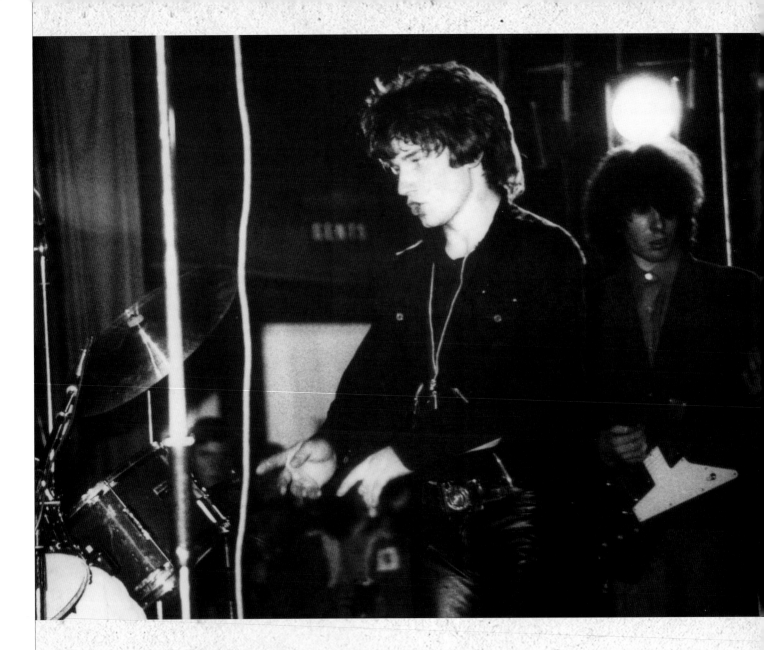

U2 support the Greedy Bastards at the Stardust
Nightclub in Artane, 21 December 1978.

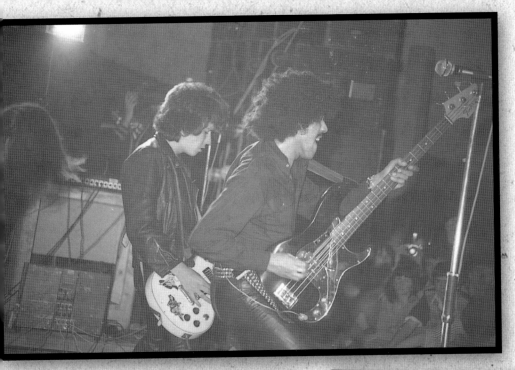

Greedy Bastards, Phil
Lynott and Steve Jones
on stage in the Stardust.

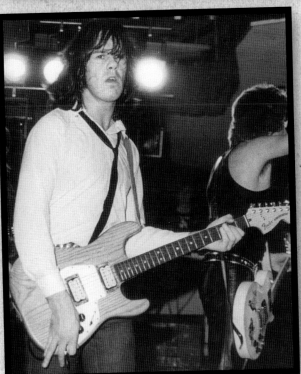

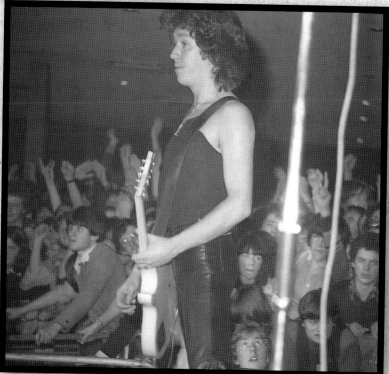

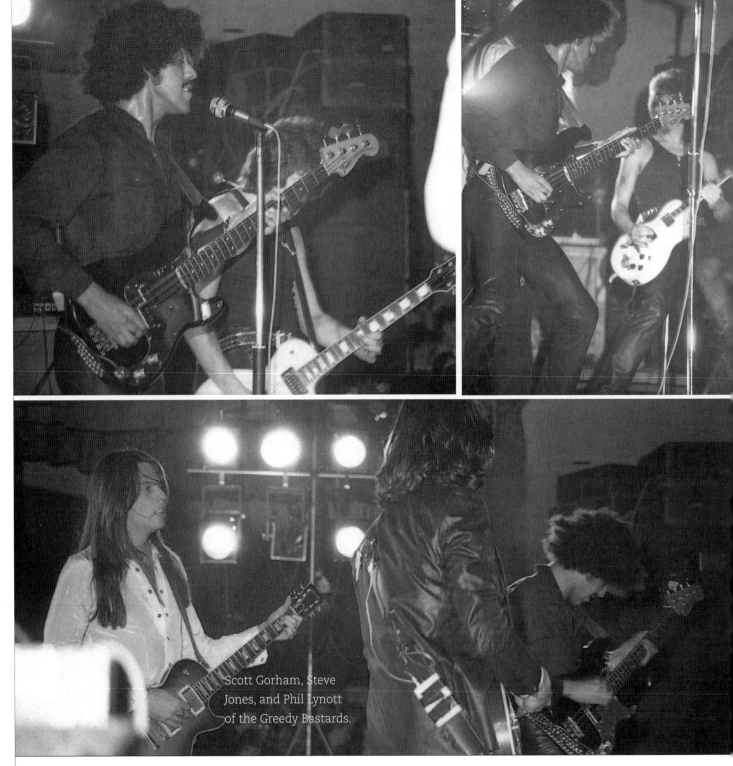

Scott Gorham, Steve
Jones, and Phil Lynott
of the Greedy Bastards.

Rory Gallagher

National Stadium, Dublin
28/29 December 1978

When asked, 'How does it feel to be the greatest guitarist in the world?' Jimi Hendrix replied, 'I don't know, go ask Rory Gallagher.' The blues legend and multi-instrumentalist was born in Ballyshannon, County Donegal in 1948, but his family moved to Cork City shortly after his birth – both places still vie to claim him as their own. Gallagher's parents gave him his first guitar at age nine, and he developed his trade as a teenager touring with showbands before forming his own band Taste in 1966. The band broke up in 1970 and Gallagher began touring under his own name with bassist Gerry McAvoy. Known for his marathon live performances and prolific output, Gallagher released ten albums between 1970 and 1980 and collaborated with lifelong heroes Muddy Waters in 1972 and Jerry Lee Lewis in 1973. He died on 19 June 1995, aged forty-eight.

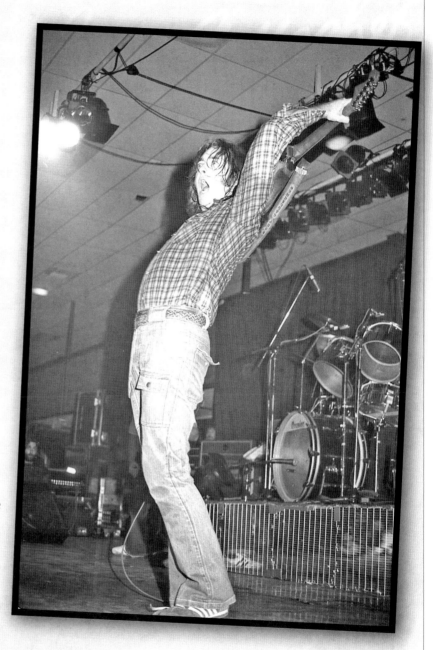

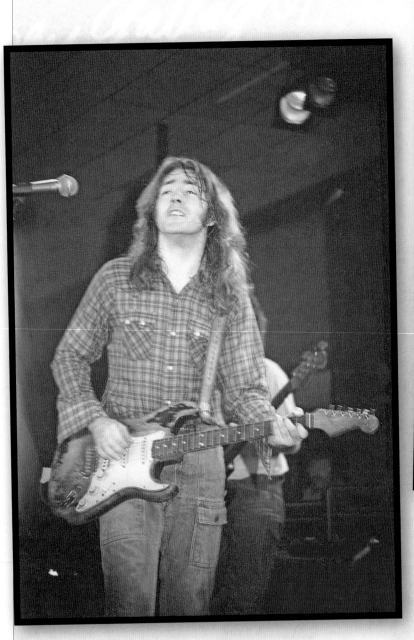
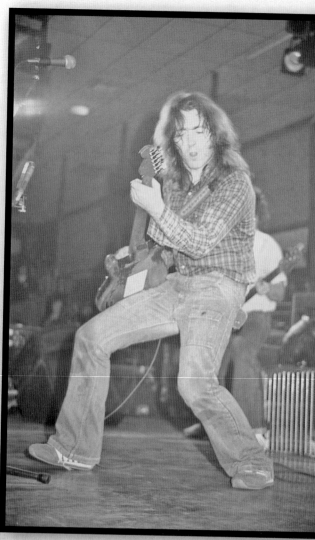

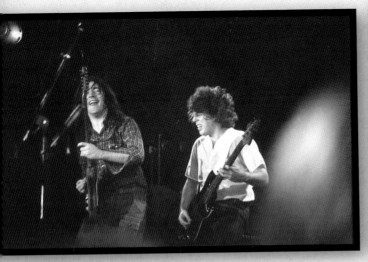

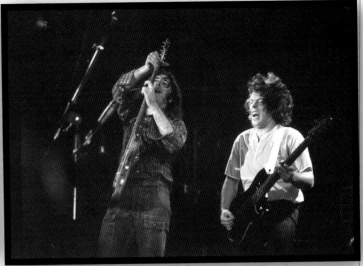

Rory Gallagher with bassist Gerry McAvoy on stage at the National Stadium, Dublin, 28/29 December 1978.

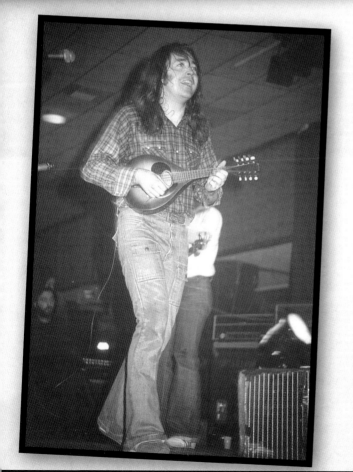

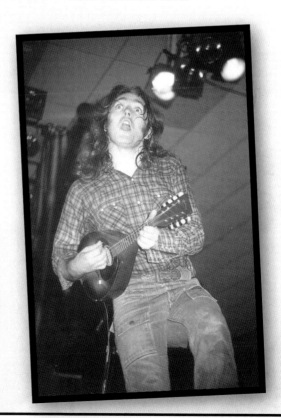

The Meanies
McGonagle's
1 January 1979

Right: Phil Chevron, Billy Morley, Barry Devlin, Johnny Fean and Jim Lockhart on stage in McGonagle's as the Meanies – a one-night-only amalgam of the Radiators from Space, Horslips, and Paul Verner inspired by Phil Lynott's Greedy Bastards. Formed in 1970, Horslips are attributed with having invented the genre of Celtic rock. The popular reception of their 1976 album *The Book of Invasions: A Celtic Symphony* proved that Irish bands did not necessarily have to set up base abroad to achieve success in the UK and further afield.

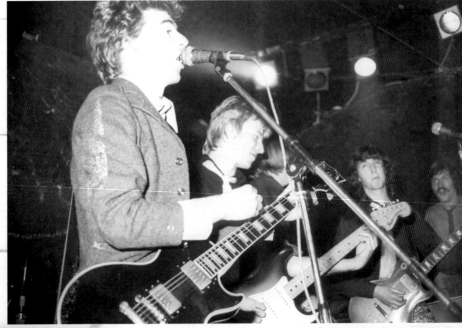

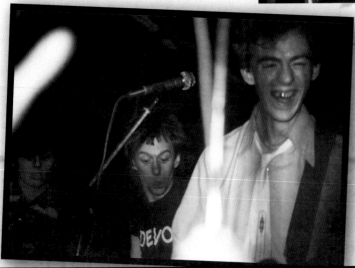

Left: Radiators from Space's Pete Holidai, Steve Rapid (Steve Averill) and Phil Chevron playing with the Meanies in McGonagle's, 1 January 1979. The Radiators' original line-up featured Steve Rapid (vocals), Phil Chevron (guitar, vocals), Pete Holidai (guitar, vocals), Mark Megaray (bass) and Jimmy Crashe (drums).

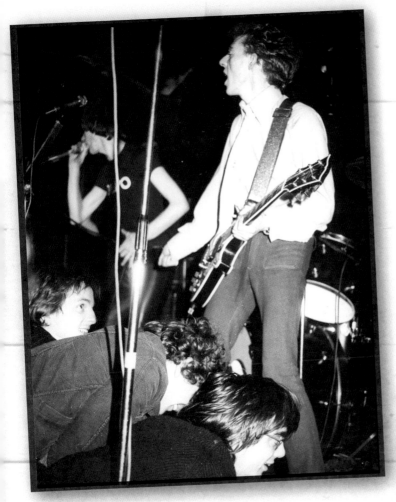

The Radiators from Space's song 'Television Screen' is arguably 'the first punk single to make the charts anywhere in the world.'* The success of their first album, TV Tube Heart, garnered the band a support slot on Thin Lizzy's 1977 UK tour.

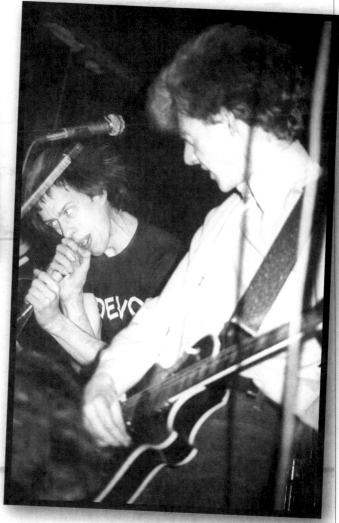

When the Radiators from Space moved to London in 1977, Billy Morley replaced Steve Rapid, who continued playing music with his new band SM Corporation while developing his career as a graphic designer. He has gone down in history as the man who proposed the name U2, and continues to act as the band's art director. His U2 designs include the cover for *Boy* which was withdrawn in the USA because of concerns that it had paedophilic connotations.

*Sam McGrath, *'The Radiators From Space Return to Earth'*, Rabble, 10 April, 2012.

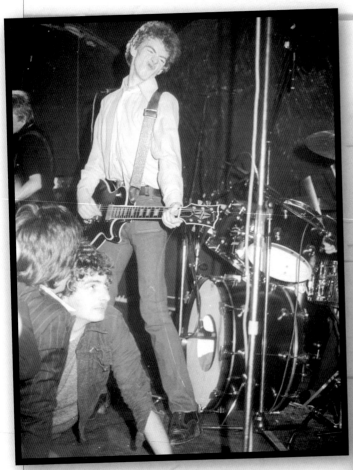

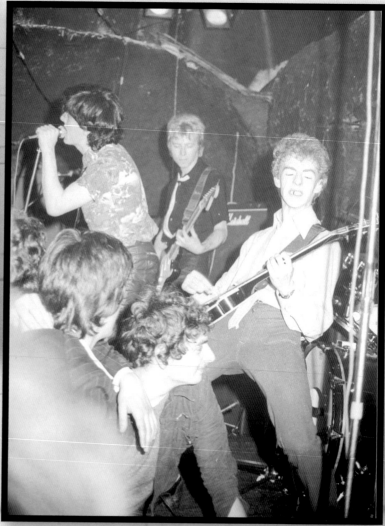

In London, Philip Chevron worked part-time in the record store Rock On, while producing artists like the Atrix and Agnes Bernelle. He joined the Pogues in 1984, taking over guitar duties so that MacGowan could concentrate on singing. In 2004 his old band reunited as the Radiators (Plan 9) and released four new albums, the last of which, *Sound City Beat*, came out in 2012.

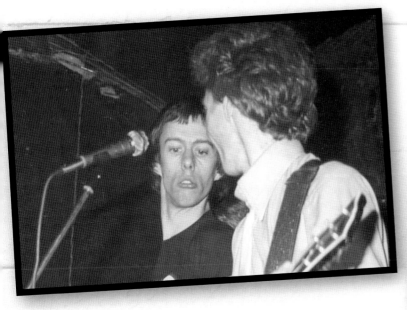

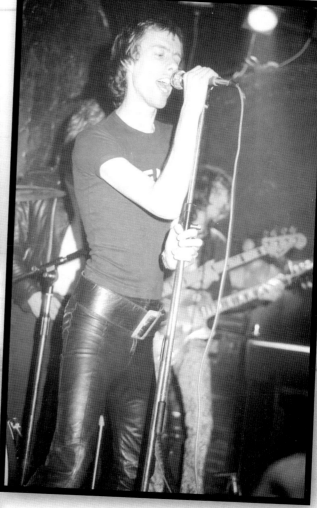

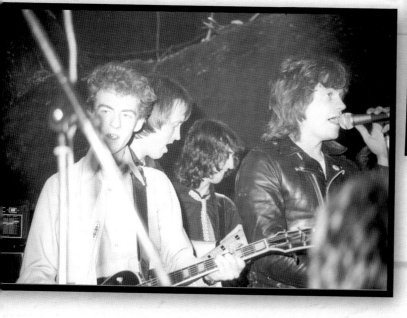

Left: Phil Chevron, Horslips' Barry Devlin and Johnny Fean, and Paul Verner. The much-loved roadie Verner, who worked with Thin Lizzy and Horslips amongst others, died in October 1991.

Right: Pete Holidai, guitarist with the Radiators from Space. In London, the band shortened their name to the Radiators. David Bowie producer Tony Visconti worked with the Radiators on their follow-up album *Ghostown*, which is numbered as one of the greatest Irish albums of all time. Conceived of as a dream-state teenage ramble through Dublin – an engagement with the ghosts of the city past and the parochialism of the city present – *Ghostown's* literary allusions were lost on audiences and despite rave critical reviews, the album flopped. The Radiators abandoned London in October 1978 and shortly after this gig with the Meanies, Billy Morley and Mark Megaray left the band.

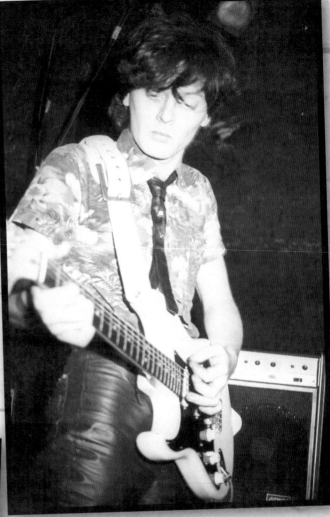

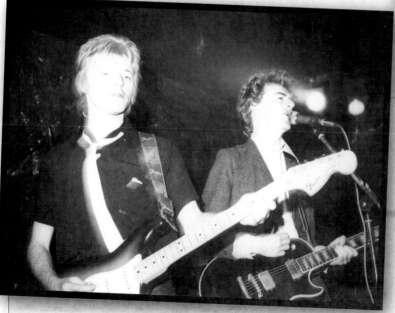

Left: Billy Morley and Phil Chevron.

1979

WHERE THE STREETS HAVE NAMES

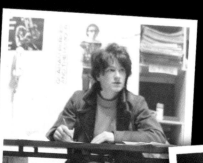

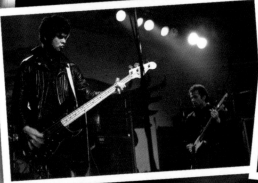

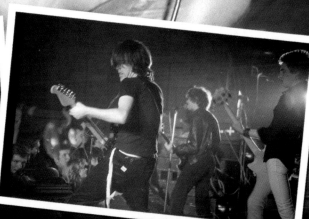

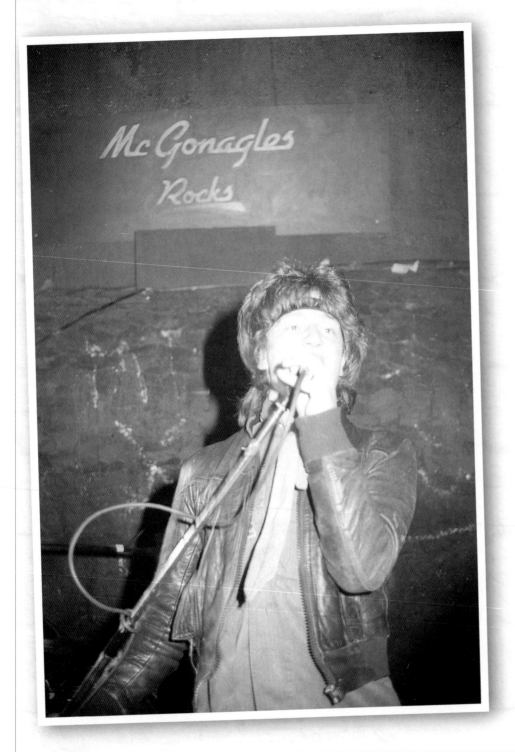

U2
McGonagle's
3 January 1979

Bono was trying out a new look at this gig . . . after seeing these photos in the *In Dublin* office, the headband was done away with.

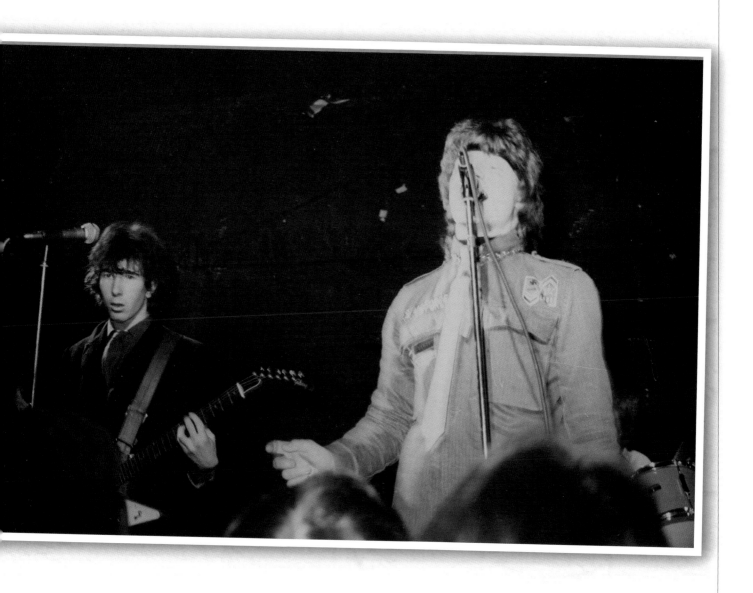

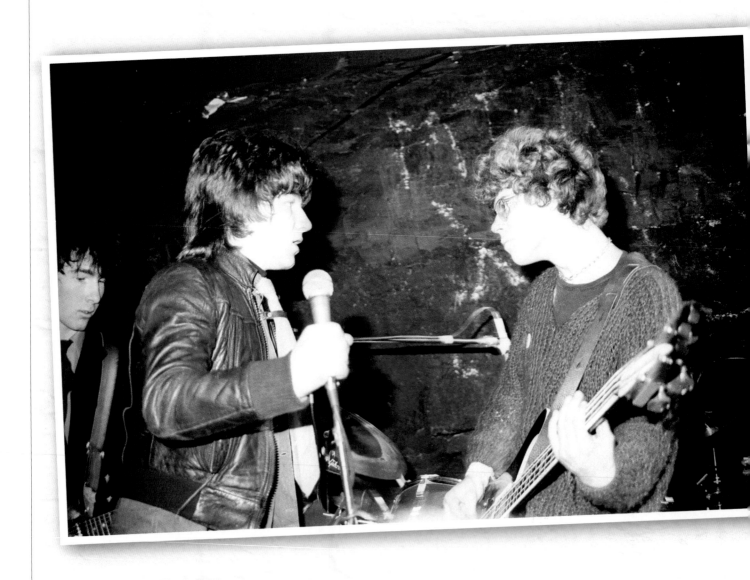

Penetration
Edmund Burke Hall, Trinity College
15 January 1979

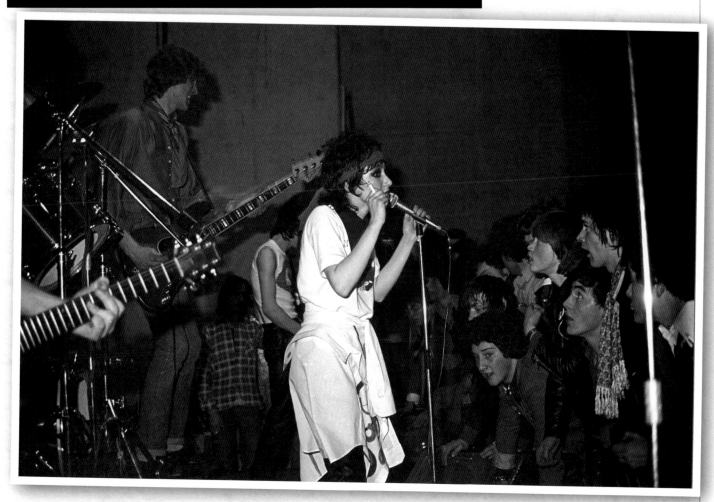

Pauline Murray, lead singer with British band
Penetration, sings to enraptured fans at Trinity
College's Edmund Burke Hall, 15 January 1979.

Bagatelle

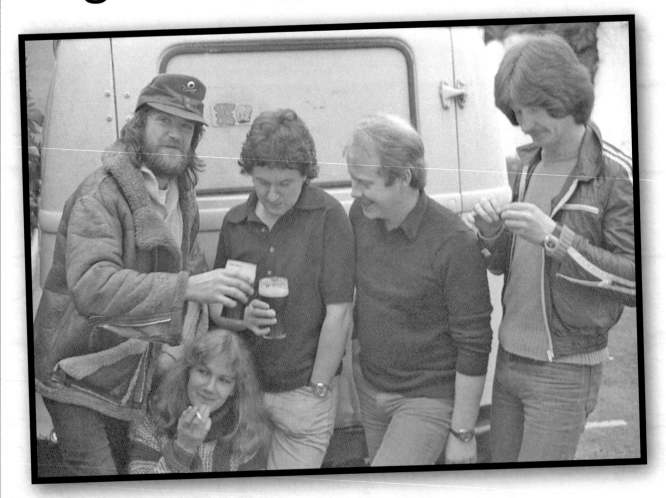

From left to right: Ken Doyle (bass, vocals), Maggie Cody (vocals), John O'Brien (guitar, vocals), Liam Reilly (keyboards, guitar, vocals) and Wally McConville (drums, vocals). These photos of Bagatelle were taken in Delgany, County Wicklow, circa early 1979 when the band had a residency in the Mississippi Rooms in Bray – Maggie Cody left the band shortly after they were taken. The following year Bagatelle released their chart-topping song 'Summer in Dublin'.

Dark Space Festival

The Project Arts Centre 16/17 February 1979

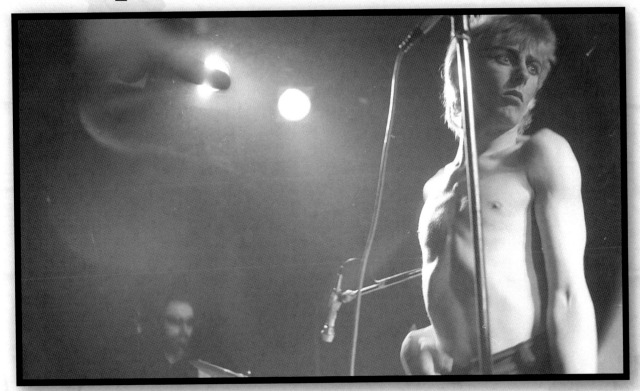

Johnny Lydon's Public Image Ltd (PIL) were due to headline the twenty-four-hour Dark Space Festival, but Lydon was in the midst of a legal battle with former Sex Pistols manager Malcolm McLaren and dropped out of the bill. The Project's chairman Jim Sheridan and manager Nigel Rolfe were said to have travelled to London to persuade Lydon to change his mind, but he was in no mood for visitors and heated words were exchanged outside his home. As a result of this disappointment, ticket prices were dropped from £6 to £4 and although an estimated eight hundred people attended over the twenty-four hours, the Project lost a lot of money. However, by all accounts, PIL's no-show actually worked out well for the other bands, who had an opportunity to display their wares without being overshadowed by the punk legend. The event turned into a thoroughly local affair, with the Mekons as the only British band in attendance. Writing in *Hot Press*, Bill Graham described it as 'the most significant Irish rock event since the Rats left town.'

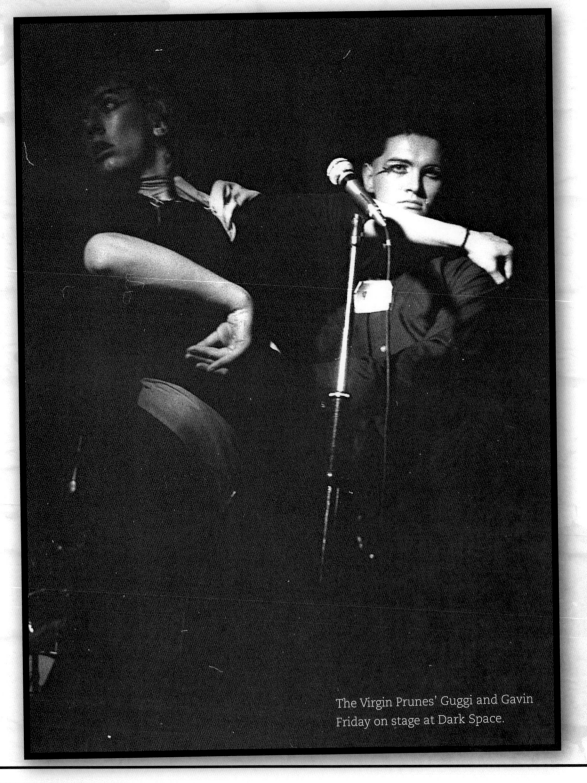

The Virgin Prunes' Guggi and Gavin Friday on stage at Dark Space.

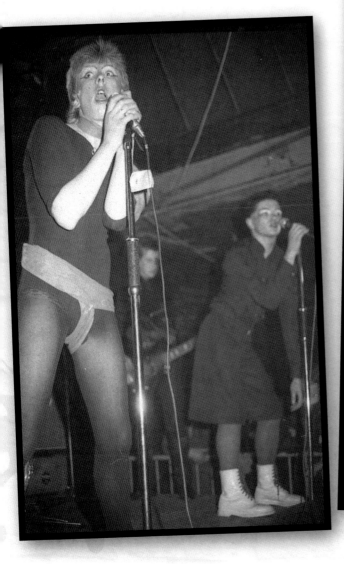

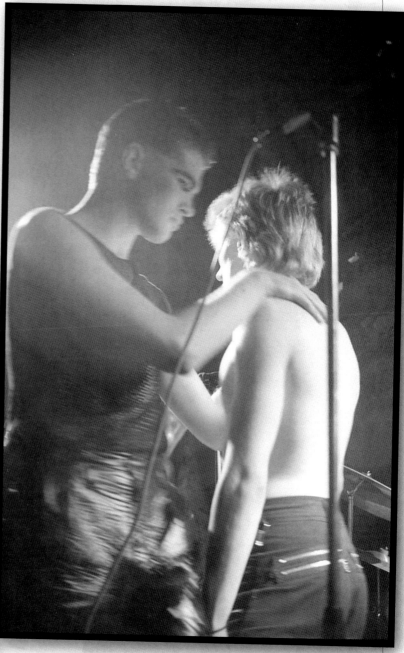

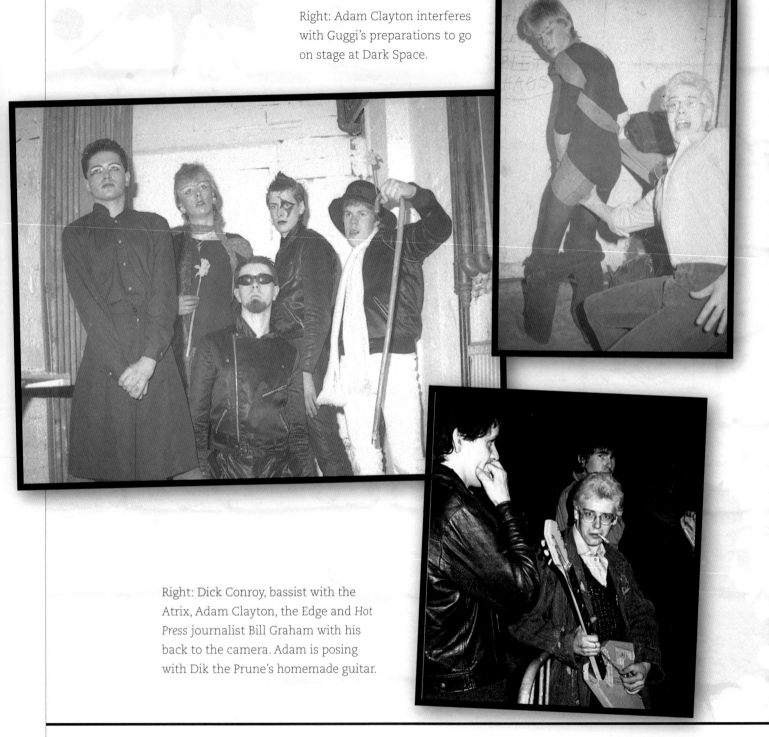

Right: Adam Clayton interferes with Guggi's preparations to go on stage at Dark Space.

Right: Dick Conroy, bassist with the Atrix, Adam Clayton, the Edge and *Hot Press* journalist Bill Graham with his back to the camera. Adam is posing with Dik the Prune's homemade guitar.

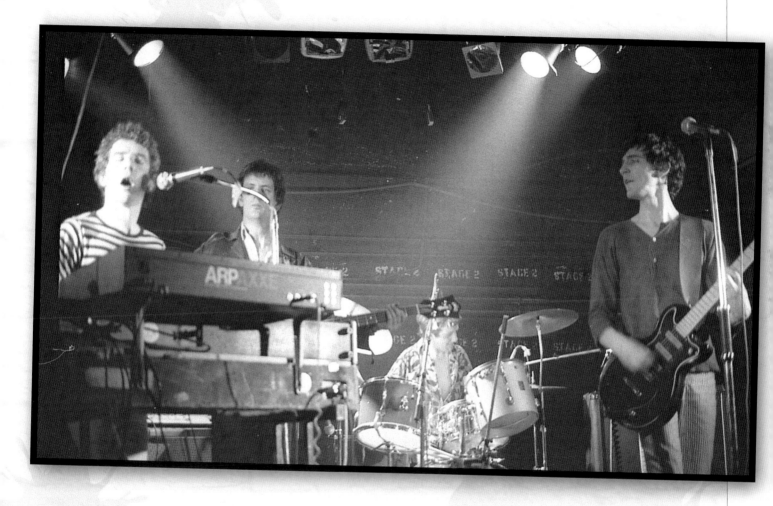

The Atrix were one of the highlights of the Project Art Centre's Dark Space Festival. From left to right: Chris Greene (keyboards, vocals), Dick Conroy (bass), Hughie Friel (drums) and John Borrowman (guitar, vocals).

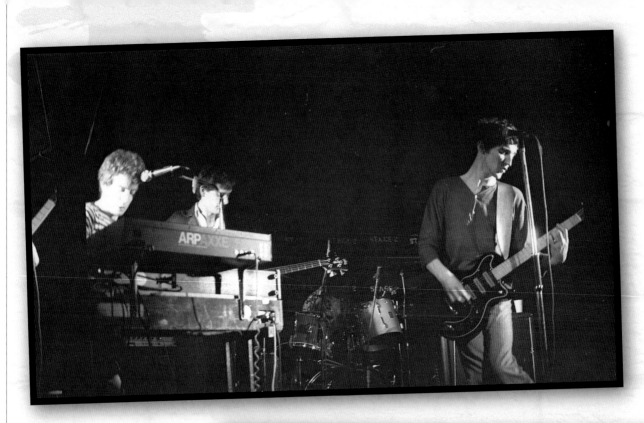

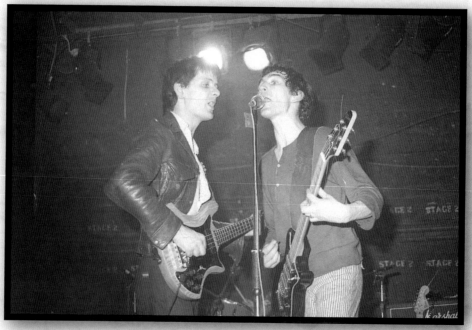

Dick Conroy and John Borrowman from the Atrix on stage at the Dark Space Festival, January 1979.

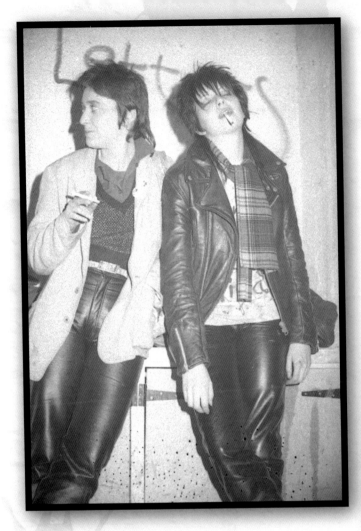

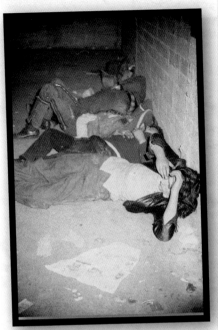

Catching up on some kip at the Dark Space Festival.

Adrienne Darragh and an exhausted Carol Walters of the Boy Scoutz at Dark Space. As can be seen, the twenty-four-hour party took its toll on everyone. Following the gig, there were badges for sale around Dublin that declared, 'I lasted 24 hours'.

Right: Legendary radio DJ John Peel at the Dark Space Festival. Peel liked the Virgin Prunes and the reggae band Zebra but was less impressed with U2.

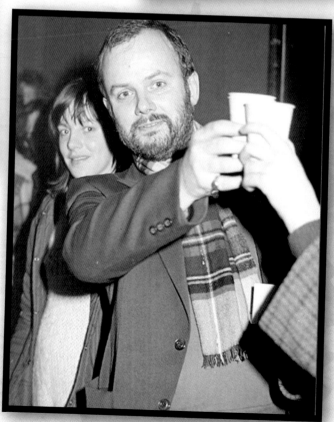

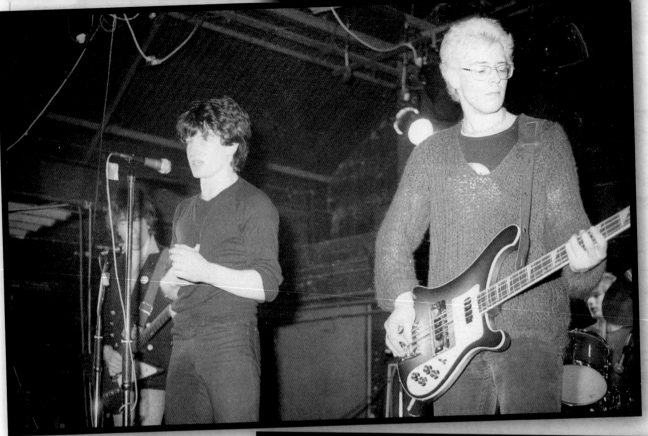

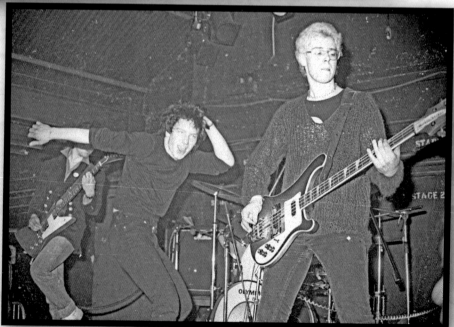

U2 finished off the Dark Space Festival in the early hours of the morning. Their gig was cut short because of late scheduling.

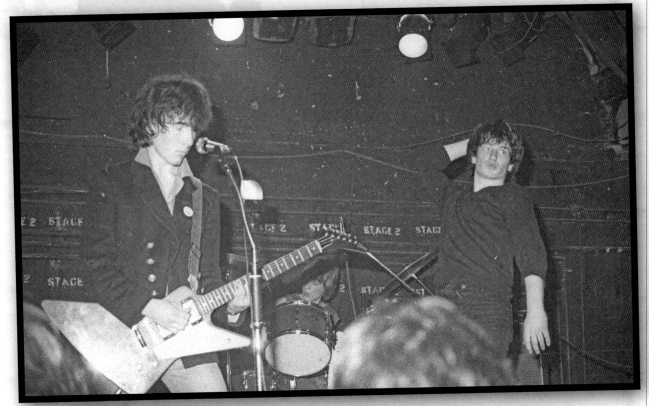

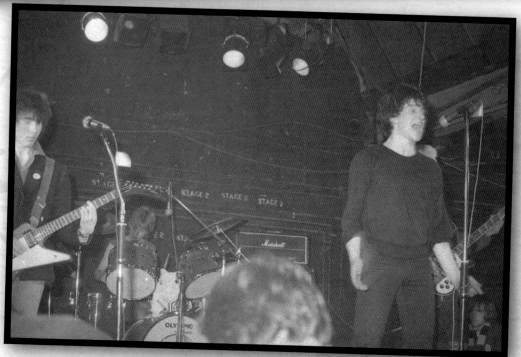

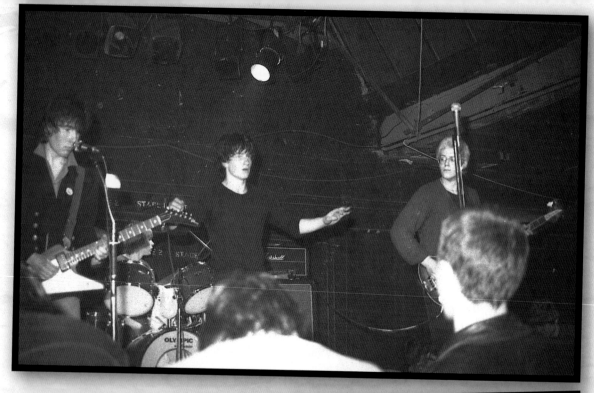

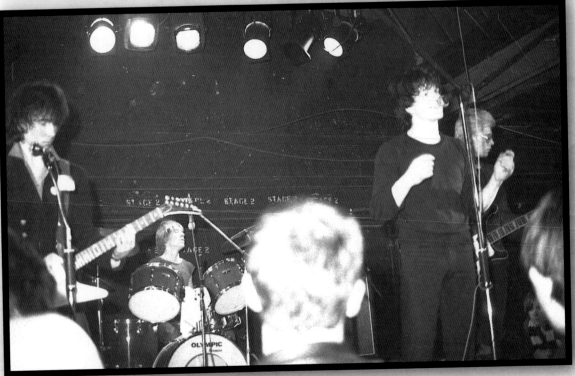

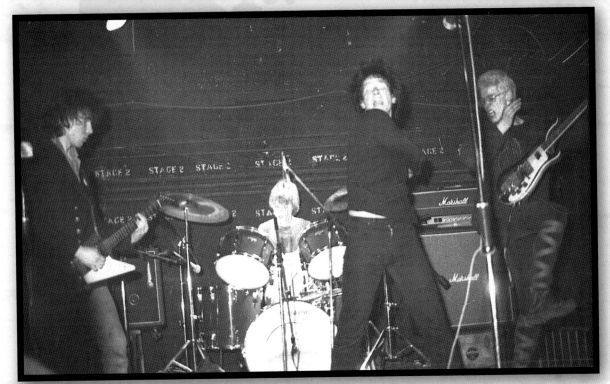

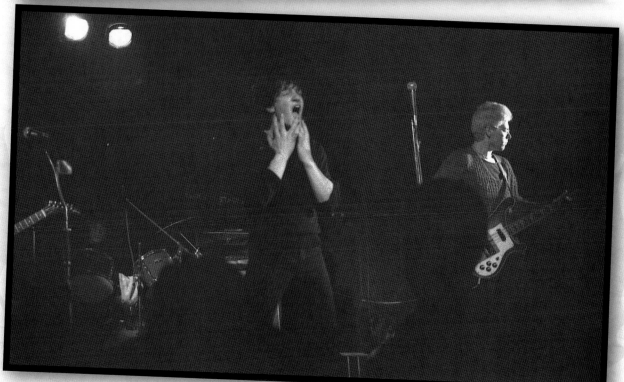

Zebra

Ireland's first reggae band, Zebra, released the single 'Repression' in 1979 on Good Vibrations Records and played in the Dandelion on 6 May of the same year. From left to right: Mark Thyme (drums), Bernard Rangel (percussion, vocals), Steve Rekab (vocals, guitar), Brian Nartey (bass), Norman Morrow (keyboards) and Pete Deane (vocals, guitar).

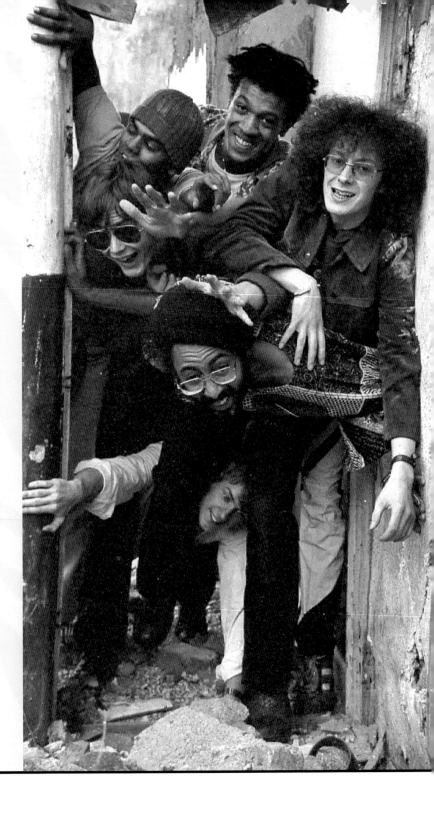

The Freddie White Band

McGonagle's
21 January 1979

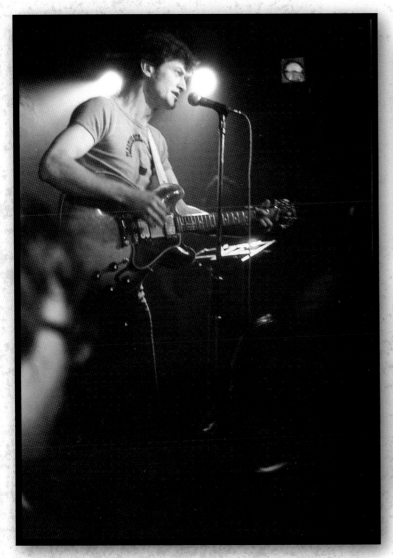

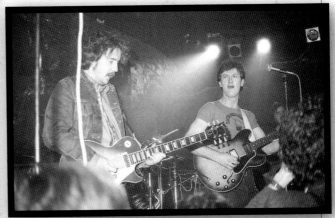

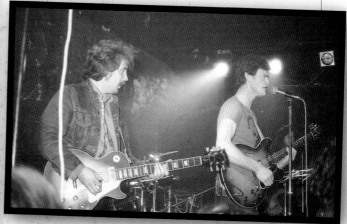

Jimmy Faulkner on stage with
Freddie White.

The Only Ones
McGonagle's

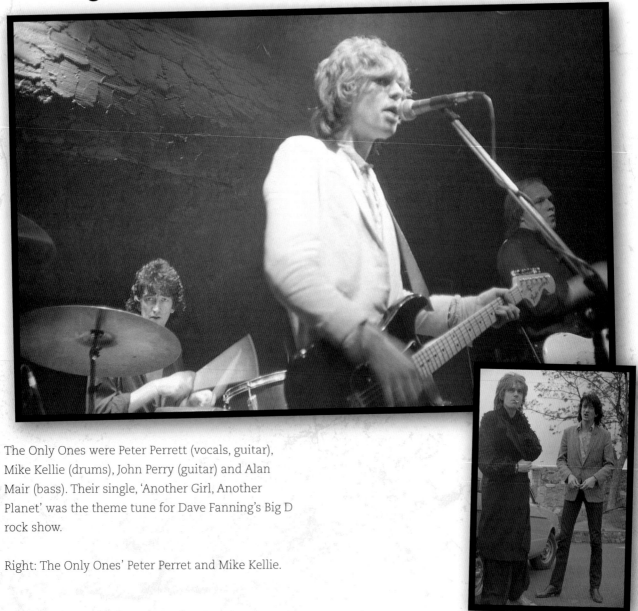

The Only Ones were Peter Perrett (vocals, guitar),
Mike Kellie (drums), John Perry (guitar) and Alan
Mair (bass). Their single, 'Another Girl, Another
Planet' was the theme tune for Dave Fanning's Big D
rock show.

Right: The Only Ones' Peter Perret and Mike Kellie.

U2 at the Buttery, 3 February 1979

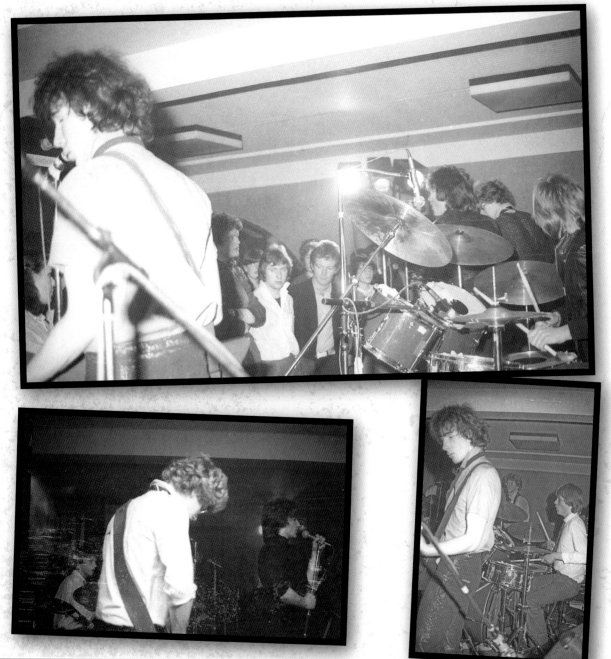

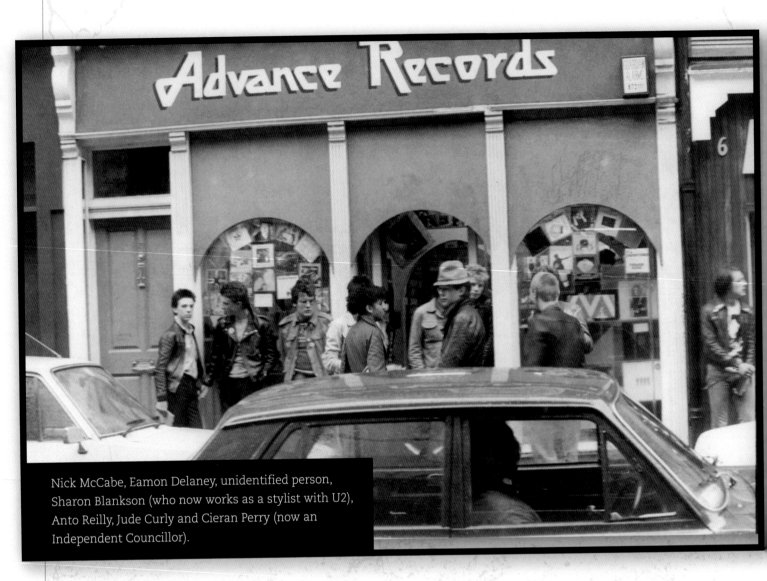

Nick McCabe, Eamon Delaney, unidentified person, Sharon Blankson (who now works as a stylist with U2), Anto Reilly, Jude Curly and Cieran Perry (now an Independent Councillor).

The Black Catholics and their friends hung outside Advance Records on South King Street every Saturday. U2's most notorious rivals, are listed as playing two gigs in the Dandelion Market, one in support of the Letters. They were Brian 'the Lad' Cawley, Ray Tague (guitar), Dustin (guitar), Jimmy 'the Ig' Cavanagh (drums) and Noel O'Carroll (bass). Tragically, Brian Cawley drowned on 15 February 1979 only days after these photos were taken.

The Black Catholics

11 February 1979

The Black Catholics came from Finglas and Ballymun – the famous towers of which Bono could see from his bedroom window. Although they are largely remembered as U2's most notorious rivals, they too received their fair share of hassle and aggression.

The ongoing feud between fans of U2 and followers of the Black Catholics came to a head on 8 September 1979 when U2 were supporting Patrik Fitzgerald in the Project Arts Centre. During U2's performance, a Black Catholics supporter was sitting on the stage drinking cider when he got to his feet and threw the drink over Adam Clayton, then raised the heavy glass flagon above his head and started flailing it about as if to hit the bassist. Bono picked up the mike stand to defend himself and his band, when suddenly Paul McGuinness arrived from the back of the theatre, grabbed the weapon from Adam's assailant and dragged him off the premises.

A skirmish outside continued with one person hospitalised and another almost losing an eye.

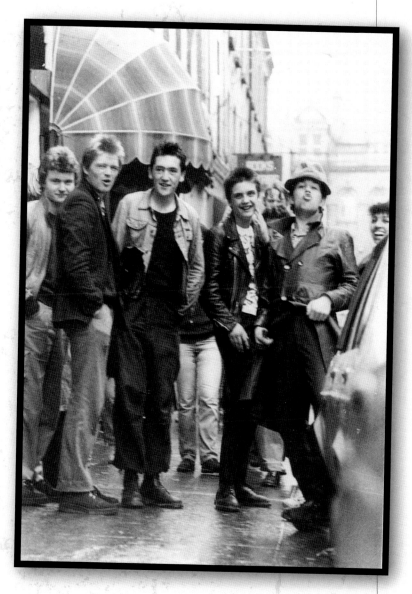

Left to right: Brian 'the Lad' Cawley, Dustin, Dave Donnelly, Frank O'Neil, Anto Reilly, Sharon Blankson.

From left to right: Eamon Delaney (writer), Nick McCabe, unidentified person, Dustin, Brian 'the Lad' Cawley, Dave Donnelly, Frank O'Neil, Sharon Blankson, Anto Reilly.

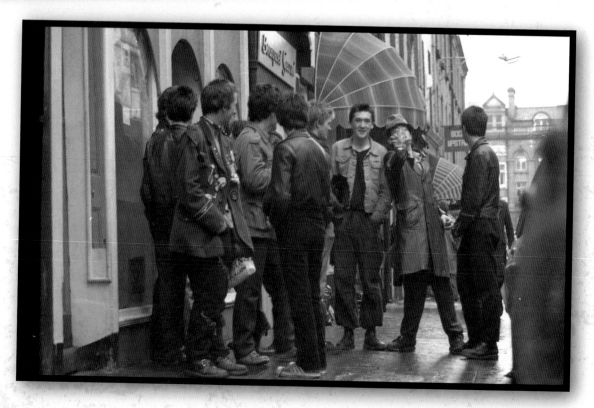

U2

Trinity College Photo Shoot
10 February 1979

In February 1979, Bono arranged for Patrick to take a series of publicity photos of U2 in Trinity Arts Block which a friend, Andrew Whiteway, had arranged for them to use. The band showed up, each with a change of clothes. Adam arrived in his distinctive Afghan coat. Bono – full of ideas – directed the whole shoot. The U2 frontman was particularly pleased with two photos of his hand underneath an icon on the door to the ladies' toilets and expressed his desire to use the image for their first-ever record cover – a 12-inch single entitled 'U23'. In the end, Steve Averill designed the cover with photos by Hugo McGuinness.

After the photo shoot, the group went for lunch in Pizzaland on Grafton Street. The band were so well acquainted with the eatery that they were able to advise Patrick on what to order without even looking at the menu.

Guggi stood in for an absent Larry at the photo shoot. Later that day, when Patrick bumped into the drummer at the Viper's matinee show in McGonagle's, Larry asked him, 'What's this about a photo shoot this morning? I didn't know of this photo shoot in Trinity. No one told me about it!'

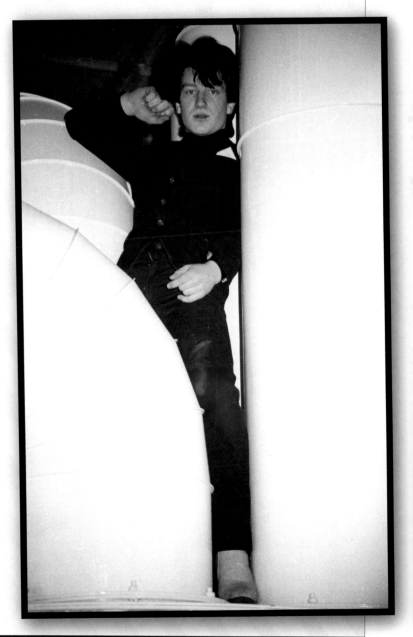

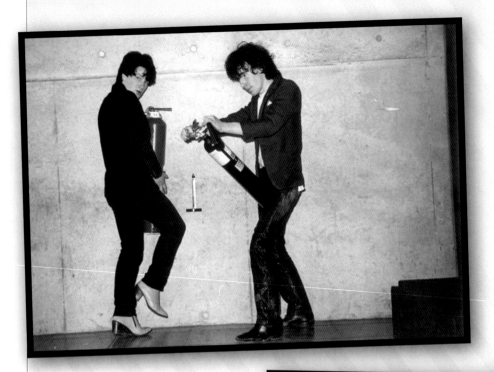

As their success grew, so did the question mark over Larry's commitment to U2. The young drummer was still in school and under pressure from his parents to study for his final year exams. Dave Greenlee, the Schoolkids vocalist, had periodically drummed with his band and on one occasion U2 called round to the Schoolkids' rehearsal space – a derelict building on Parnell Square – to talk to him about replacing Larry.

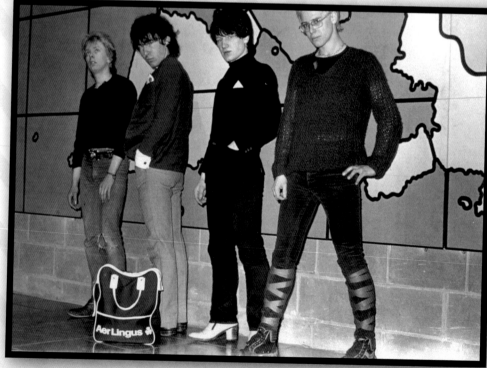

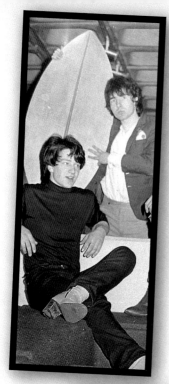

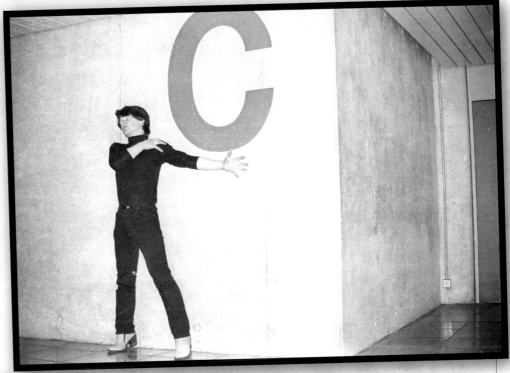

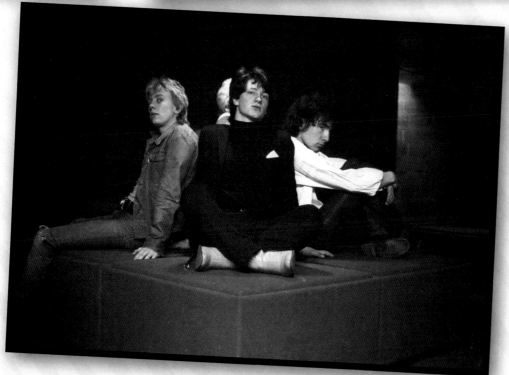

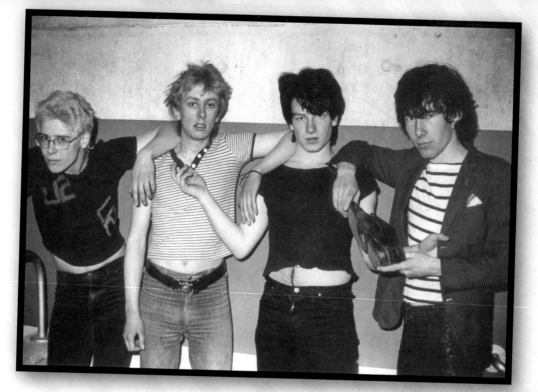

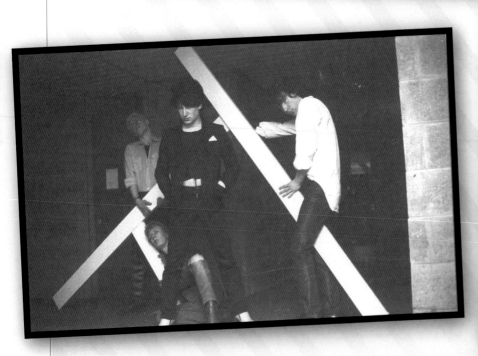

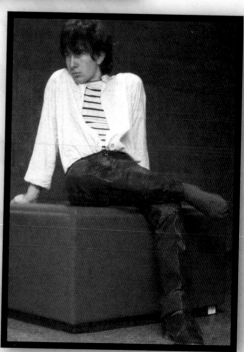

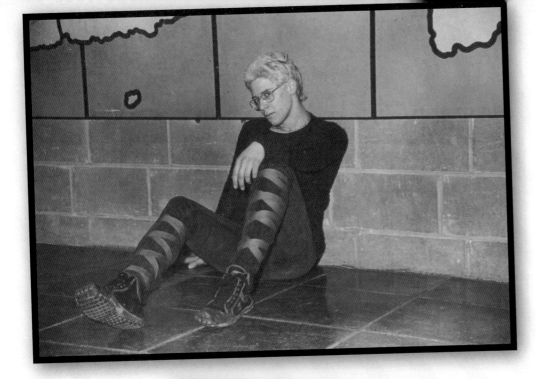

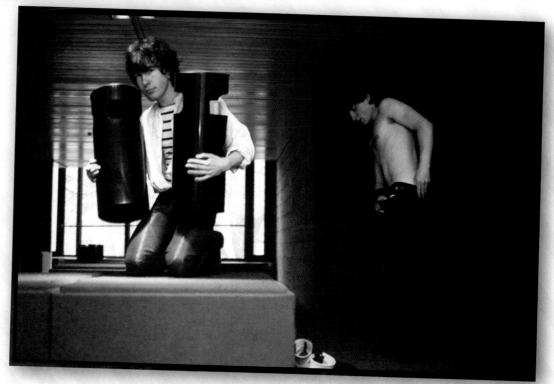

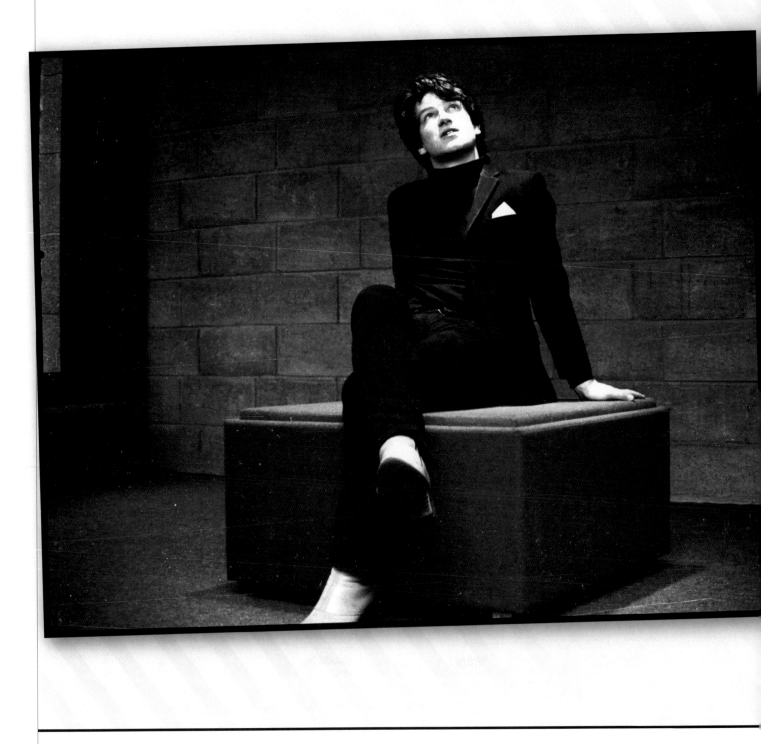

The Vipers
McGonagle's
10 February 1979

The Vipers play a matinee show in McGonagle's. Formed in 1977, the Vipers toured the UK with Thin Lizzy and the Boomtown Rats and supported the Clash, Dr Feelgood, the Jam, Wilko Johnson and the Troggs, and the Adverts to name but a few. Their 1979 line-up was Paul Boyle (vocals, guitar), Dave 'George' Sweeney (lead guitar, vocals), Brian 'Dolan' Foley (bass), and Dave Moloney (drums).

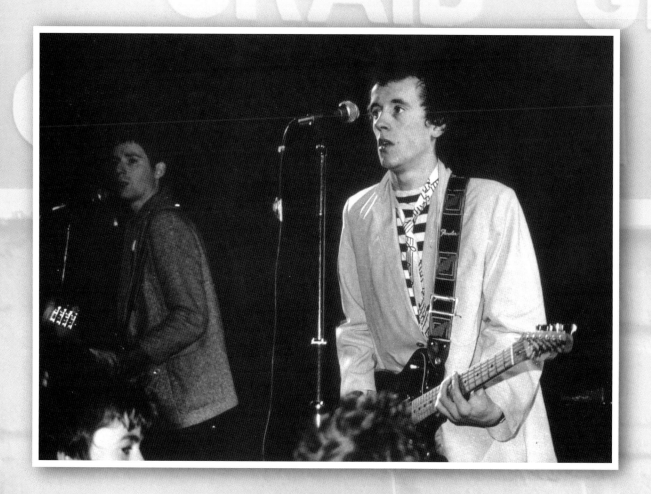

Pirate Radio

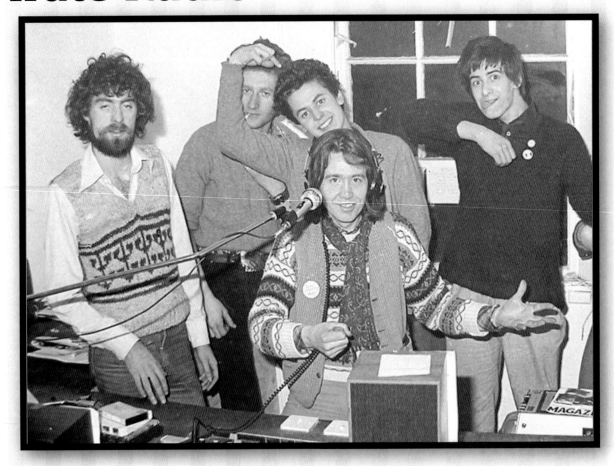

Big D staff in Feb 1979

Prior to the establishment of RTÉ Radio 2 at the end of May 1979, pirate radio stations were one of the most important resources for the dissemination of local talent.

When gigs finished and bars closed, music aficionados headed over to the Stephen's Green studio of the Big D pirate radio station where they and their cans of cheap beer were welcomed. This is where Patrick headed on the night of the U2 Trinity College photo shoot.

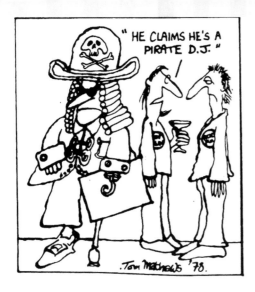

"HE CLAIMS HE'S A PIRATE D.J."

This Tom Matthews cartoon was used as an illustration for a 1978 article on Pirate Radio in *In Dublin* magazine.

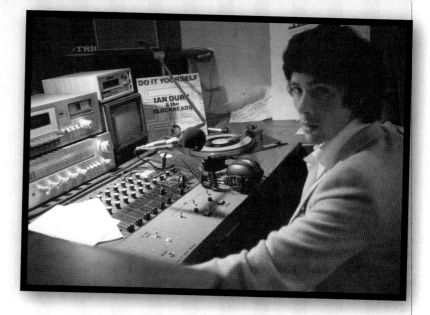

James Dillon, one of the founders of Big D. This series of photos was taken for a *Hot Press* article on pirate radio in 1979 shortly after Radio 2 came on air.

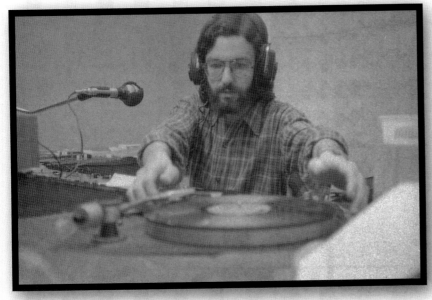

Dave Fanning's replacement, Mike Gardner on Big D.

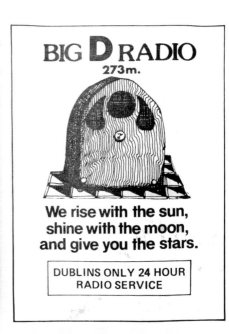

BIG **D** RADIO
273m.

We rise with the sun, shine with the moon, and give you the stars.

DUBLINS ONLY 24 HOUR RADIO SERVICE

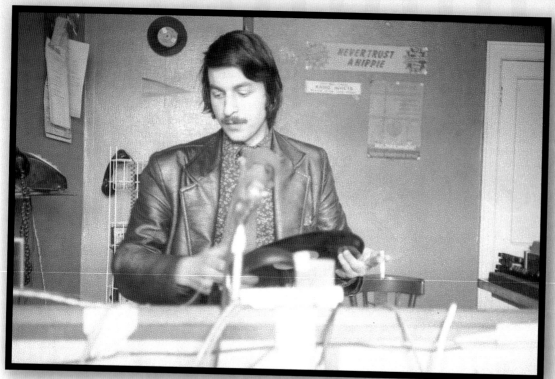

Alan Russell from Capitol Radio.

ARD 257's Dr Don.

DJ Sylvie from ARD 257 – Alternative Radio Dublin.

Radio 2

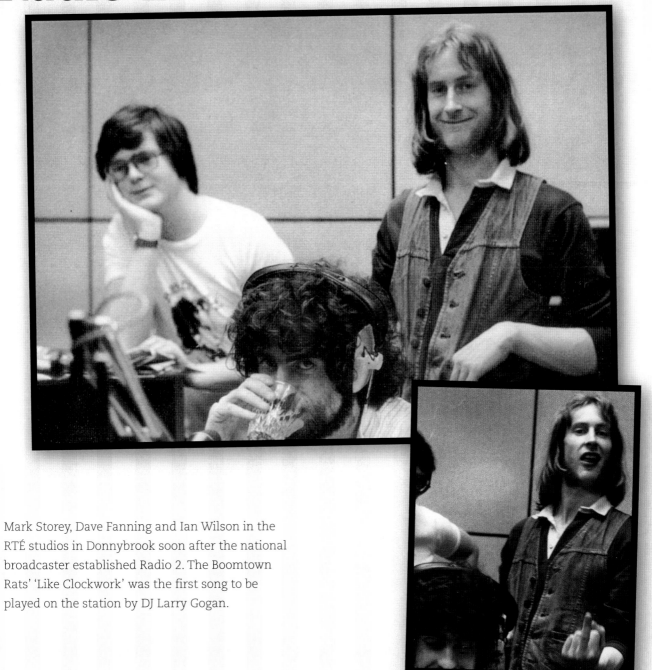

Mark Storey, Dave Fanning and Ian Wilson in the RTÉ studios in Donnybrook soon after the national broadcaster established Radio 2. The Boomtown Rats' 'Like Clockwork' was the first song to be played on the station by DJ Larry Gogan.

DC Nein
McGonagle's
11 February 1979

Below: DC Nein's Paul McGuinness (guitar) and
Damian Gunn (vocals, sax). The band's other
members were Brendan Gannon (keyboards), Brian
Seales (bass) and Ken Mahon (drums). Formed in
1976, DC Nein were a hugely popular Dublin band,
and opened for AC/DC in 1978 and Dr Feelgood and
John Cooper Clarke in 1979. Having released their
Just For Kicks LP in December 1979, they were
reborn as Tokyo Olympics in 1981.

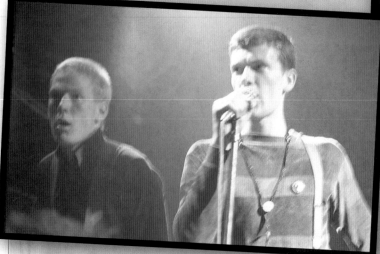

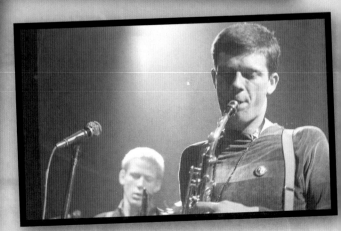

U2 Willows Interview 24 February 1979

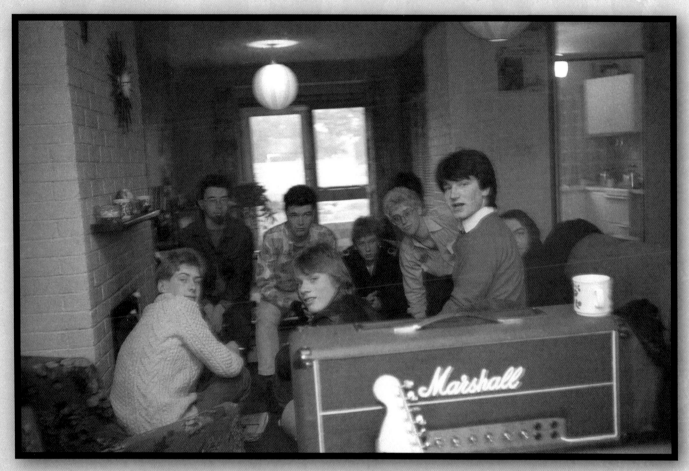

In 1977/78, three of the Rowen brothers – Strongman, Clive and Guggi – moved into the Willows estate in the shadow of Glasnevin cemetery on the north side of the city. Halloween 1978 was the first of many parties in the Willows and by early evening, the house was full and buzzing. Bedrooms were soon filled by amorous couples and one uninvited guest was kicked out of the house after attempting to disrupt one of these teenage trysts. By 4 AM, some of the more responsible Lypton Village crew decided enough was enough, turned the music off and started tidying up.

With no money for taxis, a number of guests decided to stay the night, although

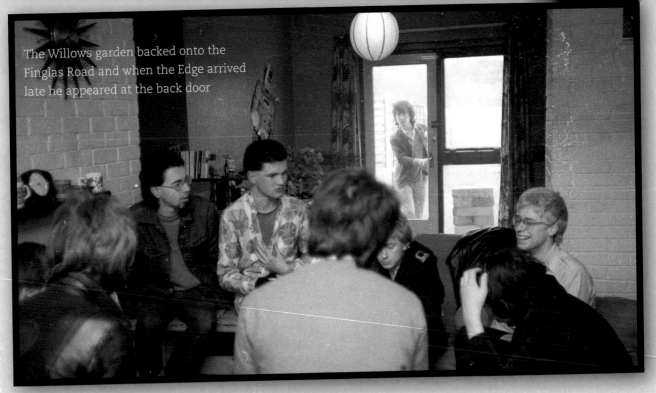

The Willows garden backed onto the Finglas Road and when the Edge arrived late he appeared at the back door

there were no spare blankets and the house was freezing cold. Bono tried to sleep on four kitchen chairs which he had arranged side by side in the living room, but when sleep was not forthcoming, one creative partygoer suggested that they take down the curtains to use as bed covers. Although a tempting idea, eventually it was decided that this was too much effort, and in the end the U2 frontman decided to make the long walk home to Cedarwood Road.

The following series of photos were taken in the Willows house during a Bill Graham *Hot Press* interview with U2 and the Virgin Prunes on 24 February 1979.

After the interview the group got the bus to the city centre directly to the Bailey Pub, off Grafton Street.

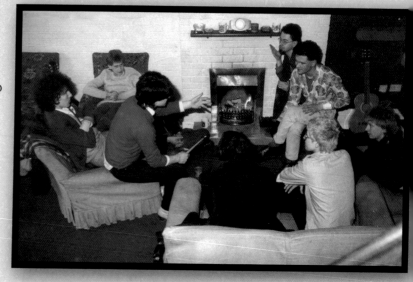

Hot Press journalist Bill Graham in conversation with U2 and the Virgin Prunes. Graham, who is frequently described as having discovered U2, introduced the young band to their manager Paul McGuinness. He is highly regarded in the worlds of Irish music and journalism, and was the author of two books about U2. He was passionate about music, food and literature and was an encyclopaedia of knowledge, offering sound advice to any up-and-coming band wise enough to ask for it. He passed away on 11 May 1996.

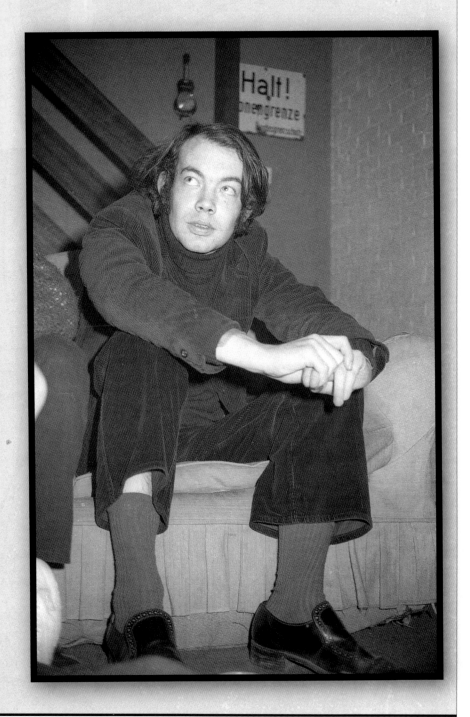

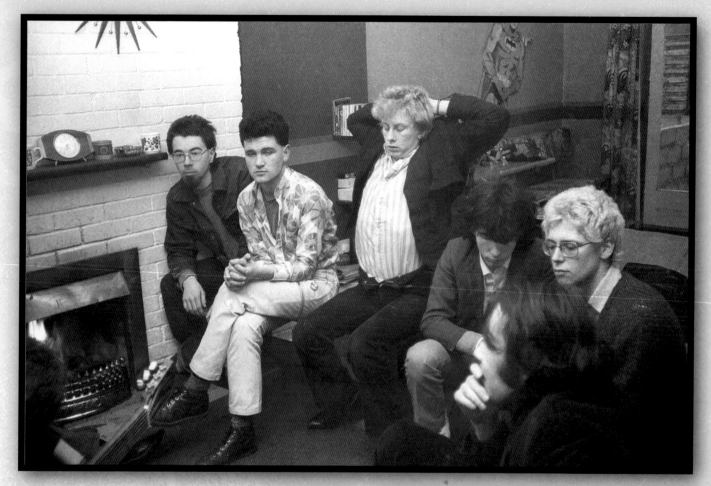

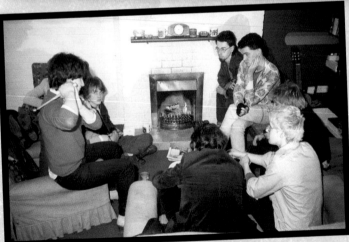

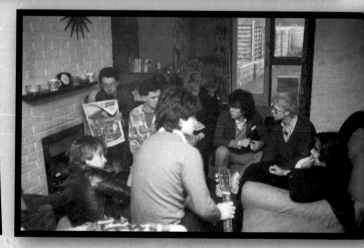

The Bailey Pub

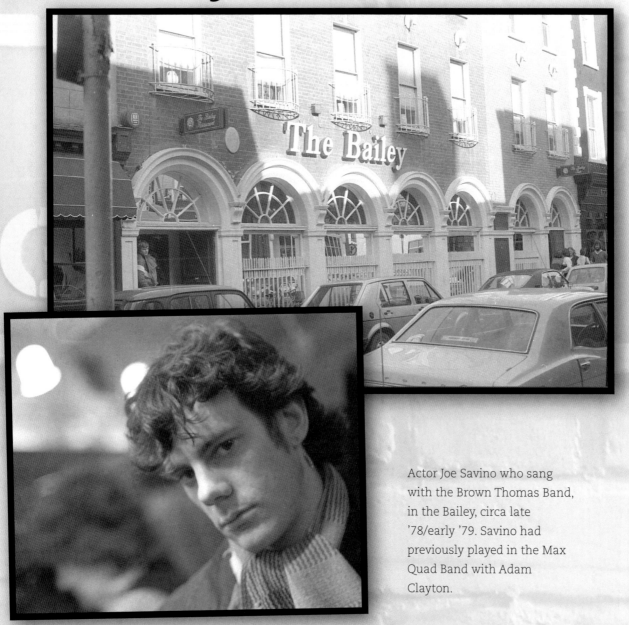

Actor Joe Savino who sang with the Brown Thomas Band, in the Bailey, circa late '78/early '79. Savino had previously played in the Max Quad Band with Adam Clayton.

Clarke

with Support from
the New Versions

The Project Arts
Centre 8 March 1979

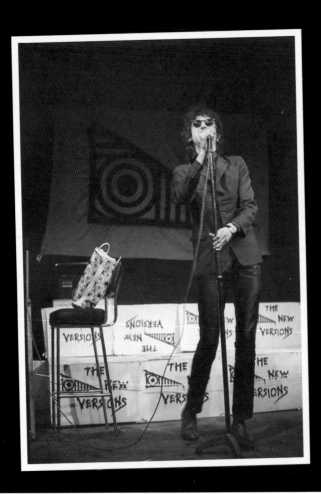

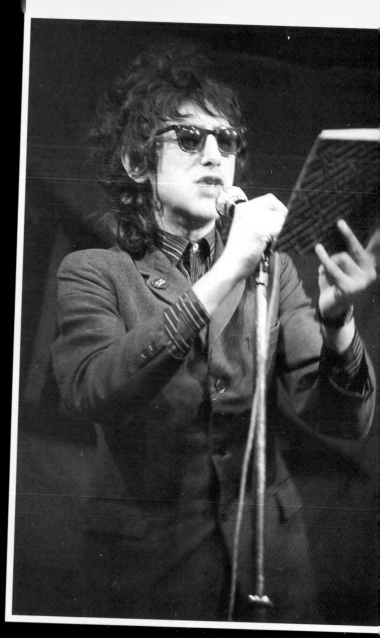

The Boy Scoutz support The Blades

Magnet Bar, Pearse Street, May 1979

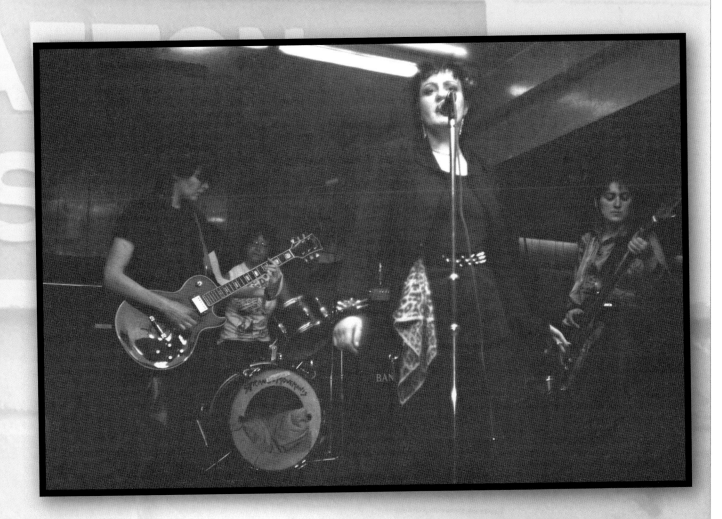

The Boy Scoutz on stage in the Magnet.

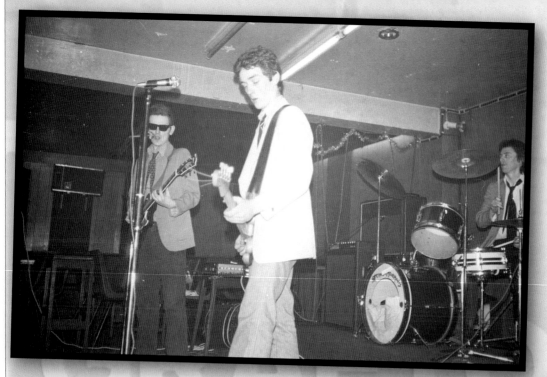

Left: The Blades, Magnet Bar, May 1979. Lar Schreiber (guitar), Pat Larkin (drums), Paul Cleary (bass, vocals).

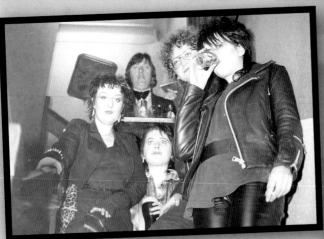

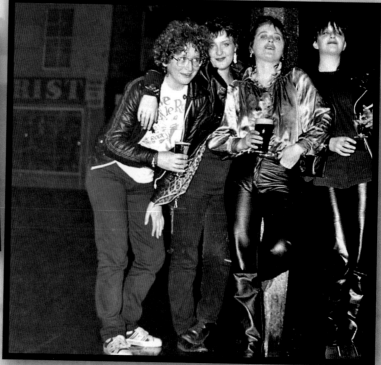

The Boy Scoutz after the gig on the stairs with the Magnet's barman and posing outside on Pearse Street.

The Skank Mooks Circa April 1979

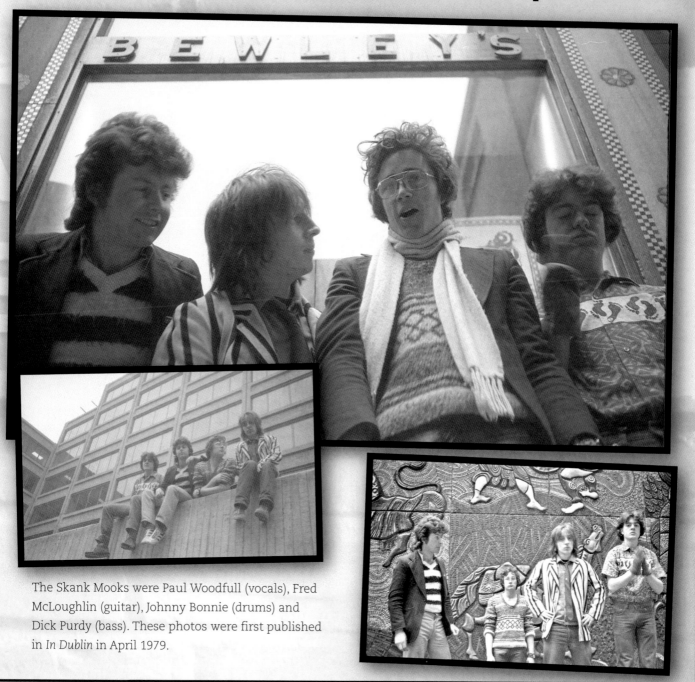

The Skank Mooks were Paul Woodfull (vocals), Fred McLoughlin (guitar), Johnny Bonnie (drums) and Dick Purdy (bass). These photos were first published in *In Dublin* in April 1979.

Stagalee

The Chariot Inn, Ranelagh
6/8 April 1979

Backstage at the Chariot Inn. From left to right: Carl Geraghty (sax), John Forbes (drums), Errol Walsh (guitar, vocals), James Delaney (keyboards), and Tommy Moore (bass).

Fran Breen (drums), Carl Geraghty (sax) and Greg Boland (guitar).

Stagalee began life in Tralee sometime in the early 1970s. Their earliest line-up included Victor and Henry McCullough, Errol Walsh and Donnie Moore. Following Victor's departure, the band enlisted Eoghan O'Neill and moved up to Dublin, where they found a manager in Billy Walsh who, according to Errol Walsh, was responsible for putting Stagalee on the map. There were over a hundred players with Stagalee over its ten to fifteen years including Colin Tully (sax, keyboards), Gavin Hodgson (bass), Maggie Riley (vocals), Dave McHale RIP (keyboards, sax) and Honor Heffernan (vocals).

Strange Movements

Magnet Bar, Pearse Street, Circa March /April 1979

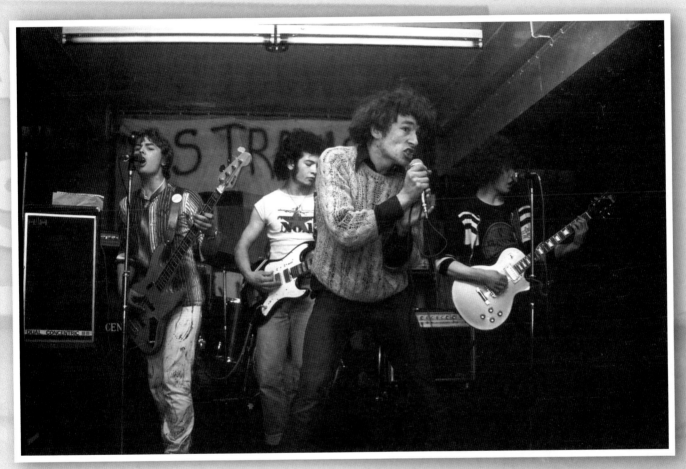

Strange Movements played at least ten times in the Magnet Bar between March and April 1979. Strange Movements were Turlough Kelleher (vocals), Lar Rogan (guitar), Tony Leonard, Lenny Lunge (guitar), Ken Doyne (bass) and Denis McGrane (drums). The band's 7-inch single 'Dancing in the Ghetto' was released on Good Vibrations Records in May 1979.

Patrik Fitzgerald
with Support from the Virgin Prunes

Junior Common Room, Trinity College
29 March 1979

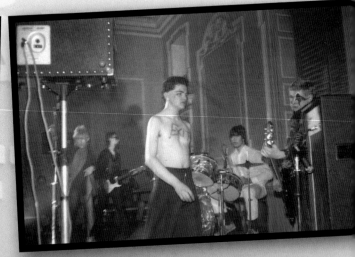

London punk troubadour Patrik Fitzgerald, whose popular first EP "Safety Pin Stuck in My Heart" was released in 1979.

The Letters
Murray's Record Centre

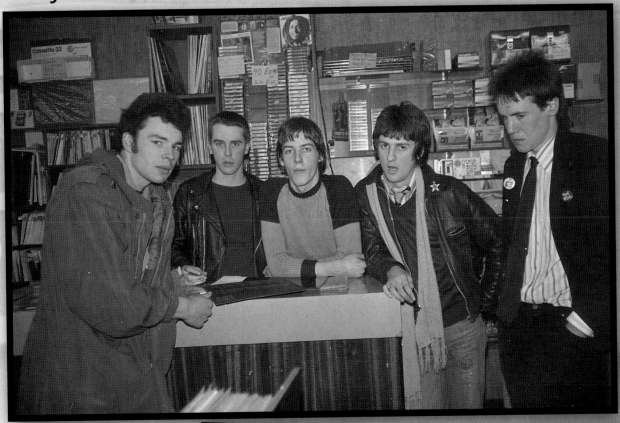

Pictured here in Murray's Record Centre in the Grafton Arcade, the Letters were Mark 'Spot' Phelan (vocals), Tom Doyle (guitar, vocals), Stephen Ryan (guitar, vocals), Des O'Byrne (bass) and Dave Herlihy (drums). These photos appeared in *In Dublin* magazine on 6 April 1979.

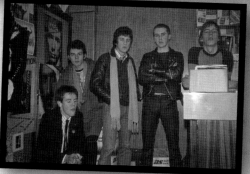

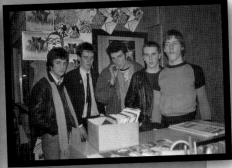

Virgin Prunes/In Dublin
'I Like It Bigger' Party
McGonagle's Circa April 1979

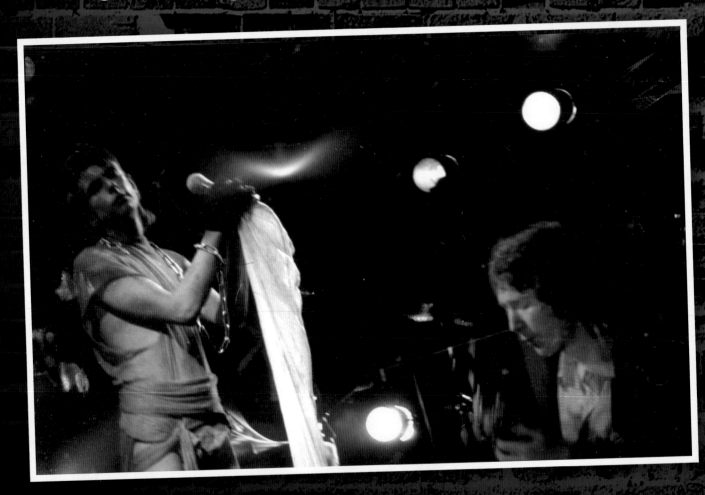

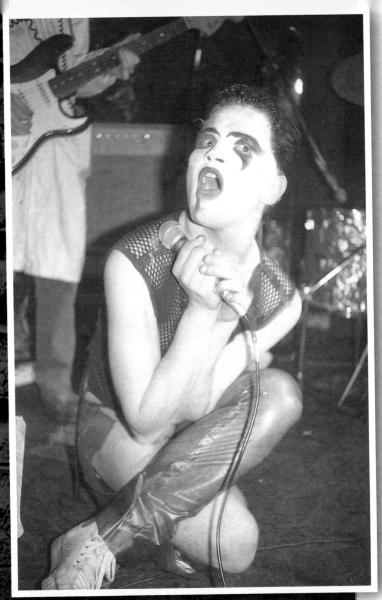

In the early months of 1979, the *In Dublin* management decided to enlarge the publication from A5 to A4 and threw a party in McGonagle's Night Club to celebrate the new format. Badges were given out at the party with the slogan 'In Dublin: I like it bigger'. Rocky De Valera and the Gravediggers, and the Virgin Prunes were on the bill, with the Prunes' stage antics offending the feminist-minded in the audience.

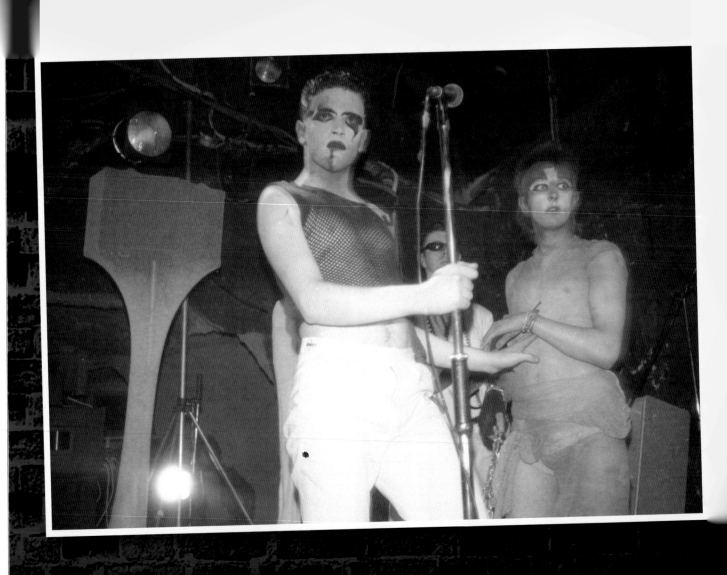

The Freddie White Band

These photos of the Freddie White Band rehearsing in the Music Circle on Dame Street appeared in the March 1979 issue of *In Dublin*. The band were supporting Eric Clapton on his Irish tour. Pictured here are Matt Kelleghan (drums), Declan McNelis (bass), Freddie White (guitar, vocals) and Jimmy Faulkner (guitar). Declan McNelis died in April 1987 after being assaulted outside the Savoy in Limerick where he was playing his regular Thursday night gig with his band Hotfoot (of which Jimmy Faulkner was also a member).

Rocky De Valera and the Rhythm Kings

Photo Shoot in the Granary Pub, Essex Street
Date Unknown

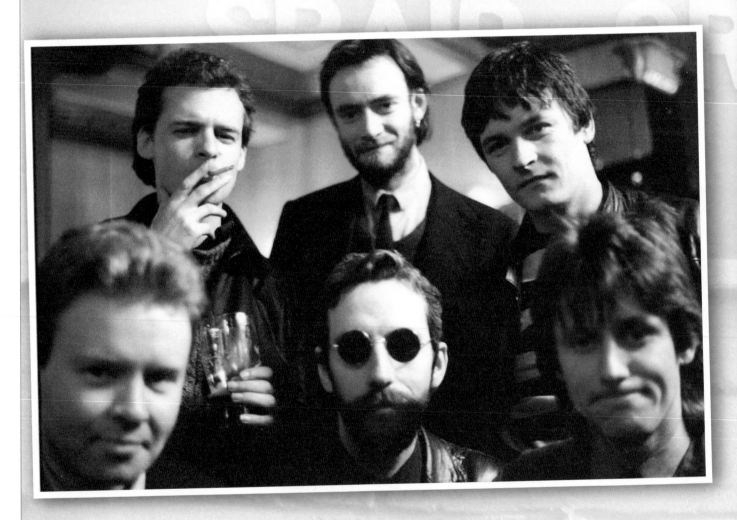

New Versions'
Photo Shoot
Circa March/April 1979

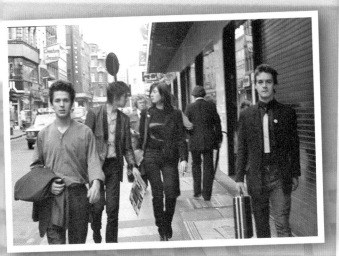

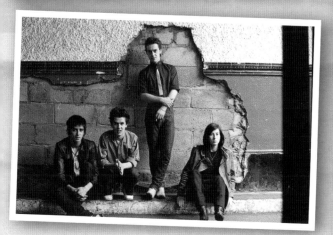

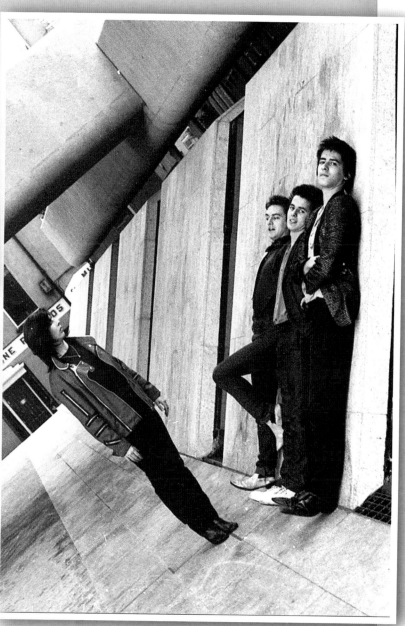

Right: The New Versions pose at
the Central Bank, Dame Street.

Berlin
The Dandelion 5 May 1979

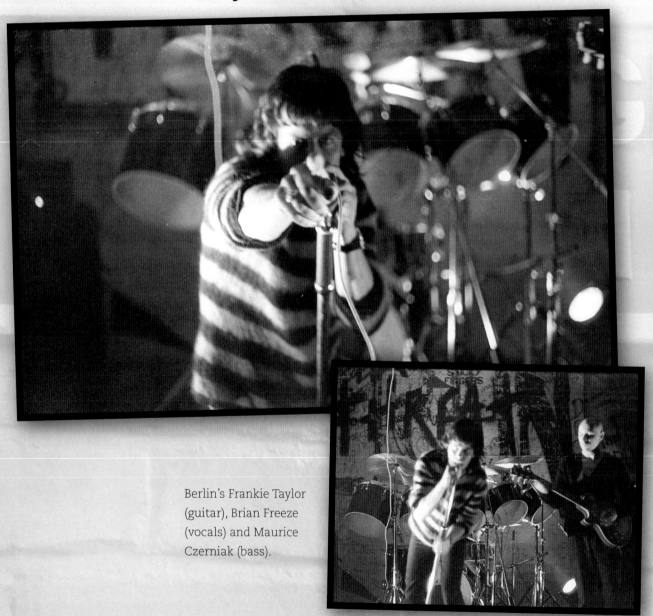

Berlin's Frankie Taylor (guitar), Brian Freeze (vocals) and Maurice Czerniak (bass).

U2 with Support from the Fast
The Dandelion 12 May 1979

Right: The Fast at the Dandelion.
Dave Boardman (vocals), Frank
Kearns (guitar), Stephen Ryan (bass)
and Eric Briggs (drums).

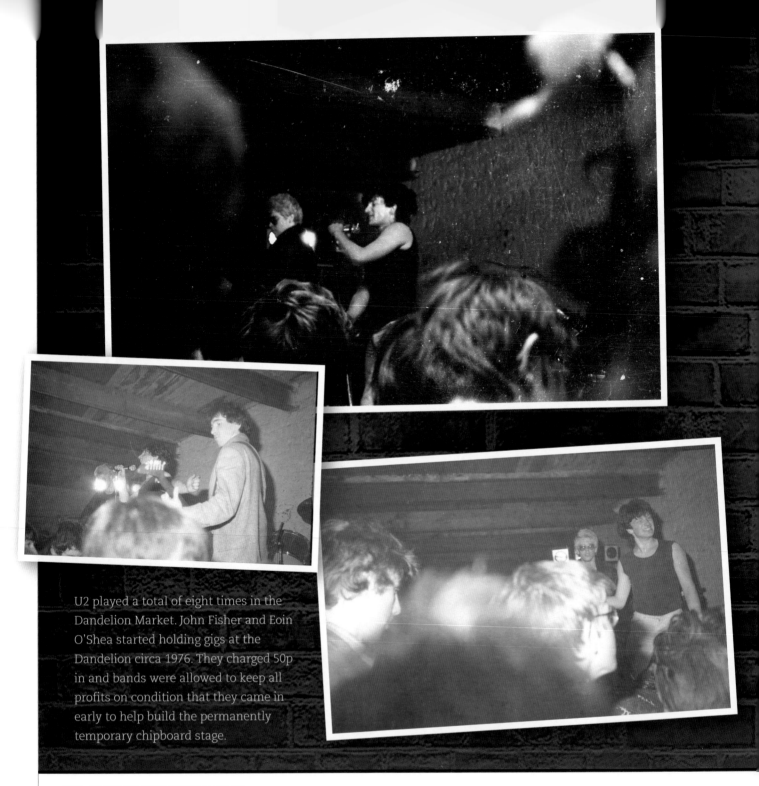

U2 played a total of eight times in the Dandelion Market. John Fisher and Eoin O'Shea started holding gigs at the Dandelion circa 1976. They charged 50p in and bands were allowed to keep all profits on condition that they came in early to help build the permanently temporary chipboard stage.

Stiff Little Fingers

with Support from Zebra, Protex, and the Starjets
Belfield 19 May 1979

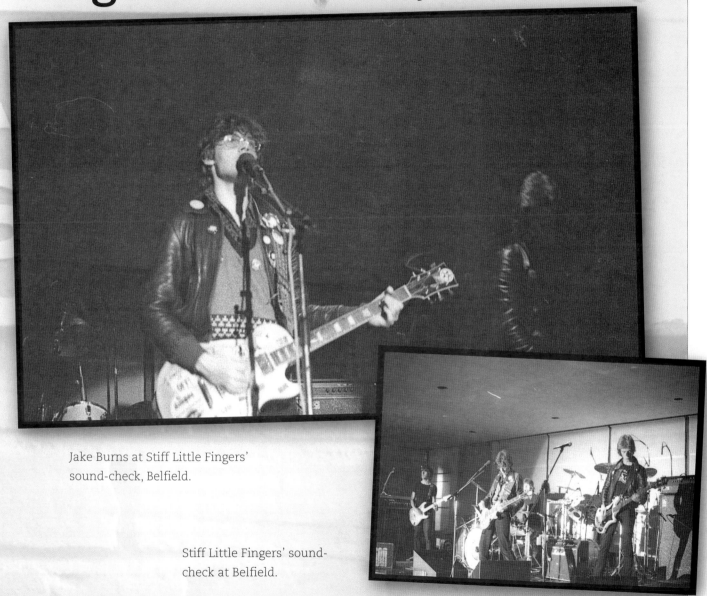

Jake Burns at Stiff Little Fingers'
sound-check, Belfield.

Stiff Little Fingers' sound-
check at Belfield.

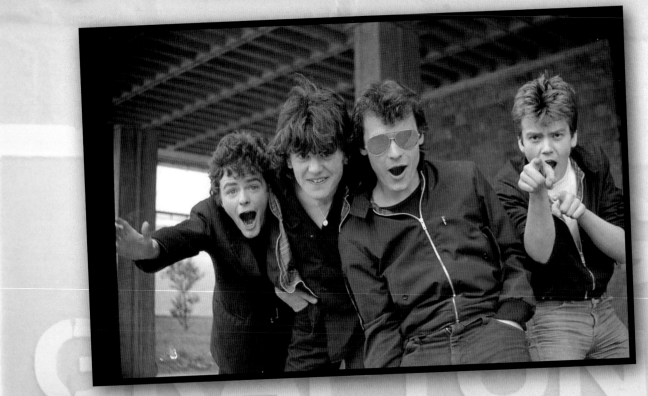

Belfast band Protex at the SLF gig in Belfield. Protex were Aidan Murtagh (guitar, vocals), David McMaster (guitar, vocals), Paul Maxwell (bass, vocals) and Owen McFadden (drums).

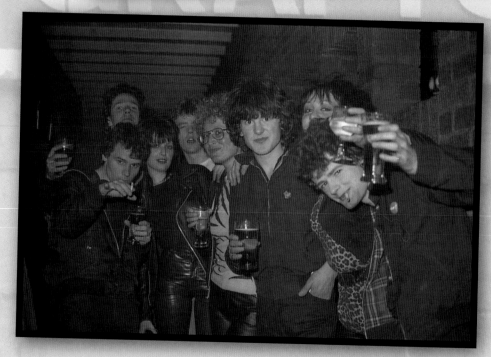

Protex and Boy Scoutz at the SLF gig in Belfield.

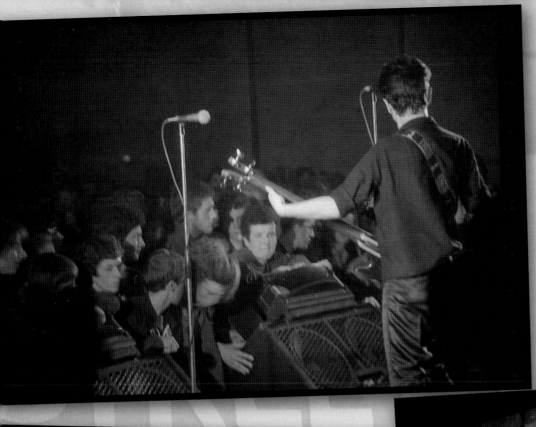

Belfast band the Starjets on stage at Belfield. Paul Bowen (guitar, vocals), Terry Sharpe (guitar, vocals), Sean Martin (bass) and Liam L'Estrange (drums). With the release of the single 'War Story' in 1979, the Starjets made a number of appearances on *Top of the Pops*.

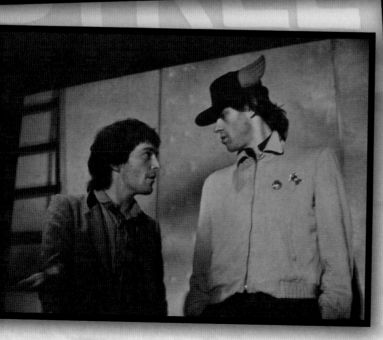

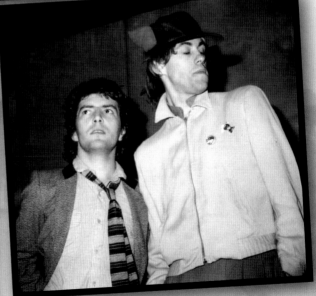

The Boomtown Rats' Pete Briquette (Patrick Andrew Cusack – bass) and Bob Geldof at the SLF gig in Belfield.

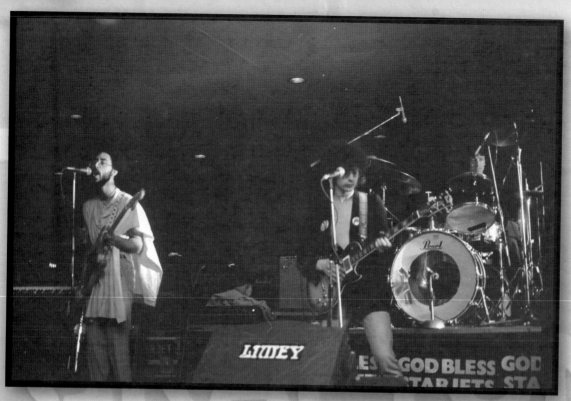

Zebra support Stiff Little Fingers at Belfield

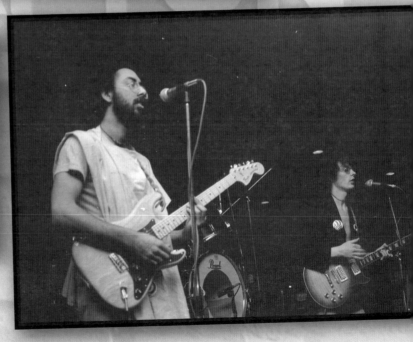

THIS WAS MY LIFE... TILL I DISCOVERED **THE BELFIELD BAR** THE EFFECT IS ECONOMICAL **THE BELFIELD BAR – MORE PINTS PER POUND**

This ad for University College Dublin's Belfield Bar was published in Tom Matthews' fanzine *Runt*, of which only one issue was ever released.

Stiff Little Fingers
in Belfield.

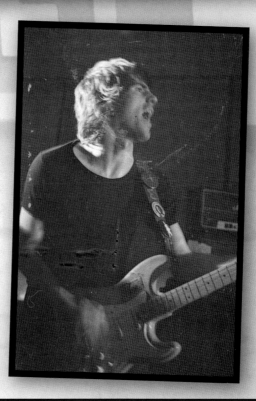

Left: Stiff Little
Fingers guitarist
Henry Cluney.

The Blades

Canal Banks, Herbert Place, circa May 1979

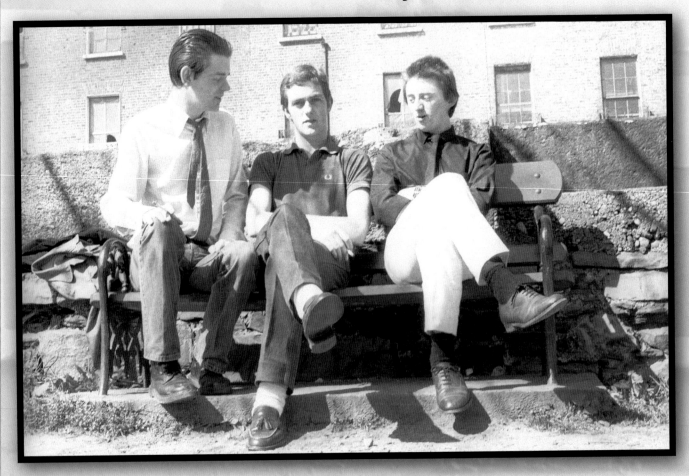

The Blades: Lar Cleary (guitar), Paul Cleary (vocals, bass) and Pat Larkin (drums). Formed in 1977, the Blades' first gig in the Catholic Young Men's Society Hall in Ringsend ended abruptly when the sound engineer took exception to their playing 'God Save the Queen', not realising that it was a cover of the Sex Pistols' song and not the British national anthem.

In 1979, the working-class band shared a six-week residency in the Baggot Inn with U2. In 1980 they released their first single 'Hot For You', which was followed up by 'Ghost of a Chance' in 1981 and 'Downmarket' in 1983. Following a number of line-up changes, the Blades split in 1986.

The Virgin Prunes
McGonagle's 2 June 1979

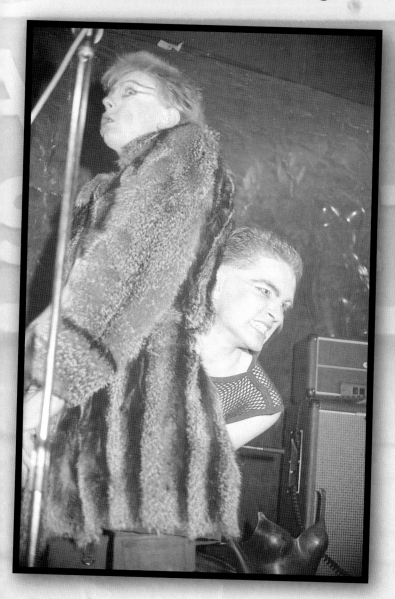

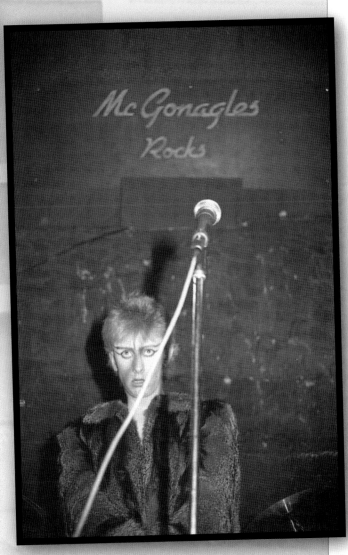

The Stranglers National Stadium 3 October 1979

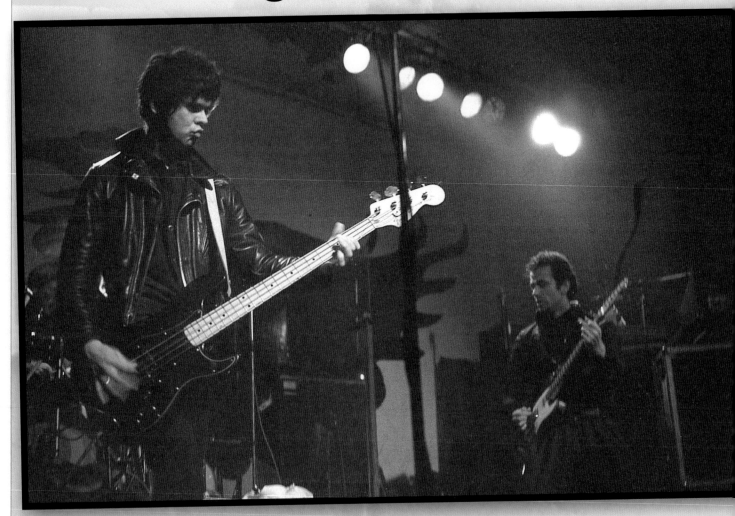

Jean Jacques Brunel and Hugh
Cornwell of the Stranglers in
the National Stadium.

Epidemix

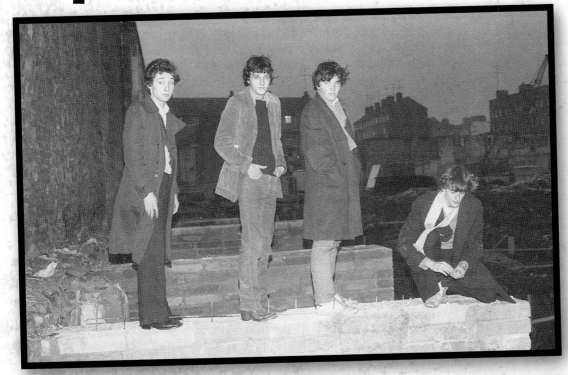

Epidemix were Gerry Grogan (bass), Colin Devlin (guitar), Paul Bonnar (sax, vocals) and Dave Bell (drums).

Joe Jackson

The Olympic Ballroom, off Camden Street

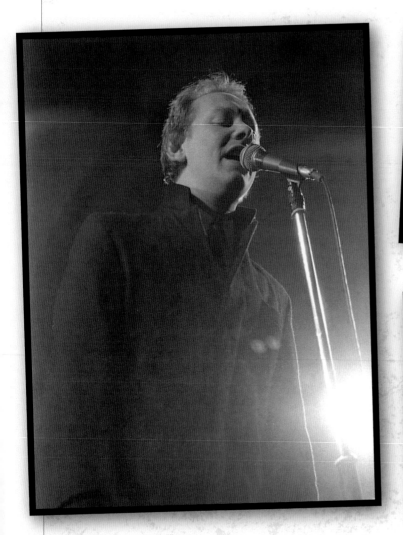

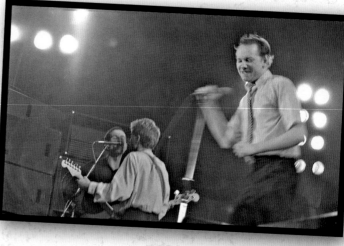

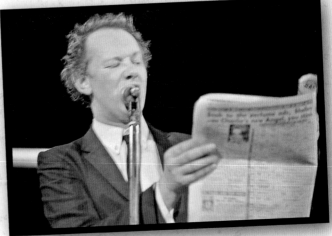

In Dublin

In Dublin was established in April 1977 by John Doyle. The magazine was mainly comprised of reviews and feature articles alongside gig, theatre, television and cinema listings. During Patrick's time at the magazine, features editor was Colm Tóibín, now an award-winning novelist. Like every publication at the time, *In Dublin* was constantly under financial pressure and in 1988 the title was sold to Vincent Browne and the offices moved from Ormond Quay to Baggot Street.

Right: Journalist Nell McCafferty and Pete Short at a creditors' meeting for *In Dublin* magazine, circa 1987. Short sold copies of *In Dublin* and *Hot Press* outside Bewley's Café on Grafton Street. Dubliners might recognise this building as the popular Winding Stair restaurant on Lower Ormond Quay.

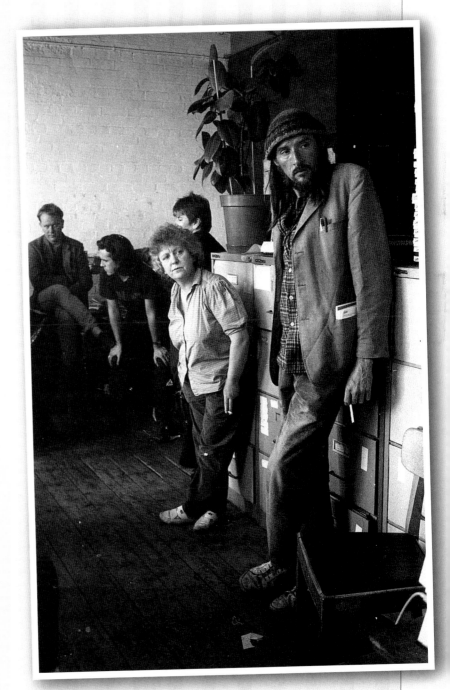

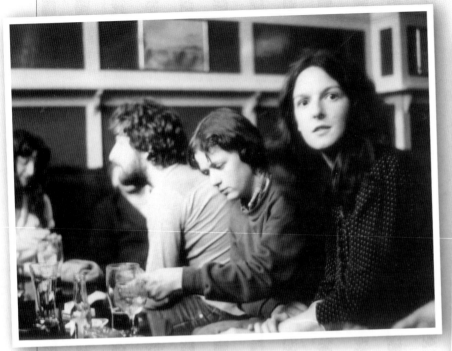

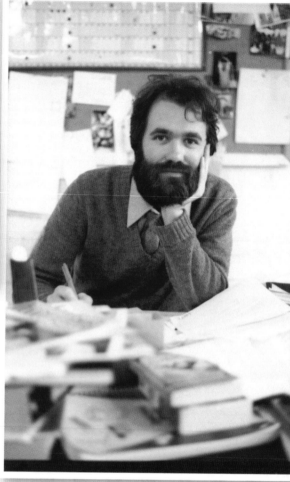

Above: Former *In Dubliners* Mary Raftery and Christine Hackney in the Norseman Pub, Temple Bar, circa August 1981. Mary Raftery went on to become an award-winning investigative journalist. The documentary series *States of Fear* which she produced in 1999, was one of the first major media investigations into the abuse of children in Irish industrial schools between 1930 and 1970 and is largely credited with inspiring an official apology to the victims of abuse in those institutions from then Taoiseach, Bertie Ahern and the resulting establishment of the Ryan Commission and the Residential Institutions Redress Board.

Above: Multi-award winning novelist, journalist, poet, literary critic and playwright Colm Tóibín in the *In Dublin* offices, where he worked as a journalist following a period living in Spain. In 1981 he was made features editor of the magazine.

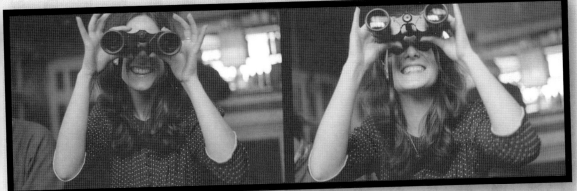

Christine Hackney, sub-editor and typesetter of *In Dublin* in the Norseman pub in Temple Bar, circa August 1981.

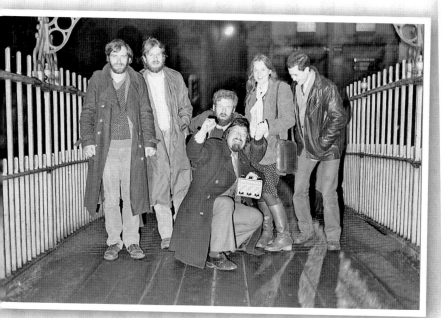

Above: Graphic artist Robert Armstrong, editor and founder of *In Dublin* John Doyle, sports journalist Jim Dowling, advertising executive Joan Burke, and DC Nein's Ken Mahon on Dublin's iconic Ha'penny Bridge.

Above: Journalist, author, broadcaster, chef and folk musician Éamonn Ó Catháin at his desk in the *In Dublin* offices. In the early 1980s Ó Catháin ran a popular French restaurant called Chez Beano on Lincoln Place in Dublin 2.

Hot Press

The first issue of *Hot Press* was released on 9 June 1977. Rory Gallagher was on the cover in anticipation of his headlining the upcoming Macroom Mountain Dew Festival, 17-26 June (tickets for the gig were £2.50). *Hot Press* quickly became the bible for every self-respecting Irish music fan, with music reviews, band interviews, and listings as well as non-music related articles. The magazine was (and still is) particularly supportive of up and coming local talent, and Stokes and his team were stalwart U2 supporters from early on.

Bono writing his piece for the 1980 *Hot Press* Yearbook in the magazine's offices on 12 January 1980. U2 played a gig in the Trinity College Junior Common Room the night before.

Left: Writer Neil McCormack photographed at his desk in the Mount Street *Hot Press* offices. Neil wrote the biography *U2 by U2* and the comedy film *Killing Bono* which tracked the demise of his musical career against the rising star of U2.

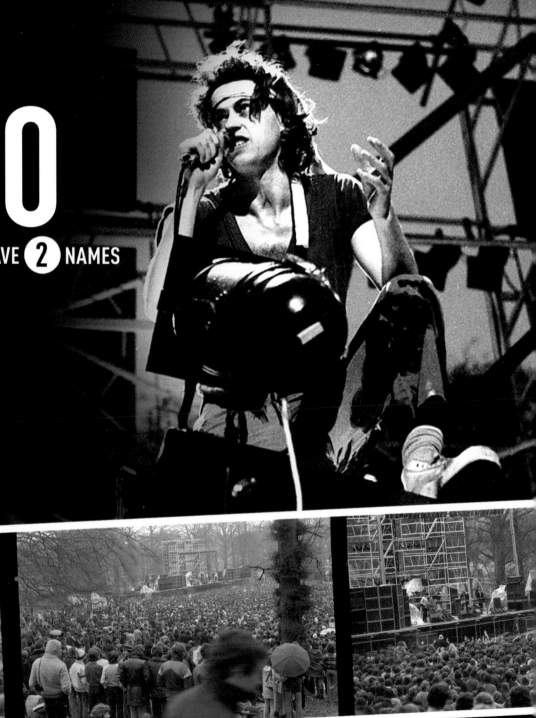

1980
WHERE THE STREETS HAVE ② NAMES

The Boomtown Rats

with Support from the Atrix, Leixlip Castle, 2 March 1980

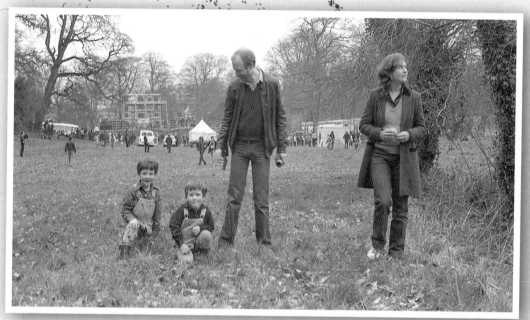

Backstage at Leixlip Castle. Former manager of Thin Lizzy and one-time manager of McGonagle's Nightclub, Terry O'Neill with his two children and then-employee, journalist Linda Duff.

The Atrix support the Boomtown Rats at Leixlip Castle.

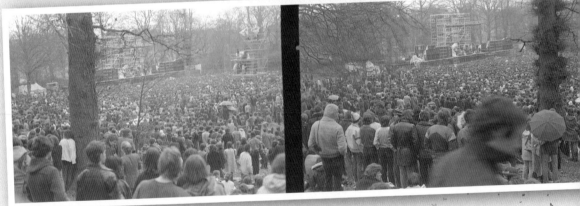

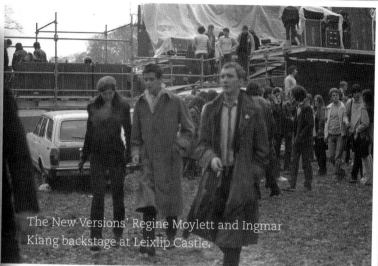

The New Versions' Regine Moylett and Ingmar Kiang backstage at Leixlip Castle.

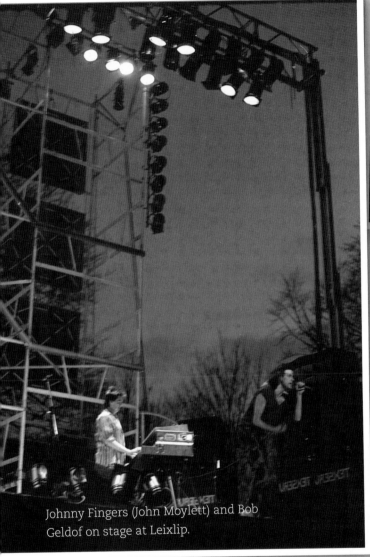

Johnny Fingers (John Moylett) and Bob Geldof on stage at Leixlip.

The Rats had been due to play at Leopardstown Racecourse a few weeks beforehand, but the concert had been cancelled by order of the courts. An RTÉ news report said that the Rats paid Desmond Guinness – owner of Leixlip Castle – 'a substantial fee' for the use of his grounds. In the news interview, Guinness declared that, 'It's not my style of music, but as long as it gives a lot of people a lot of pleasure, it doesn't seem to make much odds.'

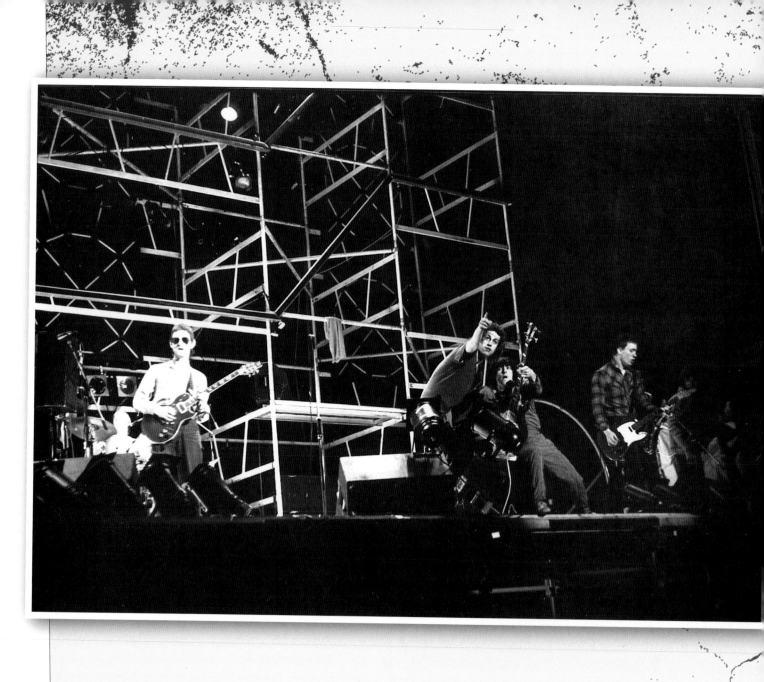

Hot Press editor Niall Stokes having dinner on Camden Street after the Leixlip gig.

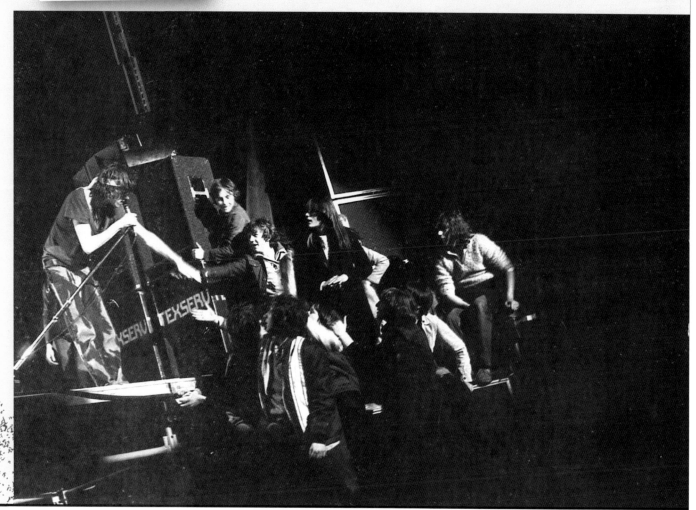

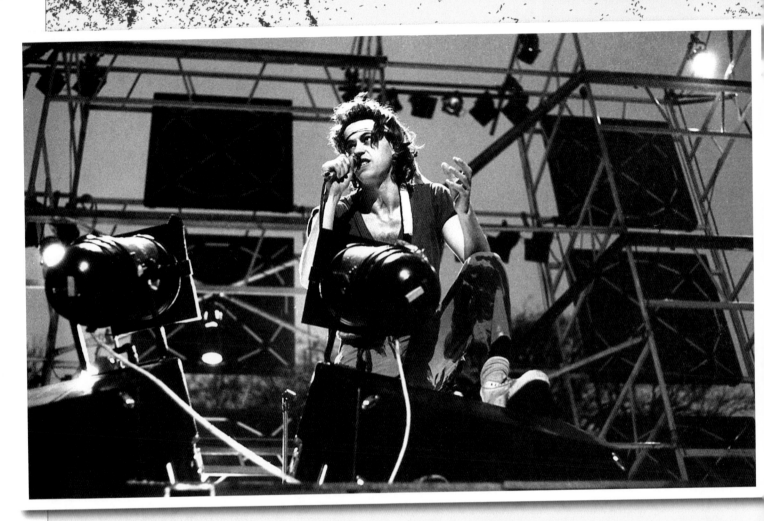

Bob Geldof on stage at Leixlip.

The Pretty's Brummie and Stone

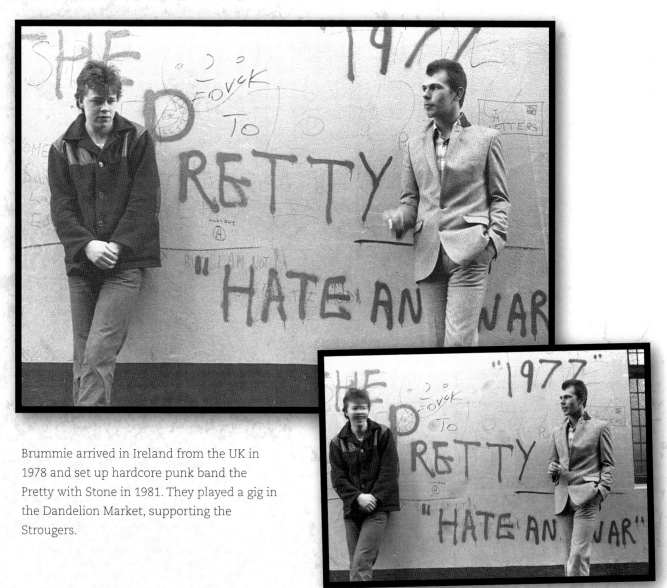

Brummie arrived in Ireland from the UK in 1978 and set up hardcore punk band the Pretty with Stone in 1981. They played a gig in the Dandelion Market, supporting the Strougers.

The Revillos Liberty Hall, 24 April 1980

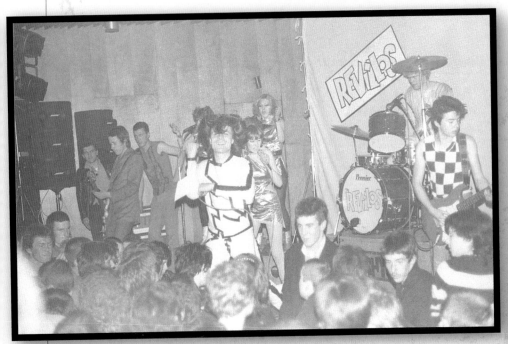

Scottish band the Rezillos were formed in 1976. After a couple of changes to their line-up, they renamed themselves the Revillos circa 1979/80.

'The Bottle of Milk': Tommy McCann and friend at the Revillos gig in Liberty Hall.

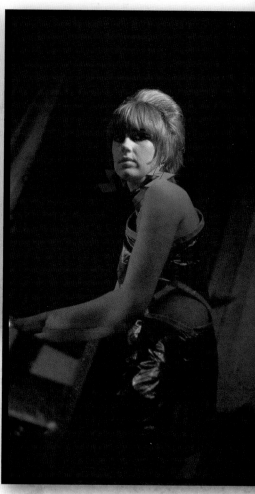

Fay Fife, vocalist with the Revillos.

U2
Theatre Hall, Gorey Arts Festival, 15 August 1980

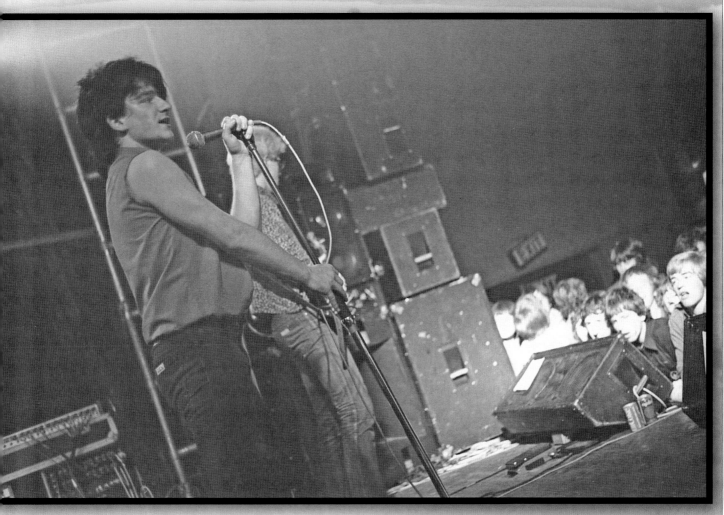

Bono on stage at the Gorey Arts Festival, 15 August 1980. The Gorey Arts Festival was organised by Paul Funge, who was also one of the founders of the Project Arts Centre. Ticket prices for this gig were £2.50 and the band played a number of songs from their forthcoming album *Boy*.

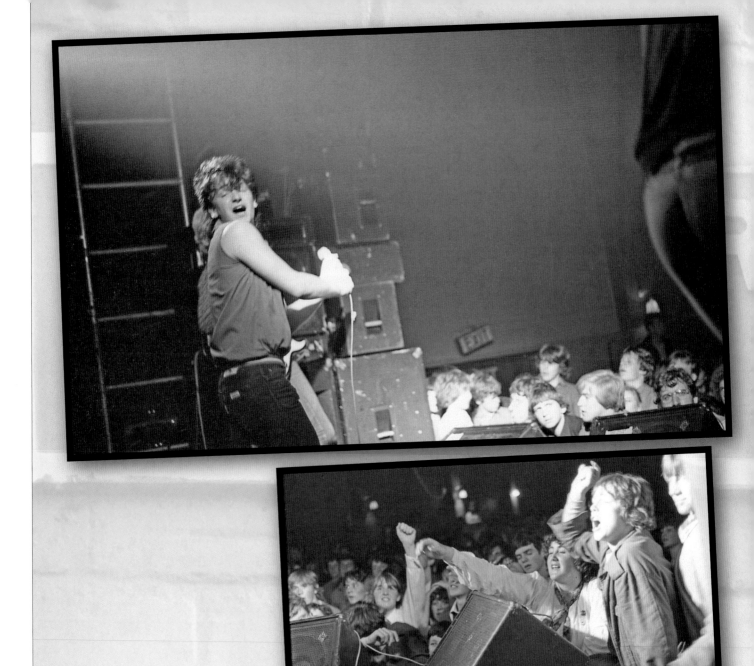

U2 fans at the Gorey Arts Festival,
15 August 1980.

The Atrix
Hope and Anchor Pub, Islington, London 20 November 1980

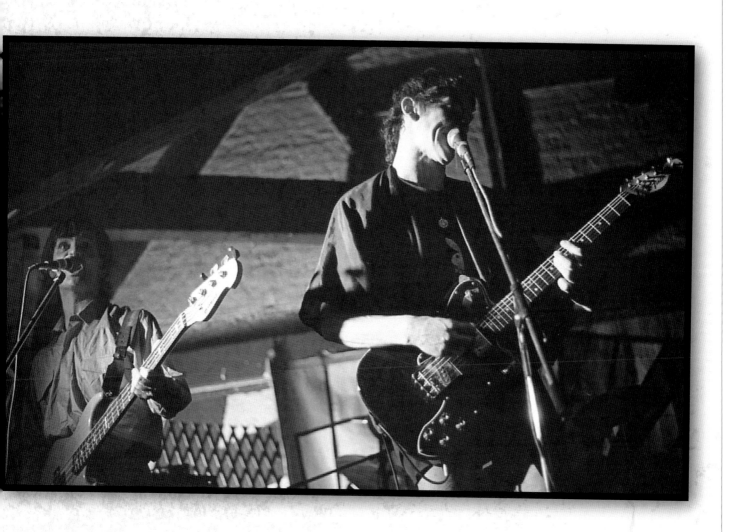

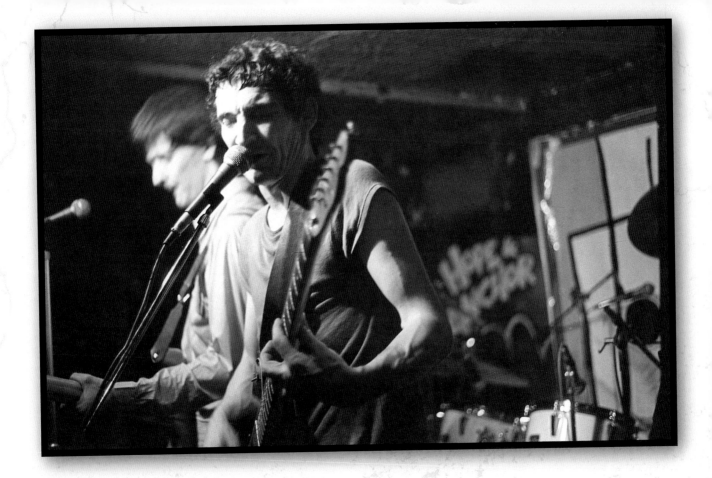

The Atrix at the Hope and Anchor Pub in Islington, London. Two well-known punk/new-wave albums were recorded at this famous venue: the Stranglers' *Live at the Hope and Anchor* and the double LP *Hope and Anchor Front Row Festival* which featured live songs from the Stranglers, Wilko Johnson, the Only Ones and Steel Pulse, recorded on 22 November and 15 December 1977.

Drummer Hughie Friel formed the Atrix with former Schoolkids' bassist Alan Finney, and John Borrowman and Chris Greene, both ex-Berlin band members. As their name suggests, they were a highly theatrical act, although their talents were not merely in the spectacular, but in drums, keyboards and lyrical poetics. Their first single, 'The Moon is Puce' was produced by Philip Chevron and released in 1979 to modest local acclaim. 'The Moon is Puce' and its 1980 follow-up 'Treasure on the Wasteland' both featured on the 1981 album *Procession*, produced by Midge Ure.

John Borrowman published two books of poetry, *Weak-Ends* (1977) and *Master of None* (1984). He died in Copenhagen in 1998.

Rocky De Valera and the Rhythm Kings

Photo Shoot Circa 1980

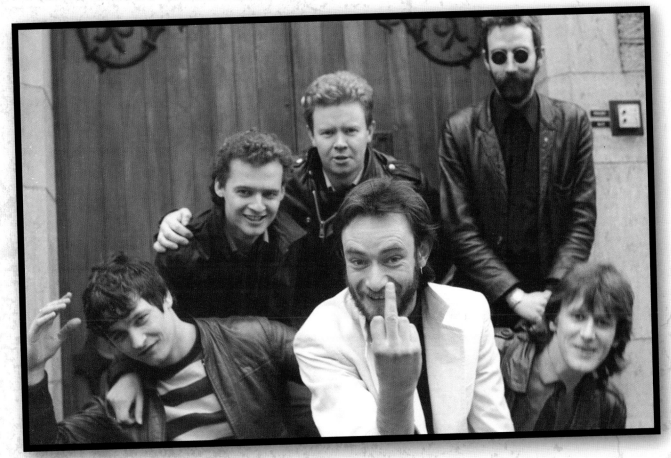

Front row: Greg 'Wong' Walsh (drums),
Rocky De Valera (vocals), 'the Individual'
Eamon Murray (sax, harmonica). Back row:
Martin 'the Lizard' Meagher, Richie 'Milkboy'
Taylor (guitar), Mark 'Clint' Clinton (bass).

Squat on Mountjoy Square

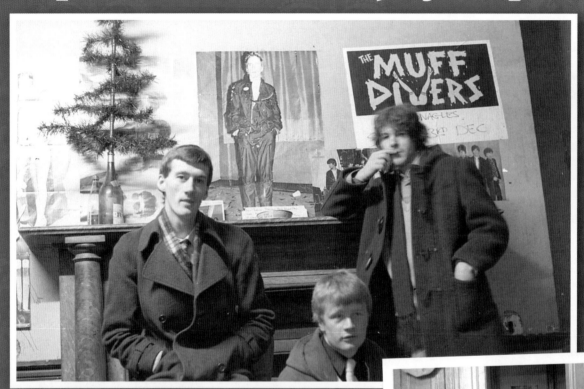

Next door to the An Óige building on Mountjoy Square, John Breen (guitarist with the Schoolkids) ran this squat and rehearsal space up until 1981, when the building was demolished. U2, the Boy Scoutz, the Schoolkids and the Brown Thomas Band were amongst the many bands who rehearsed here. The person on the left is unidentified. In the middle is Patrick Brocklebank, who lived here for about four months. Colm O'Kelly, guitarist with Revolver, is leaning against the fireplace.

U2's former rehearsal space on Mountjoy Square.

U2 TV Club, Harcourt Street, 22 December 1980

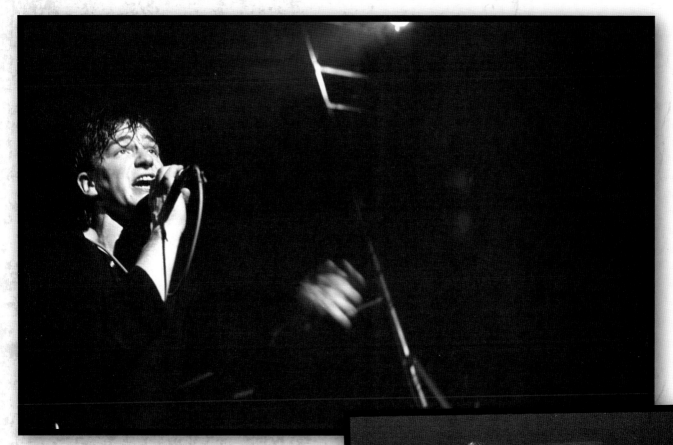

U2 at the long-since defunct TV Club in Harcourt Street, 22 December 1980. Produced by Steve Lillywhite, the band's debut album *Boy* was released on 20 October 1980. A Hugo McGuinness photograph of Peter Rowen, younger brother of Guggi, Guc, Clive and Strongman featured on the cover. The album launched U2 in America and the UK, receiving favourable reviews from *NME*, *Melody Maker* and *Time Out*. This gig in the TV Club was completely sold out – U2's star was on the rise.

Operating Theatre

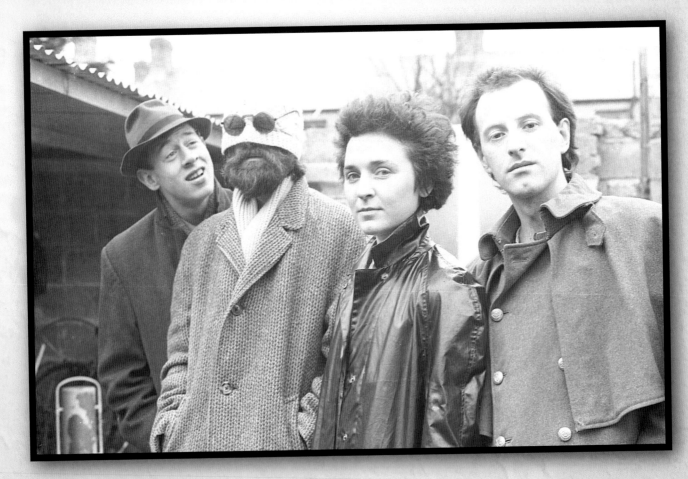

Avant-garde music-theatre company Operating Theatre. From left to right: Liam de Staic, Tom Matthews, Olwen Fouéré and Roger Doyle.

Berlin Dún Laoghaire Circa May 1981

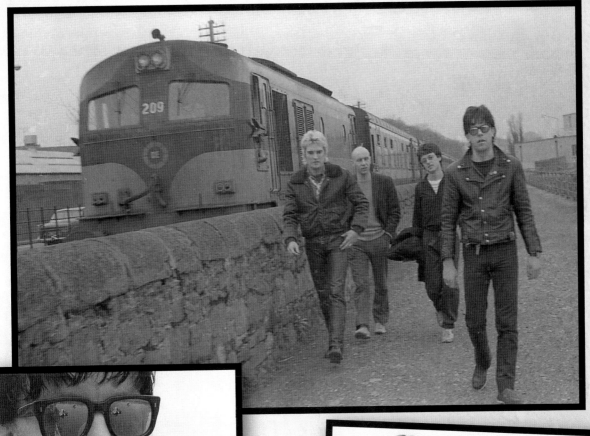

Berlin and the Wexford-bound train, near Dún Laoghaire station. The band broke up shortly after these photos were taken.

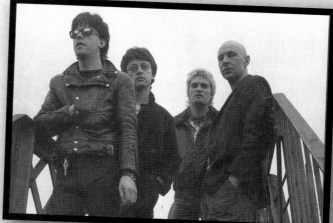

Reb Kennedy's Glam Friends

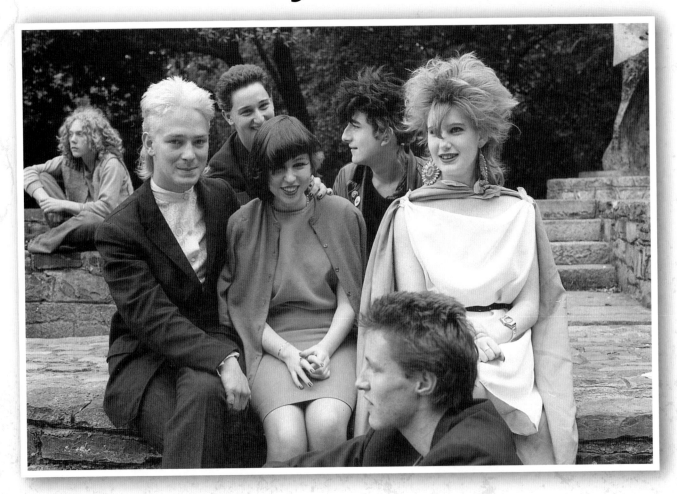

Glam punks in St Stephen's Green, circa 1980. In the
back row of the photo is Mary D'Nellon, drummer
with the Prunes, and art student John Fiddler. These
photos were taken for an *In Dublin* article which
never appeared.

Macroom Mountain Dew Festival

26/27th June 1981

The 1977 Macroom Mountain Dew Festival was the first major open-air rock festival in Ireland. Rory Gallagher was headlining, Status Quo were supporting and a fifteen-year-old, later to become known as the Edge, was in the audience. Four years later, nearly 10,000 music fans paid £12 for a weekend in the Lee Valley to see Rocky De Valera and the Rhythm Kings, Paul Brady, Elvis Costello and the Attractions, and the Undertones.

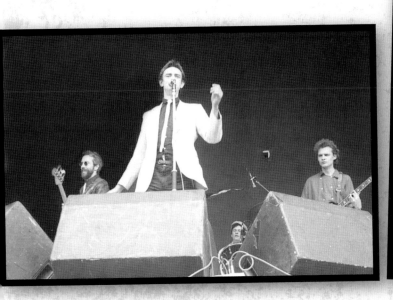

Rocky De Valera and the Rhythm Kings.

MC Dave Fanning and Mark Clinton having a pre-gig beer.

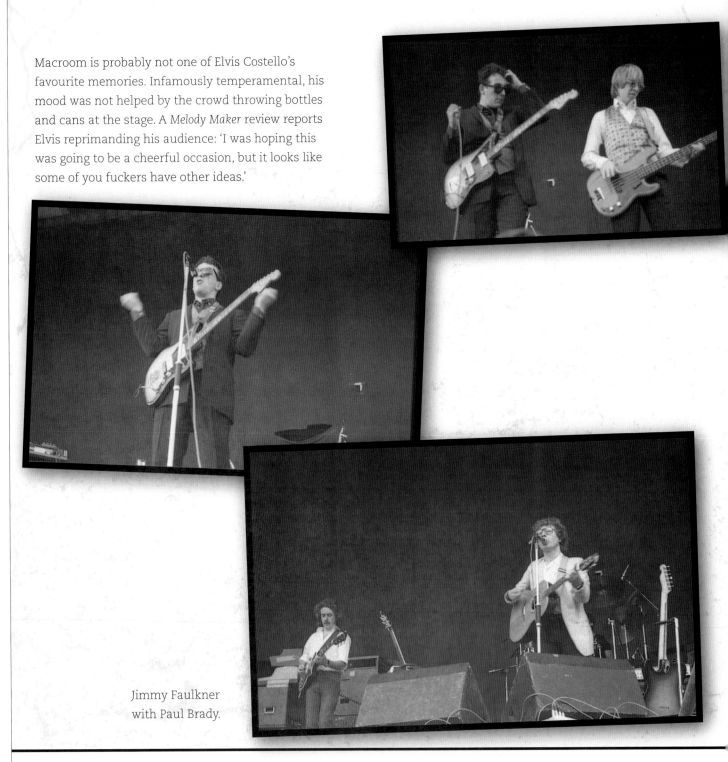

Macroom is probably not one of Elvis Costello's favourite memories. Infamously temperamental, his mood was not helped by the crowd throwing bottles and cans at the stage. A *Melody Maker* review reports Elvis reprimanding his audience: 'I was hoping this was going to be a cheerful occasion, but it looks like some of you fuckers have other ideas.'

Jimmy Faulkner
with Paul Brady.

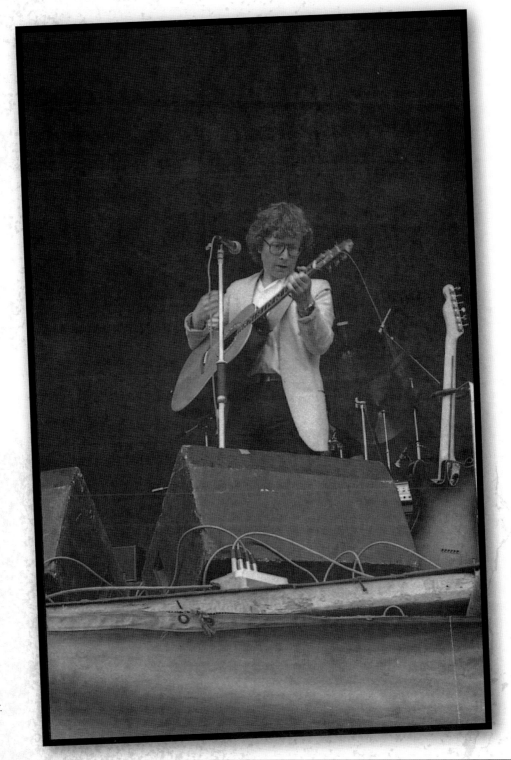

Paul Brady.

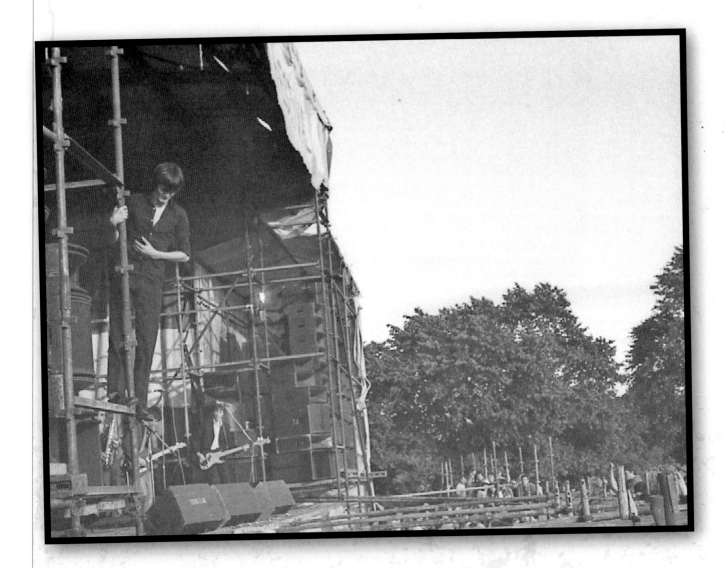

Feargal Sharkey of the Undertones headlining the second night at Macroom, putting a happy end to the festivities.

1981

WHERE THE STREETS HAVE **2** NAMES

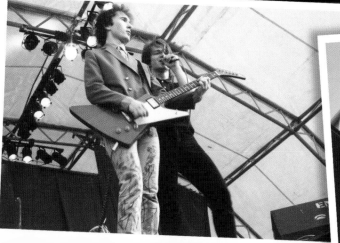

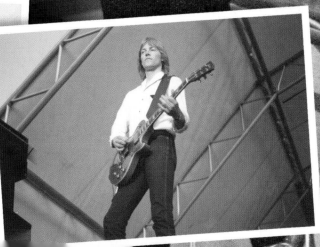

Stag Cider/Hot Press Music Awards

Royal Hibernian Hotel, Dawson Street
July 1981

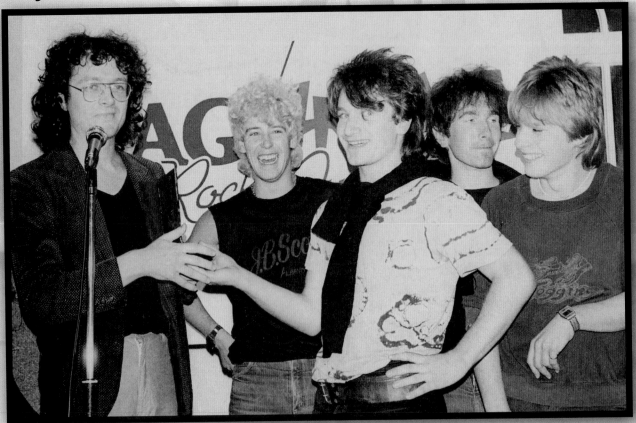

Niall Stokes congratulates U2 on their success at the Stag Cider/Hot Press Music Awards ceremony in 1981. U2 won three categories of awards including Best Band, Best Live Band and Best Album for *Boy*.

The band had just completed their *Boy* tour in February and re-entered the studio in July 1981 to record their second album, *October*.

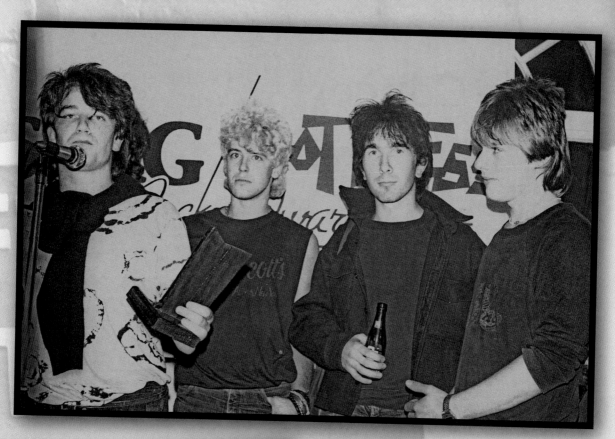

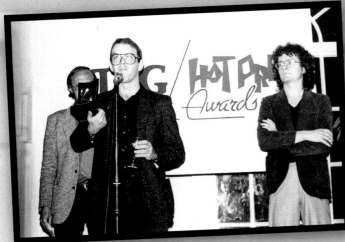

Paul McGuinness receives a Stag
Cider/*Hot Press* Music Award in 1981.

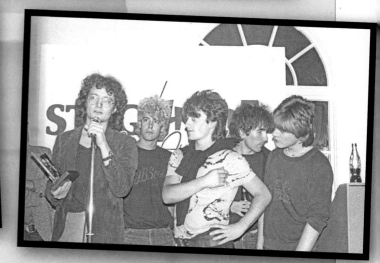

Slane Concert 16 August 1981

On 16 August 1981, the inaugural Slane Concert was held on the grounds of Lord Henry Mountcharles's castle in County Meath. The first-ever Slane line-up featured U2, Hazel O'Connor, Rose Tattoo, Sweet Savage, the Bureau, Megahype and headliners Thin Lizzy who made a dramatic entrance by helicopter into the Boyne Valley. An audience of 20,000 were expected – the biggest gig of U2's short career, but alas, it was not the glorified event that the band had been hoping for and reviews were mixed. High winds meant that sound quality was shaky and Bono had difficulty remembering the lyrics to new material from *October* (a briefcase with the album lyrics had been stolen while the band were on tour in Portland). A number of bottles were thrown at the stage, and Bono pleaded with the audience not to feed the hungry media with stories of rock 'n' roll violence. Arguably the most successful

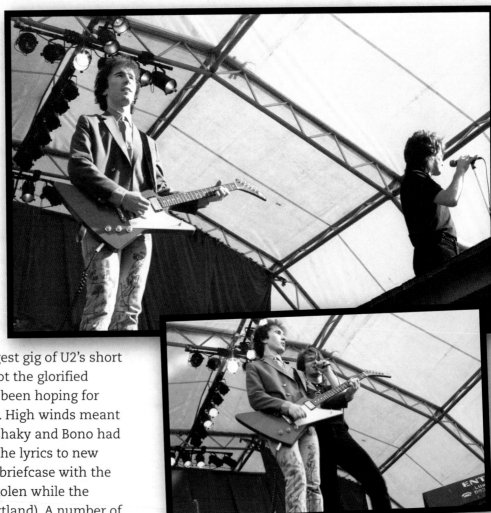

moment of the entire set was when the band persuaded the crowd to sing 'Happy Birthday' to the Edge's girlfriend, Aislinn O'Sullivan.

Below: Thin Lizzy's Phil Lynott and
Scott Gorham on stage at Slane.

Right: Scott
Gorham on
stage at Slane.

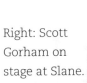

Right: Snowy White – Thin Lizzy's
guitarist – on stage at Slane.

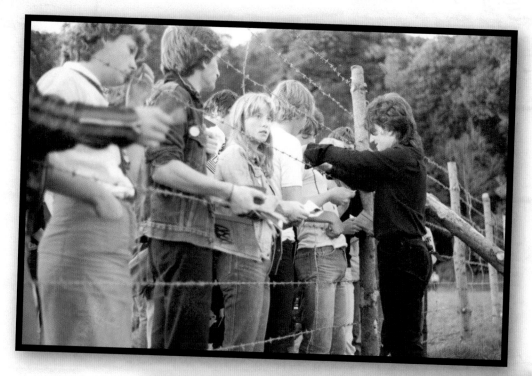

Phil Lynott signing autographs for a young fan at Slane. By this time Lynott was recording as a solo artist as well as continuing to play with Thin Lizzy, whose greatest hits album, *The Adventures of Thin Lizzy,* was released in April 1981. The band broke up in 1983 and Lynott passed away on 4 January 1986, aged thirty-six.

Afterword
by Dermott Hayes

The boy on the cover of U2's debut album *Boy* looks at the world with wide-eyed innocence and curiosity. Thirty years later, the girl in the title song of U2's 2009 album *No Line on the Horizon* tells the singer, 'Time is irrelevant, it's not linear.' This ode to the infinite nature of creativity might be interpreted as wishful thinking for these now ageing rockers, but for U2 fans it is a reassuring signal of the four Dubliners' continuity. No band has sought inspiration in the zeitgeist of their generation more than U2. While many of their songs have explored their own souls' dark journeys, they have found reflection in the lives of their worldwide army of fans and the life and times of the world that surrounds them.

The seventies is not a decade we reflect upon with a rosy glow of nostalgia. The first major oil crisis of the last century set the tone for a decade marked by strikes, international hijackings, rampant inflation and progressive rock. In Ireland, violence in the north-east had reduced to sectarian, tit for tat murders while the IRA exported terrorism to the streets of British cities. Closer to home, security issues were so pressing, State intervention was perceived as invasive and oppressive. Was it any wonder punk came along? The revolutionary cry went up: out with the old, in with the new. It was an exciting time to be making music and living in Dublin. A whole scene grew up around the Grafton Street corner of St Stephen's Green.

There were few venues for emerging punk bands and those there were, were overbooked. U2 were just minor players in a scene inspired by new policies of 'do it yourself' but occupied still by the old guard in new clothes. The band of likeminded classmates put together by Larry Mullen got their first gigs in local north-side venues as the Hype, playing Bowie covers. By the end of 1978, a browser in the Dandelion Green flea market could catch them playing Saturday afternoon free gigs in a partially flooded stable. Participation was a byword for U2 as they embraced the audience that ventured to embrace them. In the boiling pot of this incestuous Dublin scene, the involvement of some members of the band in the Shalom group, inspired devotion and derision. A rival group emerged calling themselves the Black Catholics, opposed to all things U2.

In the grand scheme of things, it didn't

amount to a hill of beans. U2 had a plan to become the biggest rock 'n' roll band in the world and when they met Paul McGuinness, they found the man who might have the moxy to realise their dream. McGuinness was a Trinity graduate who had already dabbled in music management with the Celtic rock outfit Spud. He was well-read and widely admired. He had worked in the world of advertising and commercial production and understood the power of image and the value of intellectual copyright.

U2's deal with Island Records was mutually beneficial. Although Island had considerable success in the seventies introducing reggae and Bob Marley to a worldwide audience, carving its own niche in the prog rock scene with Jethro Tull as well as tradrock and troubadours with Cat Stevens, Sandy Denny, Richard and Linda Thompson, among others, it failed to make any impression on the punk or new wave scene. For Paul McGuinness and U2, it was a canny alliance. Island was cash rich and inclined to allow creative freedom.

Despite this support, it took more than three years of hard slog, thousands of road miles in hard touring and countless, nameless motel rooms before some faint flicker of light and hope appeared. Heavily in debt, with their personal convictions troubled by the rock 'n' roll lifestyle, the band almost split after the release of their second album, *October*. They persevered in adversity and when the lyrics for the album were lost whilst touring, the band composed the songs on the hoof. The singer 'wrote' his lyrics at the microphone while producer Steve Lillywhite was mixing the track. *October* was not a commercial success, but in retrospect it helped shape how they worked in the future.

The picture of Peter Rowen, the boy on the cover of *Boy*, changes significantly on the cover of *War*, the band's third studio album. He's growing up. There's an inquisitive anger in the eyes. The album announced U2's arrival as a band with something to say. They now had a distinctive sound.

The Unforgettable Fire laid the foundation for what was to follow. As the first album with the production team of Daniel Lanois and Brian Eno, it was greeted with suspicion by U2's American fan base, but it consolidated a sound that was already manifesting itself since *October* and made a creative virtue of the band's willingness for impromptu experimentation.

All of this came to fruition with *The Joshua Tree*, a massive album exploring the journey of the soul through a material wasteland, the American hinterland, drunk on imperial power and lust. Suddenly U2 were on the cover of *Time* magazine and on top of the world.

Hardly overnight success, but it allowed

them to buy bigger homes and stay in better hotels. As individuals, they were rock stars without portfolio. They felt like pretenders. *Rattle and Hum*, the double album and feature film that followed *The Joshua Tree*, was panned by critics as pretentious, presumptuous and arrogant. It was misinterpreted. U2 wore its creative heart on its sleeve. When *Boy* was released in 1980, Bono declared they had no influences, as though they'd emerged in a vacuum. But what was simply an assertion of the band's singular creative vision would come back to haunt him. In *Rattle and Hum* they sought to explore, absorb and pay homage to the heritage that informed their own music: blues, soul, country and gospel. It was no wonder that at the end of the subsequent tour, in the Point theatre in Dublin on the last day of the decade, the band declared their intention to go away and reinvent themselves.

Ironically, the world around them was going through the same process. As though a corked steam kettle had popped, popular unrest and impatience spilled over into direct action. The Berlin Wall was torn down, brick by brick, in Czechoslovakia, writer Vaclev Havel lead the Velvet Revolution, and in Poland, Lech Walensa was leading a popular movement towards democratic freedom and independence. U2 chose Hansa studio in Berlin to record *Achtung Baby*, arguably the

band's creative zenith and the point where the band's creative output and the cultural zeitgeist coalesced. From the opening track, as the U2 locomotive chugs out of 'Zoo Station' and Bono declares, 'I'm ready for what's next . . .' It was as though the eighties had never happened and *Rattle and Hum* was someone else's nightmare.

In the nineties U2 grew up, as a band and as individuals. It was a period that was not without cringing embarrassment as they embraced the new dance culture and *Zoo* became the argot of postmodern irony. As MacPhisto, Bono could make prank calls, ordering pizzas for an audience of thousands and phoning Bill Clinton for a natter about world peace. However, in the *POP* tour, the band's emergence from a giant lemon was too reminiscent of Spinal Tap for comfort. They appeared to choke on their own postmodern joke.

But what artist cannot embrace failure? Failure, in U2 terms, meant earning millions less than expected from what they produced. The only 'loss' they could suffer now was creative and the three albums the band released in the noughties – *All that you Can't Leave Behind, How to Dismantle an Atomic Bomb* and *No Line on the Horizon* – have found them returning to basics in different measures and with varying results. In the meantime, Bono has become a global statesman, at home in

the company of world leaders. Adam has been through rehab and just recently married and the Edge is in a new marriage with a second family. Larry Mullen has a family and just recently launched himself in a new role as a film actor.

They're boys no more.

Dermott Hayes

Dublin 2012